The Lauren Rogers Museum of Art
HANDBOOK
OF THE COLLECTIONS

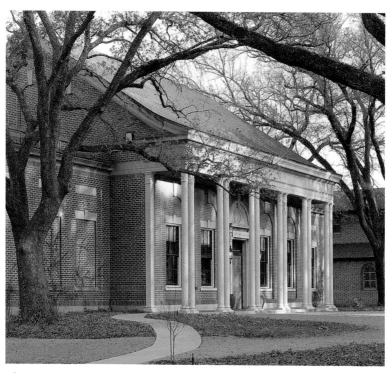

The Lauren Rogers Museum of Art

The Lauren Rogers Museum of Art

HANDBOOK
OF THE COLLECTIONS

REVISED EDITION

THE UNIVERSITY PRESS OF MISSISSIPPI
Jackson and London

LIBRARY OF CONGRESS CATALOGING-IN-PUBLICATION DATA

Lauren Rogers Museum of Art (Laurel, Miss.)
 The Lauren Rogers Museum of Art: Handbook of the collections.
 Rev. ed.
 p. cm.
 Includes bibliographical references and index.
 ISBN 1-57806-557-7 (pbk. : alk. paper)
 1. Lauren Rogers Museum of Art (Laurel, Miss.)—Catalogs.
 2. Art—Mississippi—Laurel—Catalogs. I. Title: Handbook of collections.
II. Title.

N582.L.23A57 2003
708.162'55 — dc21 2003041111

CONTENTS

ACKNOWLEDGMENTS

On the occasion of the eightieth anniversary of the founding of the Lauren Rogers Museum of Art, we are pleased to present the second edition of the *Handbook of the Collections*. The handbook serves not only as an introduction to the collections of the museum but also as a guide for visitors who want to learn more about the significant holdings of LRMA.

This second edition allows the museum to include acquisitions made since the original publication of the handbook in 1989 and to revise narrative entries to accommodate changes in scholarship. The efforts of former LRMA Directors Mary Anne Pennington and Estill Curtis Pennington in editing and producing the first edition of this book are gratefully acknowledged.

This revision of the original publication was directed by LRMA Curator Jill Chancey and Registrar Tommie Rodgers. I am grateful for their leadership and coordination in editing this second edition. Other staff members who assisted in the project include Allyn Boone, Mark Brown, Sandy Hayes, and Beth Henderson. Appreciation is given to writers Mark Brown, Jill Chancey, Kenneth Carleton, Dr. Betty Duggan, Dawn Glinsmann, Joyce Herold, Tommie Rodgers, and Dr. Donald Wood, all of whom provided new or revised entries.

Photography is an important factor in any art publication, and it is appropriate to recognize the services through the years of photographers Jimmy Bass, Birney Imes, Owen Murphy, the late J. B. Tomlinson, and Rand Williams.

The Eastman Memorial Foundation Board of Trustees has provided support and guidance in making this second edition a reality. Of course, I must recognize museum founders Mr. and Mrs. Lauren Chase Eastman and Mr. and Mrs. Wallace Brown Rogers, without whose vision the Lauren Rogers Museum of Art would not be celebrating eighty years of artistic excellence and accomplishment.

George D. Bassi
Director

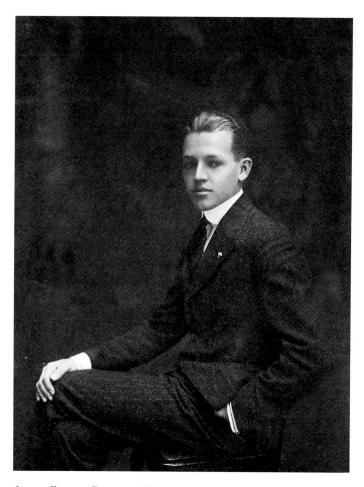

Lauren Eastman Rogers, c. 1920

INTRODUCTION

The Eastman, Gardiner, and Rogers families came to Laurel, Mississippi, from Clinton, Iowa, in the 1890s to establish Eastman-Gardiner Lumber Company. After the turn of the century, Laurel prospered, thanks to a total of four active sawmills in the area. The timber families built large residences along broad avenues, designed public parks, and influenced the development of strong schools.

The Lauren Rogers Museum of Art is located on Fifth Avenue, one block from the center of Laurel, Mississippi, and is surrounded by historic homes, live oaks, azaleas, and Asiatic jasmine. The museum is the sole beneficiary of the Eastman Memorial Foundation, which was established on May 26, 1922. The foundation and the museum are both memorials to Lauren Eastman Rogers, the only child of Nina Eastman and Wallace Brown Rogers and the only grandchild of Elizabeth Gardiner and Lauren Chase Eastman. Lauren Rogers died on July 3, 1921, after an appendectomy at the age of twenty-three, and his untimely death ended the dream of his running the family lumber business.

The Eastman Memorial Foundation had as its original purpose "to promote the public welfare by founding, endowing, and having maintained a public library, museum, art gallery, and educational institution, within the state of Mississippi." The driving forces behind this impressive memorial were Lauren Rogers's father, W. B. Rogers, who had the vision, and Elizabeth and Lauren Chase Eastman, who provided the funding.

On May 1, 1923, the museum opened to the public in a building on the site of what was to have been the home of Lauren and his wife, Lelia Hodson Rogers. The Georgian Revival structure with its formal axial symmetry was designed by Rathbone deBuys of New Orleans. The building has double-hung sash windows in an exterior of local brick with Indiana limestone. The slender, attenuated metal columns were made by Laurel Machine and Foundry Company. The original building contained one art gallery and space for a public library.

The interior lobby, which was initially conceived as part of the library, features quarter-sawn golden oak paneling and cork floors. The hand-molded plaster ceiling, suggested by Charles J. Watson of the

American Gallery, 1927

Chicago interior design firm of Watson and Walton, is the work of master craftsman Leon Hermant and uses intricate naturalistic motifs. The handwrought iron gates, railings, and hardware throughout the building were created by Samuel Yellin, a master blacksmith from Philadelphia, Pennsylvania.

With the completion of a new wing in 1925, the museum gained five galleries to house the museum's permanent collections and a lower level space for the Laurel Library Association, which occupied the building until 1979. In 1953, Lauren's widow Lelia created the Reading Room, which was filled with furniture and a rug from the home of Lauren's parents. Located in what was the original art gallery adjacent to the main lobby, the Reading Room houses family memorabilia and Lauren's portrait. In 1983, another addition to the museum, designed by Michael Foil of Jackson, was completed. The new space provided office, storage, and work areas as well as gallery space for temporary and traveling exhibitions. Also added was a large gallery, featuring a grand staircase of Tennessee black marble with brass railings.

The collections began when the museum opened in 1923 with a gift from Lauren Rogers's great-aunt, Catherine Marshall Gardiner, who donated her collection of some five hundred Native American baskets. This collection features more than eighty tribes from North America and provides visitors with a strong survey of Native American weaving from the late nineteenth and early twentieth centuries.

Following the museum's founding, the Rogers and Eastman families donated important nineteenth- and twentieth-century paintings by Winslow Homer, Albert Bierstadt, Jean-Baptiste Camille Corot, Jean François Millet, George Inness, Thomas Moran, John Frederick Kensett, and Rosa Bonheur. Works by noteworthy artists John Singer Sargent, Mary Cassatt, Eugène Boudin, James Abbott McNeill Whistler, Robert Henri, Grandma Moses, Romare Bearden, Eastman Johnson, John Sloan, Ernest Lawson, Fairfield Porter, Elizabeth Catlett, and Charles Burchfield were acquired thereafter.

In the 1920s, Lauren's father, W. B. Rogers, donated his eighteenth- and nineteenth-century Japanese woodblock print collection, including 142 works by such masters as Harunobu, Masanobu, Utamaro, Eishi, Hokusai, and Hiroshige. This collection had been assembled by Mr. Rogers over a period of fifteen years with the assistance of art dealer Frederick W. Gookin of Chicago. The museum acquired an additional twenty-two prints through a bequest from the Rogers family in the 1950s.

In 1972 and 1973, Thomas Michael Gibbons and his wife, former museum trustee Harriet Stark Gibbons, donated their extensive collection of Georgian silver. Silversmiths include Hester Bateman,

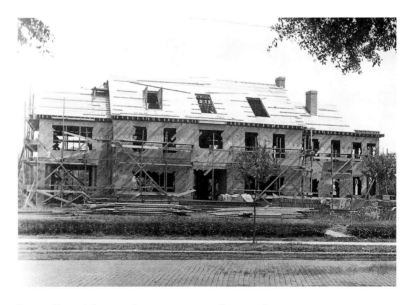

Lauren Rogers's home under construction at the time of his death; museum was built upon this foundation.

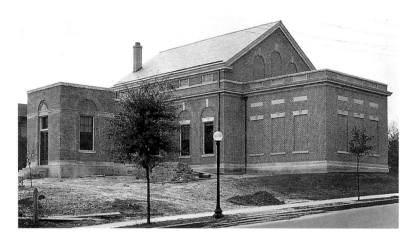

Lauren Rogers Library and Museum of Art, original building, rear view, 1923

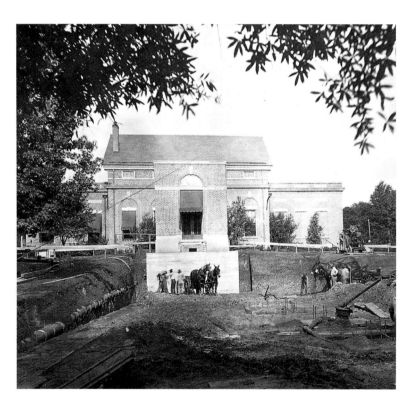

Construction of museum galleries wing, 1924

Paul Lamerie, William Plummer, Thomas Powell, and Paul Storr, and the collection features some seventy major objects related to the service of high tea.

To strengthen the museum's holdings, LRMA has continued to acquire works by late twentieth-century American artists, Mississippi artists, and prominent African-American artists. This important list includes Robert Motherwell, Helen Frankenthaler, Josef Albers, Wolf Kahn, Jacob Lawrence, Richmond Barthé, Marie Hull, Walter Anderson, William Hollingsworth, and Karl Wolfe.

The five sections of this handbook correspond with the museum's collecting areas: European art, American art, Japanese prints, Native American baskets, and British Georgian silver. Each section contains works which represent the broad holdings of the museum. Although it is difficult to choose fewer than two hundred objects from almost two thousand works in the collection, the museum feels that those which are included in this handbook highlight eighty years of excellence in collecting fine art.

The sections dealing with European art, American art, and Japanese prints are arranged chronologically by the artist's year of birth. Native American baskets are presented by tribe in alphabetical order. The works in the section on silver appear in chronological order by year of the object's origin. Entries include a photograph of the object, technical data, means of acquisition, and interpretive text. This second edition of the handbook contains

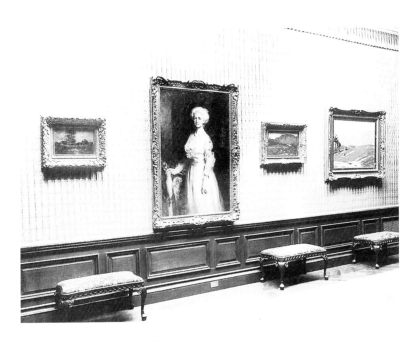

Portrait of Catherine Marshall Gardiner

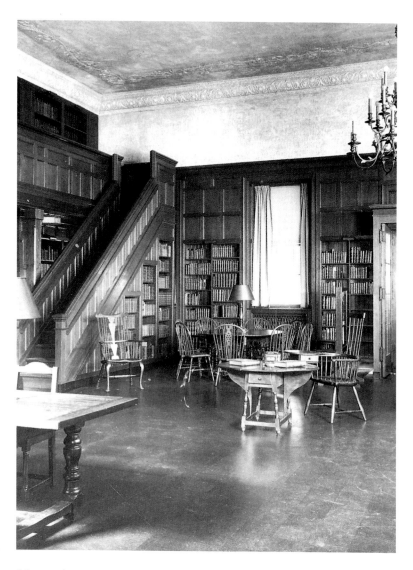

Library reference room, c. 1925

some new and revised interpretive text written by Dr. Donald A. Wood, chief curator and the William M. Spencer III Curator of Asian Art at the Birmingham Museum of Art; Kenneth H. Carleton, archaeologist of the Mississippi Band of Choctaw Indians; Dr. Betty Duggan, research affiliate, Peabody Museum of Archaeology and Ethnology, Harvard University; Dawn Glinsmann, independent scholar, University of Washington; Joyce Herold, curator of ethnology of the Denver Museum of Nature and Science; Jill R. Chancey, LRMA curator; Tommie Rodgers, LRMA registrar; and Mark Brown, LRMA curator of education. Each of these new or revised entries is signified by the author's initials.

Lauren Rogers Library and Museum of Art, upon completion, 1923

THE COLLECTIONS

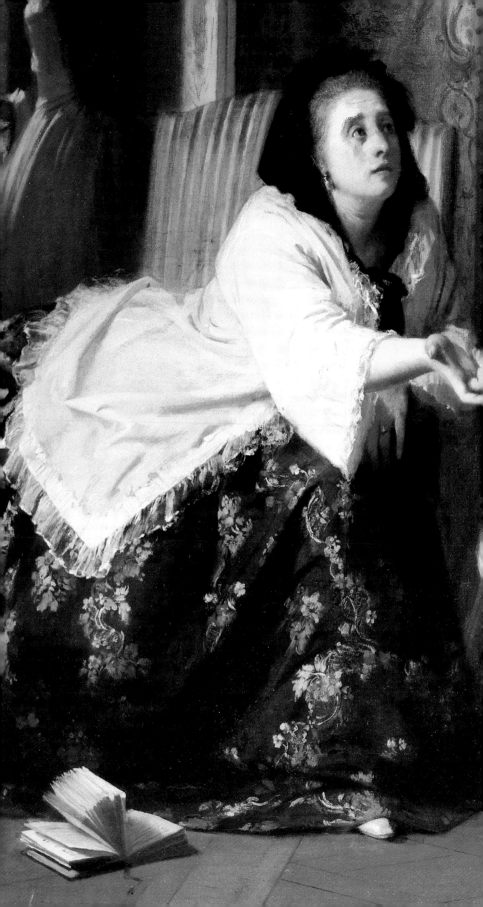

EUROPEAN ART

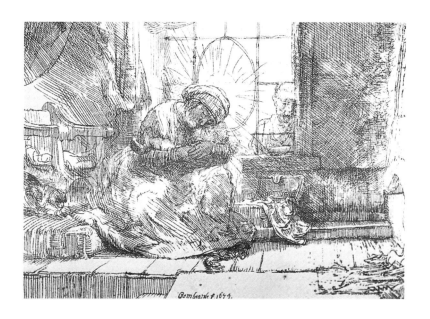

REMBRANDT VAN RIJN
Dutch, 1606–1669
The Virgin and Child with a Cat, 1654 (second state)
Etching 3³/₄" x 5⁵/₈"
47.1 Gift of Clara Baldwin

This interior scene of Mary with the infant Jesus cradled in her arms and Joseph outside the window peering in reflects the artist's concern with the essential humanity of the Christian ethic. The Virgin and Child, in a pose taken from an engraving by Mantegna, appear in a contemporary domestic setting that includes a cat which appears to be asleep. According to legend, the "cat of the Madonna" (*gatta della Madonna*) produced a litter of kittens in the stable where Christ was born. A snake emerging from under Mary's skirt heads toward the viewer. Renaissance artists used the serpent to represent the Devil, the wily tempter who betrays man into sin. As a Christian symbol the snake reminds the viewer that Christ overcame evil during his life as well as in his death. Rembrandt may also be using the snake to represent temptation and evil as persistent forces in the world.

JAMES NORTHCOTE
English, 1746–1831
Miss Grace Hundley, 1798
Oil on canvas, 30" x 25"
82.47 Gift of Thomas M. and Harriet Gibbons

Northcote, a student of English portrait painter Sir Joshua Reynolds, was
both a portraitist and a narrative history painter. This picture of a young
society lady is representative of his work during the final two decades of
the eighteenth century. At some time in the nineteenth century, the hat
was painted over and an oval frame liner was added that obscured the red
drapery in the background. Conservation of this painting revealed the
beribboned hat with its frilled lining and the velour draperies. The oval
liner has been removed to show the original composition.

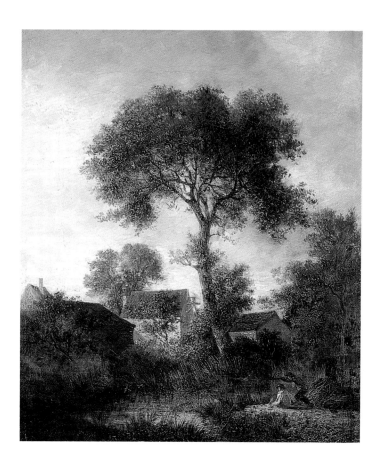

JOHN CROME
English, 1768–1821
Ormesby Broad, Norfolk, c.1800
Oil on canvas, 14" x 12"
23.516 Gift of W. B. Rogers

John Crome was a founder of the Norwich school, the only English school of painting to have developed around a specific geographical area. He played an important role in the awakening of English artists to the aesthetic potential of their native landscape. Because Crome preferred to remain at home rather than make his career in London, he chose to promote the beauties of his region.

Crome's subtle sense of atmospheric contrasts is evident in this painting of a rural Norfolk landscape near Norwich at midday. The strong vertical thrust of the central tree guides the eye from the dense ground area upward to the relatively empty sky. Two hunters at lower right have flushed their quarry, which take flight from the pond. Crome used small brushes and painted the image in minute detail. He worked outdoors, as did Corot, and once remarked, when asked why he was not working in his school, "I *am* in my school."[1]

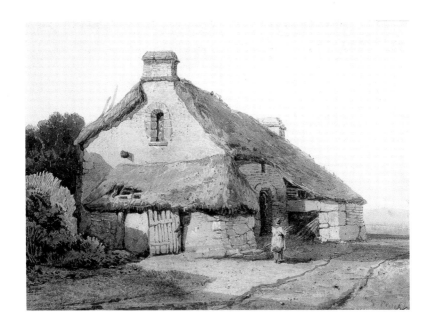

SAMUEL PROUT, OWS
English, 1783–1852
Near Chagford, Devon, 1810
Watercolor on paper, 8⅝" x 11¾"
98.29 Museum Purchase

Samuel Prout was born in Plymouth, England, and trained as a draftsman in his youth. He began his career drawing local architecture for an antiquarian and became a noted teacher of drawing. He was a member of the Royal Academy of England and the Old Water-Colour Society, a national organization devoted to raising the reputation of watercolor as a fine art painting medium. Prout also published books of picturesque English and European views, as well as several instructional books, such as *Hints on Light and Shadow, Composition, Etc.* (1826). His most famous student and devotee was the influential art critic John Ruskin, who held sway over English art criticism for many decades.

 The thatched-roof rural cottage depicted in *Near Chagford, Devon* is typical subject matter for Prout. He rarely depicted the modern, Neo-Classically styled Georgian buildings that were springing up all over England; instead he preferred ramshackle buildings of antiquated style and picturesque charm. In 1810, watercolors were often viewed as drawings rather than paintings, which was a view the Old Water-Colour Society vigorously battled. Prout's work is a good example of watercolor as painting: it is a work based on fine draftsmanship enhanced by subtle, naturalistic color technique.

JRC

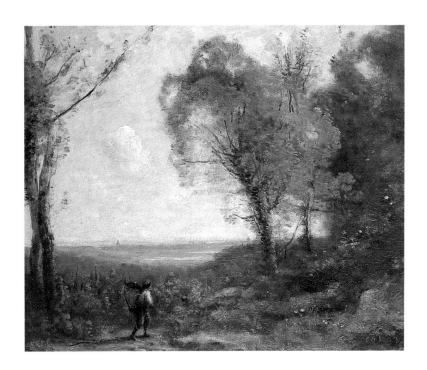

Jean-Baptiste Camille Corot
French, 1796–1875
Landscape near Paris
Oil on canvas, 17" x 13½"
34.20 Gift of W. B. Rogers

Corot, regarded by many as a precursor of the Barbizon style of painting, perfected the subtle variation of tone to create atmosphere. He traveled extensively through the French provinces and to Switzerland, the Netherlands, Belgium, and England. In the paintings he made during his travels, Corot treated light as essential for life.

This small painting of a landscape near Paris has the spontaneity characteristic of Corot's work outdoors. The blurred skyline of Paris appears on the horizon. The natural light flooding the picture emphasizes the foreground. A man with a wood carrier on his back enters the forest to gather kindling.

Constant Troyon
French, 1810–1865
The Ferry, c. 1850
Oil on canvas, 26" x 33"
34.19 Gift of Nina Eastman Rogers

Troyon, who had been trained as a painter of porcelain, in 1843 began working in Barbizon, where he received his true introduction to landscape painting. In 1847, influenced by the work of Dutch artists Cuyp and Potter, he introduced domestic animals into his paintings. His depiction of animals subsequently brought him international fame.

 This landscape of a river ferry transporting cattle and a horse-drawn cart illustrates Troyon's interests in landscape and animals while also showing his skills as an accurate draftsman and painter.

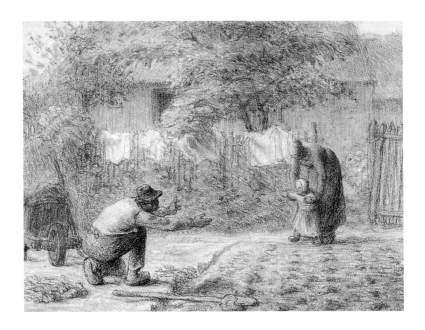

Jean François Millet
French, 1814–1875
First Steps, c. 1856–1858
Pastel on paper, 12¾" x 17"
27.17 Gift of Lauren Chase Eastman

Millet moved to Barbizon in 1848. During the ensuing decade he executed many drawings of rural peasant life, including this pastel, which was the source for Vincent van Gogh's painting with the same title. Millet's move to Barbizon from Paris coincided with his determination to return to the world of nature. He watched country people at work and rediscovered his own peasant origins while painting and drawing what he described as "rustic life."

This drawing depicts an important moment in family life: the first steps of a child. The peasant farmer is interrupted in his work in the field by his wife and child. He kneels, with arms outstretched, as his child begins to walk to him. The scene's intimacy is increased by such mundane details as the bed linens hanging out to dry, the farming implements, and the thatched roof of the farmhouse in the background. The rounded contours of the figures and the spare use of color are characteristic of Millet's mature work.

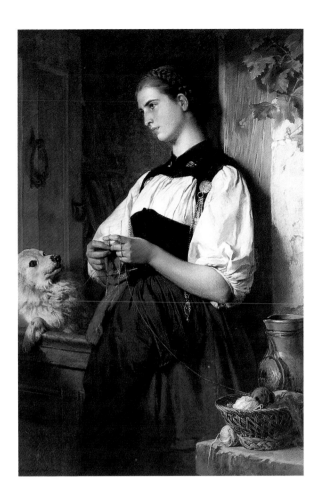

LOUIS-EDOUARD DUBUFE
French, 1820–1883
Knitting Reveries, 1870
Oil on canvas, 55" x 37"
83.37 Museum Purchase

The son of the painter Claude-Marie Dubufe (1790–1864), Edouard Dubufe achieved popular fame as a society portraitist, although he was denounced by the critics, as his father had been before him, for his tendency to idealize. Dubufe used his considerable technical skill to imbue all of his subjects with beauty.

Knitting Reveries shows a young woman standing outside her door, knitting needles in hand, daydreaming. A white dog has jumped up against the lower portion of the Dutch door and stares intently at her busy hands. The strong contrasts of black and white are intensified by the pure colors of the blue, red, and yellow balls of yarn. Dubufe's skill is also evident in his adept handling of the stoneware pitcher and metal ornamentation on her clothing.

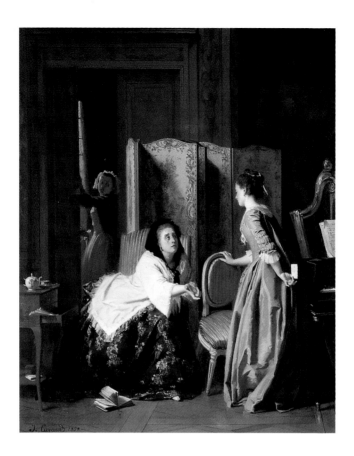

JOSEPH CARAUD
French, 1821–1905
The Message, 1858
Oil on canvas, 30" x 24"
83.74 Museum Purchase

The Message, an example of narrative painting, presents a scene of
universally understood conflict. While a curious and somewhat
apprehensive maid watches, an older woman, perhaps a mother, asks a
younger woman, perhaps her daughter, for the piece of paper the latter is
holding in her hand. The opened drawer of the lacquered table and the
book on the floor indicate that the written message, concealed in the book,
was discovered accidentally. The pleading expression on the face of the
seated woman tells the viewer that the situation is serious and heightens
the tension present in the elegant drawing room.

Caraud embellished this painting with tapestries, Louis XV furniture, an
elaborate screen, musical instruments, and a teapot without its handle.
These objects are all rendered in such detail that they seem to be
symbolically important in the lives of the women.

Caraud remained a popular painter until the end of his career, although
his critical acclaim diminished with the rise of Impressionism.

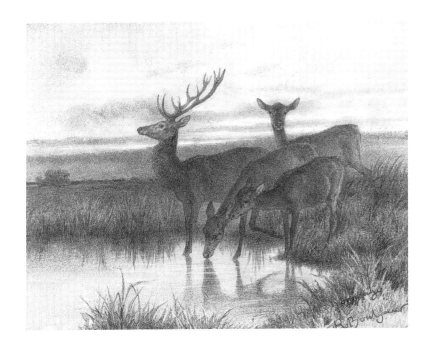

MARIE ROSALIE (ROSA) BONHEUR
French, 1822–1899
Deer
Charcoal on paper, 8½" x 10½"
23.515 Gift of W. B. Rogers

Rosa Bonheur was the daughter of the landscape painter Raymond Bonheur
and one of four children who all became artists specializing in animal
subjects. She was the first female artist to receive the cross of the French
Legion of Honor. This charcoal drawing of deer pausing to drink from a
pool during the early evening hours shows her lifelong concern with direct
observation from nature. Chinese white creates a shimmer on the water
and highlights the moon in the sky. One of the deer gazes at the viewer as
if a sudden sound had disrupted the tranquillity of the moment.

EUGÈNE BOUDIN
French, 1824–1898
*Entrance to the Port
at Dunkirk*, 1889
Oil on canvas, 20" x 29¼"
98.31 Gift of Sara Lee
Corporation, Millennium
Gift to America

The son of a ship's captain,
Eugène Boudin was born in
Le Havre and spent most of his life on the Northern coast of France. He
received no formal training until 1850, but as a young man was encouraged
by artists such as Troyon and Millet, who patronized his framing and
stationery shop in Le Havre. In turn, he inspired Monet and other young
artists who would eventually form the Impressionist avant-garde to begin
painting *plein-air* (out of doors).

 Though he painted in Paris in the 1840s and 1850s, Boudin never painted
Paris. Instead he focused on the seashore and rural life in northern France.
The LRMA painting is of a typical Northern seaport, Dunkirk, which today
is best known as a World War II battle site. The work was begun during
Boudin's second trip to Dunkirk, along with a smaller, nearly identical
version which now resides in a private collection. By 1889, Boudin had
exhibited at the first Impressionist exhibition in 1874 (although not the
rest of them) and was considered an important transitional figure by Monet
and his compatriots, who saw Boudin as the link between themselves and
the great French Realists such as Corot and Millet.

JRC

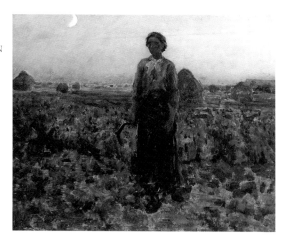

JULES ADOLPH BRETON
French, 1827–1905
The Gleaner, 1885
Oil on canvas,
11" x 15"
34.22 Gift of Nina
Eastman Rogers

Jules Breton wrote
about the Barbizon
region (*Savarette*,
1898; *La Peinture*,
1904) in addition to
being a Barbizon painter. His work was strongly influenced by Millet, as we
see in this picture of a peasant farmer. Immensely popular with the public for
the nobility he gave his subjects, Breton received critical praise before he
reached the age of thirty. The lone figure in this painting stands resolutely,
scythe in hand, as evening approaches. The Barbizon concern with depicting
the harsh reality of rural peasant life is evident in this work.

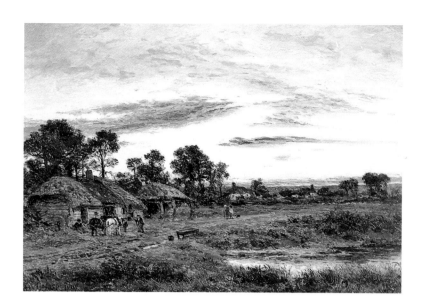

Benjamin Williams Leader
English, 1831–1923
Evening; A Village Smithy, 1907
Oil on canvas, 18" x 24½"
23.496 Gift of W. B. Rogers

Although he was christened Benjamin Leader Williams, Leader rearranged his name when he began his career in order to distinguish himself from the well-known artists of the Williams family. He studied at the Royal Academy in 1853 and regularly exhibited there beginning in 1854. Leader worked throughout Great Britain and lived in Surrey. His work was exhibited in America and at the Columbian Exposition in Chicago in 1893.

This painting shows the flat fields and thatched-roof cottages of rural England. Two draft horses stand to the left on a muddy, rutted path as villagers complete their tasks. At the right is a deep pond partly filled with vegetation. The clouds in the sky indicate that the sun is setting.

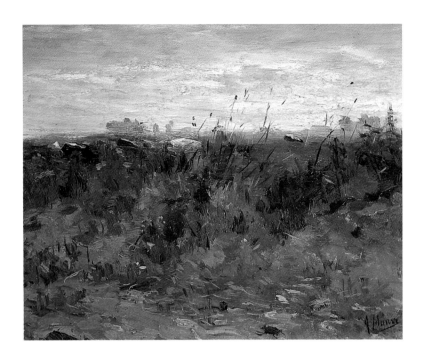

Anton Mauve
Dutch, 1838–1888
Cattle, c. 1880
Oil on canvas, 10½" x 13½"
34.26 Gift of Nina Eastman Rogers

This small painting of cattle partially obscured by the flora of the field in which the animals are grazing shows the artist's sensitivity to the natural world and to the inherent qualities of his medium. Mauve, the uncle of Vincent van Gogh, shares with his more famous nephew a free, experimental style. This painting reflects the strong influence of Mauve's contemporaries in France, which separated him from the more conservative Hague school traditions in which he was trained. The sharply delineated foreground gives way to abstract treatment of the forms of the cattle.

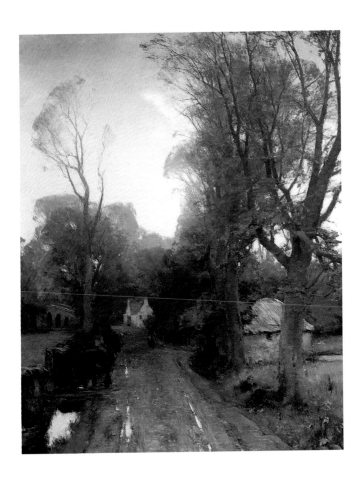

DAVID FARQUHARSON
Scottish, 1839–1907
Autumn Evening, Bridge of Doon, Ayr, 1902
Oil on canvas, 36" x 30"
83.101 Gift of Robert C. Hynson

David Farquharson, a Scottish artist, spent his final years in Cornwall, England. This painting is characteristic of Farquharson's mature work. The rutted lane with its rain-filled ditch guides the eye deep into the autumnal Scottish landscape, around a curve, and over a stone-arched bridge. A man leads two Clydesdale horses out of a field onto the road as another man approaches on a bicycle. A thatched cottage in the foreground contrasts sharply with the more modern white house farther back on the picture plane. The composition of the tranquil scene hints at the threat posed to the traditional rural way of life by the Industrial Revolution.

Farquharson exhibited at the Royal Scottish Academy and the Royal Academy in London. He was primarily self-taught and did not begin exhibiting until he was twenty-nine. His work is bolder in its composition and statements than most turn-of-the-century landscape paintings by Great Britain's artists.

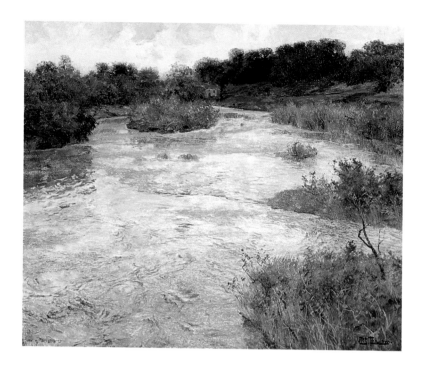

Fritz Thaulow
Norwegian, 1847–1906
Shenango River, 1898
Oil on canvas, 32¼" x 39¼"
25.9 Museum Purchase

Thaulow studied and traveled in Norway, Germany, France, Italy, and America. Under the guidance of his brother-in-law, Paul Gauguin, he adopted the landscape painting style of the Impressionists in the late 1870s.

While visiting the United States, Thaulow painted this picture of the Shenango River in northern Pennsylvania. *Shenango River* was displayed in the home of Henry Clay Frick, the affluent industrialist and art collector, until it was sold to the O'Brien Gallery in Chicago before being purchased in 1925 for this museum's collections. The painting shows the artist's interest in the interplay of natural light on water with the intricate patterns caused by the river's currents. The artist has located the viewer in the middle of the river, thereby closing the gap between the viewer and the scene and emphasizing the importance of the river as subject matter.

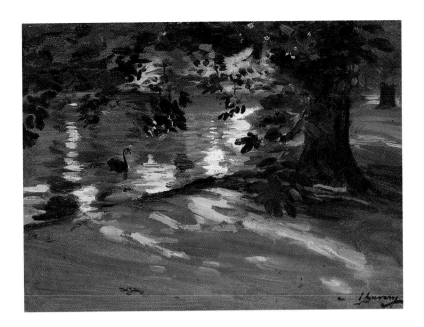

Sir John Lavery
Irish, 1856–1941
Black Swan
Oil on panel, 10½" x 14½"
26.53 Museum Purchase

Lavery's adopted home was Glasgow, Scotland. After seeing the work of the French Impressionists there during their first serious exhibition, he decided to incorporate their brush technique and palette into his own experimental style. *Black Swan* reveals the influence of the Impressionists as well as that of John Singer Sargent, whose landscape style Lavery admired. The technique is bold and spontaneous, with the swan an accent on the natural scene. Lavery later became a successful portraitist during the early years of the twentieth century and painted battle scenes during World War I. Lavery was knighted in 1918 for his painting of King George V, Queen Mary, and the royal family. During his years in London, he cofounded, with James McNeill Whistler, the International Society of Sculptors, Painters, and Gravers.

AMERICAN ART

Benjamin West, 1738–1820
J. Fall, c. 1765–1770
Oil on canvas, 30" x 25"
85.51 Museum Purchase

Magdalen Whyte, Mrs. Fall, c. 1765–1770
Oil on canvas, 30" x 25"
85.52 Museum Purchase

West, an expatriate artist who spent almost all of his adult life in London, exerted such a profound influence on his American contemporaries and on succeeding generations of artists that he has been called the father of American painting. He radically changed portraiture by painting his subjects in the dress of the day rather than in Greco-Roman classical attire. West was a generous patron to many artists who came to London to

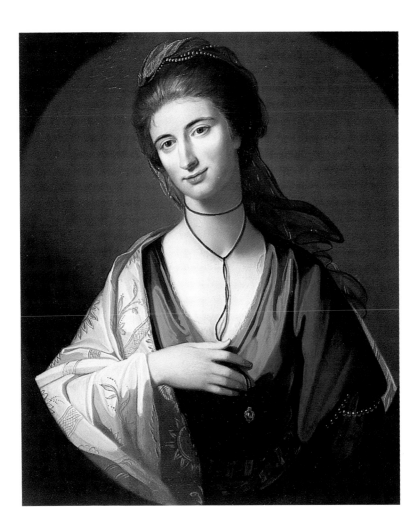

study under his guidance. His theories about painting returned to America with such students as Gilbert Stuart, Rembrandt Peale, and Thomas Sully.

This pair of portraits of the married couple J. Fall and Magdalen Fall is typical of West's work during the period when he was actively engaged in portraiture. The influence of Italian fashion is evident in Mrs. Fall's costume: she wears a double-looped neck ribbon from which a lavalier is suspended and has pearls entwined in her hair as well as on the sleeves of her dress. The portrait of Mr. Fall strikingly resembles the portrait of West's student Charles Willson Peale, completed in 1769. The three-quarter pose highlights the subject's prominent nose and full lower lip. The glazed surface of the painting adds luster to the blue and gold of his waistcoat and vest.

JAMES PEALE, 1749–1831
Portrait of Nicholas Brewer II, c. 1800
Oil on canvas, 28" x 23¾"
82.1 Museum Purchase

James Peale, the younger brother of Charles Willson Peale, began his career as a cabinetmaker and turned to painting professionally under his brother's influence. He produced portraits and miniatures in watercolor upon ivory, his specialty, until the early 1800s. When failing eyesight prevented him from painting miniatures, Peale turned to detailed still lifes, which continued to occupy him until his death.

Nicholas Brewer II (1771–1839) was the nephew of Charles Willson Peale's first wife, Rachel. He was called "Young Nick" because his father was also named Nicholas. This painting was attributed to Charles Willson Peale until 1952, when Charles Coleman Sellers, a Peale scholar, reattributed it, arguing that James Peale, a Romantic painter, would use landscape background to set the picture's tone, but that Charles Willson Peale, an artist representing the Age of Reason, would not.

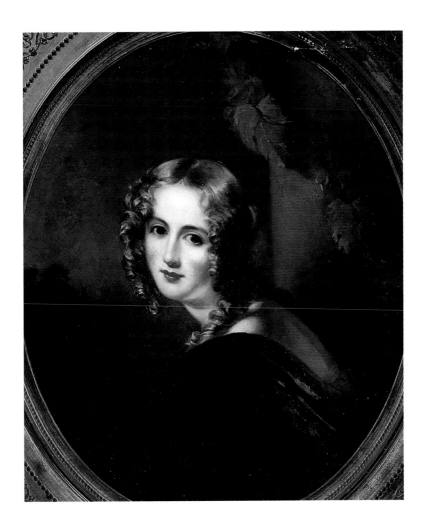

THOMAS SULLY, 1783–1872
Ideal Head, c. 1850
Oil on canvas, 30" x 25"
83.6 Gift of Margaret M. McLaurin

Sully, considered the leading American portraitist of his generation, is known for the romantic mood he expressed in all of his work, including more than 2,000 portraits and nearly 500 landscapes and historic compositions. He was born in England but was brought to South Carolina when he was nine and spent the rest of his life in America. Sully's technique combined idealization with a flair for the dramatic and painted in smoothly flowing oil. He once wrote, "From long experience I know that resemblance in a portrait is essential; but no fault will be found with the artist (at least by the sitter) if he improve the appearance."[2]
This portrait of a young woman, facing left with a green drapery over her shoulder, attests to Sully's romanticism. She is posed in front of a column encircled by a trailing vine with autumnal leaves.

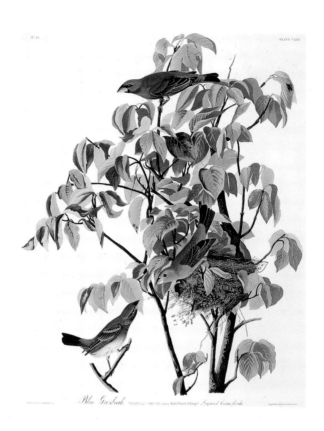

John James Audubon, 1785–1851
Blue Grosbeak, No. 25, Plate 122
Aquatint engraving by R. Havell, London, 26" x 20½"
70.13 Museum Purchase

Until 1826, when he sailed to England, Audubon's life was filled with
misfortune and failure. Audubon was born in Haiti, the illegitimate son of
a French sea captain and a Creole woman. While he was still an infant, his
mother died, and his father took him to France. The young Audubon
studied for a career in the navy but failed the officer-training tests and fled
to America to escape military conscription. After failing in business and
spending a year in debtor's prison, he turned to ornithology, a lifelong
interest. American publishers were not interested in his work, and so he
moved to England, literally gambling everything on a positive reception
there. The thirty-five-year-old frontiersman was a great success in the
London drawing rooms, and the career was launched that would establish
Audubon as a naturalist without peer.

Audubon's watercolors were engraved on copperplate by R. Havell and
Son and published in 1838 as *The Birds of America*. The museum owns the
four-volume set which is valued not only for Audubon's work but also for
the engravings by the artist, Havell. This print depicts a male and female
grosbeak with a juvenile male. The female, with yellow ochre coloring,
perches on a dogwood branch near her nest.

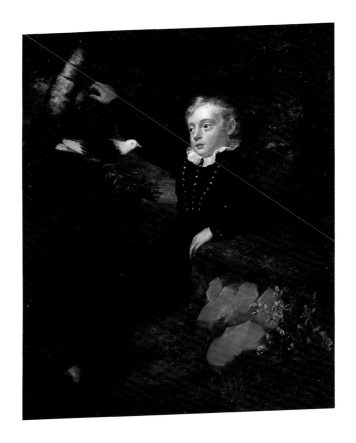

HENRY INMAN, 1801–1846
Boy with Bird in Woodland Scene, c. 1835
Oil on canvas, 48" x 38"
84.12 Gift of Jean C. Lindsey in Memory of Anne Green Reeder

Inman was born in New York and served a seven-year apprenticeship to the portraitist John Wesley Jarvis beginning in 1814. Inman was a versatile painter of portraits, miniatures, landscapes, and genre scenes but derived most of his income from portraits. He served as a director of the Pennsylvania Academy of the Fine Arts in 1834 and by 1838 was one of the most highly paid painters in America. Upon his death in 1846 from heart disease, Inman was honored by a memorial exhibition at the National Academy of Design devoted exclusively to his work. It was one of the first of its kind in the United States.

This painting shows a young boy seated on the ground. His right arm is outstretched while he looks at a black-and-white bird. A clump of smartweed is rendered in careful detail in the right foreground. Children were frequently portrayed in a landscape scene to convey the message that the purity of childhood has its counterpart in unspoiled nature. On the reverse of this painting, lettered in red paint, appear the words "H. Inman, Mt. Holly."

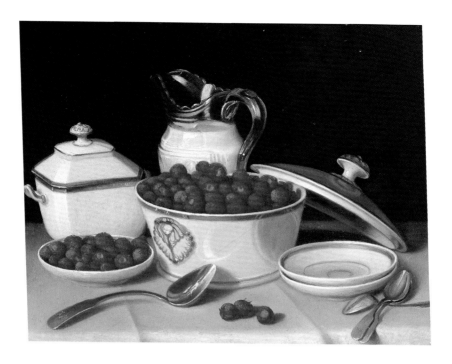

John F. Francis, 1808–1886
Still Life with Strawberries and Cream, c.1850
Oil on canvas, 15" x 19"
91.6 Gift of Jean C. Lindsey

John F. Francis was born in Philadelphia and spent much of his life in the Northeast. He began his career as an itinerant portrait painter, influenced by his Philadelphia contemporary Thomas Sully. By 1850 he had become a still life specialist in the tradition of the Peale family. However, his still lifes are more opulent and colorful than the earlier works by the Peales.

Most of Francis's works have been in private collections as he was not widely regarded during his lifetime. However, he has become more widely known in recent years as he serves as an important link between the Peale still life tradition and the late nineteenth-century trompe l'oeil painters, such as Harnett and Peto. *Still Life with Strawberries and Cream* is an exemplary Francis work; it is painterly yet precise, filled with bright colors and typical Francis subject matter. In fact, he returned to this subject several times, but always made changes, such as substituting glasses of milk for pitchers of milk or changing the arrangement of the silverware.

JRC

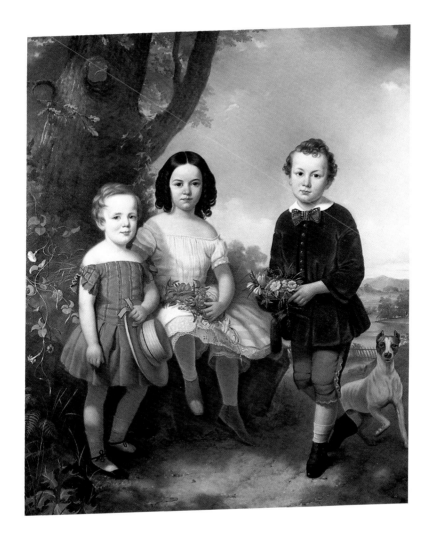

James Henry Wright, 1813–1883
Three Children in a Landscape, 1855
Oil on canvas, 68" x 54"
83.35 Museum Purchase

Very little is known about the life of James Henry Wright. He was a native of New York and exhibited regularly at the National Academy of Design from 1842 until 1861. He is remembered principally for portraiture, still lifes, and naval pictures.

This portrait was exhibited at the National Academy of Design in 1857. M. Woodruff, who lent it for exhibition there, is believed to be the children's father. This work shows Wright's interest in still life and portraiture. Two of the children hold detailed bouquets of flowers, and a morning glory vine trails from the tree to the right. Behind the dog, far in the distance on the left, stands a building that resembles a Greek temple beside the lake.

John Frederick Kensett, 1818–1872
From the Meadow at Cold Spring, Long Island, 1870
Oil on canvas, 21½" x 27"
27.20 Gift of Lauren Chase Eastman

Kensett is regarded as one of the finest painters of the second-generation Hudson River school, a group of realistic landscape painters, mostly based in New York, which flourished between 1820 and 1880. Kensett created powerful pictures with emphasis upon the effects of weather. His eye for detail and sensitivity to atmospheric variations heightened the realism of his images. Kensett was elected to the National Academy of Design in 1849. In 1870 he became a founder, and later a trustee, of the Metropolitan Museum of Art in New York City.

This pastoral painting of a meadow in New York depicts the Hudson River upon which boats are sailing. The meadow is busy with seasonal labor as field workers load a wagon with the hay from the stacks that dot the landscape on the left. The darkening sky on the left contributes urgency to the scene as a storm approaches.

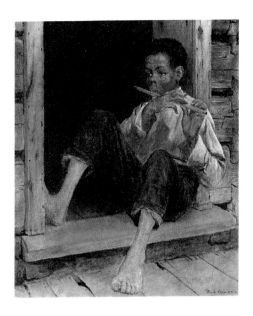

Eastman Johnson, 1824–1906
Piccolo Player, c.1860
Oil on canvas, 13³/₈" x 11³/₈"
2002.2 Museum Purchase

Eastman Johnson is best known for portraits and genre scenes (scenes of everyday life). He was born and raised in Maine, trained with a lithographer in Boston, and in 1849 went to Dusseldorf, Germany, where a great many young American painters had gone to study. He was not greatly impressed with the Dusseldorf school and went to Holland, where he was impressed by Rembrandt and Frans Hals, the great painter of common folk in the Dutch Baroque era. He ended his European travels in Paris, studying with the academic painter Thomas Couture in 1855, and returned to the United States. He traveled for a few years and settled in New York in 1859.

Piccolo Player was painted the next year, in 1860. It was quite common for Johnson to make second versions of his own favorite paintings, and this is his second version of the subject. In 1860, just a few years after his return to the United States, Johnson was elected a full member of the National Academy. To become a full member, he was required to submit a self-portrait and another picture of his choosing. The one that is today in the National Academy Museum in New York is the first version of *Piccolo Player*. The LRMA version's composition has been reconsidered, changed from a horizontal to a vertical format. *Piccolo Player* is a small and modest study of a young African-American boy playing a homemade flute. As the Eastman Johnson scholar Patricia Hills has noted, he sits in a doorway, a place of transition: between childhood and adulthood, between home and the outdoors, between slavery and freedom—this is 1860, after all. Johnson himself was at an important transition point: he had gone from student to master in five short years, and he was 36 years old, with a long career ahead of him.

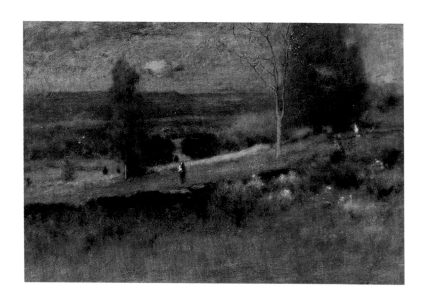

GEORGE INNESS, 1825–1894
Close of a Rainy Day, c. 1880–1883
Oil on canvas, 20" x 30"
27.19 Gift of Lauren Chase Eastman

Inness was born in New York and suffered from epilepsy all his life. He grew up in Newark, New Jersey, for a time managed his father's grocery store, and was later apprenticed to an engraver in New York City. He received his only training in painting from an itinerant painter and an academic painter in Brooklyn. Inness always maintained that he was self-taught. He was influenced by Thomas Cole and Asher B. Durand, first and second-generation leaders of the Hudson River school. Since Inness could not hike out into the wilderness to paint, he concentrated on pastoral scenes near his home. He wanted to surpass Cole and Durand by projecting his personal vision into his landscape paintings and consequently did not paint what he saw literally. During travels abroad he painted in Barbizon, France, and his work shows his debt to Corot. His late work drew extraordinary power from his synthesis of the natural world with his spiritual vision. Inness's work profoundly influenced the painters who followed him.

Close of a Rainy Day was painted at Milton on the Hudson River during the late summer. In a letter to his wife, Lizzie, he wrote that he had been out to see the setting sun and was "studying the solemn tones of the passing daylight. There is something peculiarly impressive in the effects of the buildings, and the general sense of solitariness."[3] The sense of the solitary is rendered by the lone figure and the tree, already signaling the onset of autumn, highlighted by the sun late in the day.

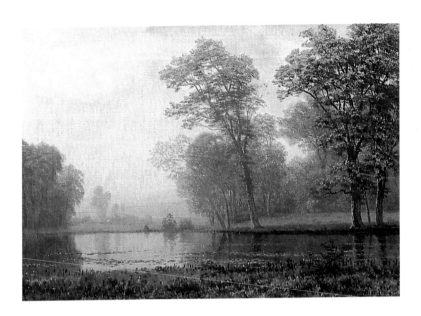

ALBERT BIERSTADT, 1830–1902
Autumn in New Hampshire, no date
Oil on canvas, 15½" x 21½"
26.137 Gift of Lauren Chase Eastman

Bierstadt, a German, emigrated to the United States at the age of two. He grew up in New Bedford, Massachusetts, and is said to have shown only a casual interest in art as a boy. In 1853, he decided to return to Dusseldorf to study with the landscape painters Andreas Aschenbach and Karl Friedman Lessing. Under their influence, he developed a respect for drawing and learned many techniques that he used for the rest of his life. Bierstadt returned to America in 1857 and in 1858 joined a surveying expedition to the American West. After this trip he produced the grand paintings of the West that established his reputation.

This painting of a scene in New England shows why many historians place Bierstadt in the Hudson River school. The broad vista and attention to detail recall the Hudson River artists, yet Bierstadt differs in technique and locale. This scene shows a still pond bordered on the right by deciduous trees in autumnal foliage. The sweep of the water and the angle of the trees at the center guide the viewer's eye back to a distant range of mountains.

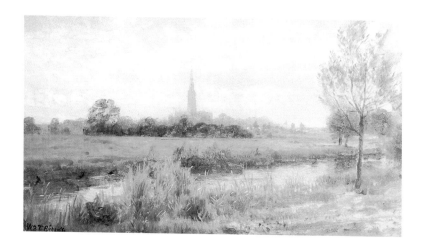

WILLIAM TROST RICHARDS, 1833–1905
Salisbury Cathedral, no date
Oil on board, 8³/₈" x 15³/₈"
83.75 Museum Purchase

Richards, a painter of landscapes and coastal scenes, was influenced by the Hudson River school artists Cole and Church and by the Pre-Raphaelite painters. He was born in Philadelphia and began to draw when he was very young. When he was thirteen, circumstances forced him to support his family, which he did by designing lighting fixtures, but by 1853 he was ready to devote all of his time to art. He traveled in Europe accompanied by William Stanley Haseltine, with whom he studied. After his return two years later, Richards married Anna Matlack and devoted his attention to naturalistic landscapes, many with literary themes.

This painting of Salisbury Cathedral from a distant viewpoint is apparently an oil sketch that Richards made during one of his visits to England. The foreground is rendered in meticulous detail, while the Gothic cathedral appears as a blue-gray form on the horizon surrounded by the town of Salisbury.

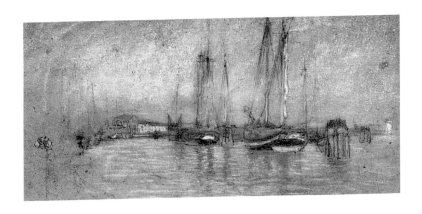

JAMES ABBOTT MCNEILL WHISTLER, 1834–1903
Nocturne in Venice Harbor (The Little Riva in Opal), c. 1879–1880
Pastel on paper, 6" x 12"
27.31 Museum Purchase

Although Whistler was born in Massachusetts, he went to Paris in 1855 and never returned to America. He settled permanently in London in 1859. Whistler established himself as a printmaker early in his career and was deeply influenced by Japanese art. As an expatriate American artist, he was an outspoken advocate of art for art's sake. His work outraged the critics and the public because he refused to use it to tell a story in accordance with Victorian convention. He emphasized compositions of shapes and colors rather than subject matter. When his work finally received recognition, Whistler became one of the most influential artists of the nineteenth century.

This pastel drawing of the Guidecca in Venice was probably made in 1879 or 1880 during a trip that Whistler made to Venice after he had alienated major patron Frederick Leyland by redecorating Leyland's dining room (subsequently called "The Peacock Room") in an elaborate oriental style and inviting the public in during his absence. Whistler faced bankruptcy at the end of the 1870s and recouped his losses during the Venice trip, when he made more than 50 etchings and 100 drawings in a single year. These works were sold upon his return to London. The museum's pastel of the harbor shows fishing boats at their moorings, with Venetian buildings in the background. The sensitive line drawing sharply contrasts with the hazy atmosphere of the scene.

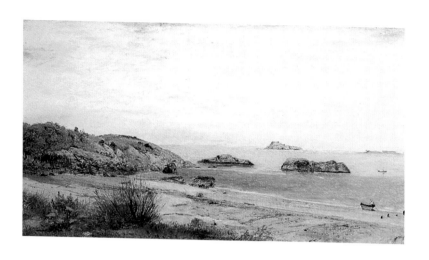

HOMER DODGE MARTIN, 1836–1897
Casco Bay, Maine, no date
Oil on panel, 10½" x 18½"
34.10 Gift of Mr. and Mrs. W. B. Rogers

Martin, a landscape painter, was born in Albany, New York, and was largely self-taught. His early work was influenced by the Hudson River school, but as his career progressed, his work evolved from realism to a more impressionistic style. He battled a variety of health problems during his life, including deteriorating vision. His dedication to painting finally led him to the discovery of his personal vision, which drew on the "plein-air" work of the early French Impressionists.

Casco Bay, Maine is an early work that reflects Martin's interest in the cold and unforgiving side of nature. The bay with its protruding boulders is rimmed by an almost empty beach. A lone dinghy is moored by the water's edge at lower right. Directly above it, in the water, is another boat with a lone figure.

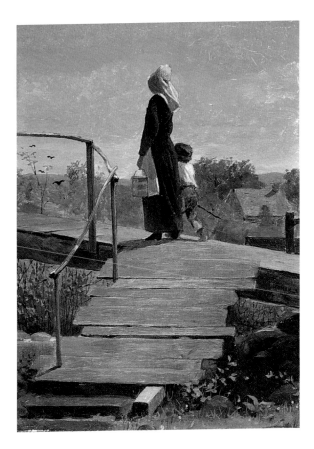

WINSLOW HOMER, 1836–1910
Fisherman's Wife, 1873
Oil on wood panel, 8" x 6½"
26.140 Gift of Lauren Chase Eastman

Winslow Homer, who became one of America's foremost nature painters, began his career as an illustrator. During the Civil War, Homer was an artist for *Harper's Weekly*, working on the front lines and drawing dispassionate scenes of the war. He did not begin painting seriously until after the war. In his middle years, he began painting in watercolor, and raised it to a level of excellence never before seen in the United States. In both oil and watercolor, Homer focused on the sea and life along its coast.

This small, serene painting is closely related to *The Morning Bell (The Old Mill)* (1873, Yale University Art Gallery). *Fisherman's Wife* was likely a study for the larger work, as it depicts only a small portion of the Yale picture, and exhibits a lesser degree of detail and finish than is customary in Homer's work in oil. The composition, the wooden walkway and rail, and small building in the background are nearly identical to the central portion of the Yale painting, and the female figure with her tin lunch-bucket is similar in pose and proportion. In the LRMA work, the costume is different: it is a long red dress with white apron and bonnet instead of a two-piece outfit with a beribboned straw hat. The small boy she is escorting does not appear in *The Morning Bell*, and the horizon line is much lower in the LRMA work.

Thomas Moran, 1837–1926
A Glimpse of Long Island Sound from Montauk, 1907
Oil on canvas, 31" x 41½"
34.13 Gift of Nina Eastman Rogers

Barranca Bridge, Mexico, 1909
Oil on canvas, 20" x 30"
51.2 Bequest of Nina Eastman Rogers

Thomas Moran is known for his panoramic paintings of the American West, which were instrumental in persuading Congress to establish Yellowstone National Park. The Moran family came to America from England in 1842. Thomas worked for a wood engraver in Philadelphia and shared a studio with his brother, Edward. He exhibited a painting at the Pennsylvania Academy of the Fine Arts in 1858. In 1862 he traveled to England with his bride, Mary Nimmo (a printmaker of note) and his brother. He was inspired by the paintings of J. M. W. Turner and returned to America to "paint as an American on an American basis."[4] He had a long career and made his last Western trip at age eighty-six.

These two landscape paintings show Turner's influence and Moran's own interpretation of the effects of natural light. *A Glimpse of Long Island Sound from Montauk* was painted near his summer home in East Hampton. The vivid colors of the sunset in the center background contrast with the bright greens of the foreground wetlands. In a letter of 1908, Moran referred to this painting as ". . . among the best of my works."[5] In contrast, *Barranca Bridge, Mexico*, has a cool and pale background and depicts an ancient village with a Romanesque church. The eye is led through the dark green shadows of the foreground across an arched bridge to the brightly lighted hilltop, the painting's central focus.

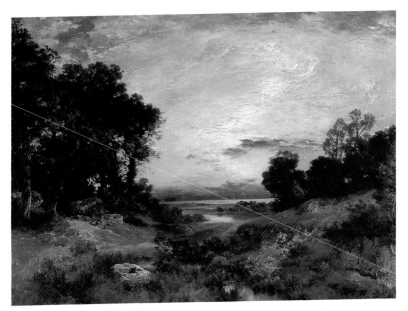

A Glimpse of Long Island Sound from Montauk

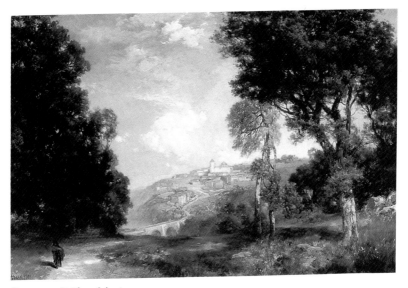

Barranca Bridge, Mexico

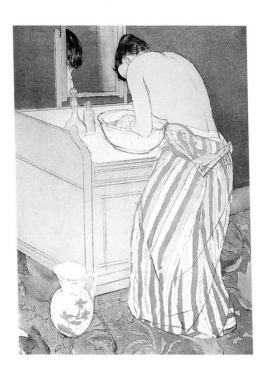

Mary Cassatt, 1845–1926
Woman Bathing, 1891
Aquatint, edition of 25, 14¼" x 10½"
72.22 Museum Purchase

Mary Cassatt was born into a wealthy family in what is now Pittsburgh, Pennsylvania, but lived in France most of her life. Her decision to be a painter dismayed her family. During her studies at the Pennsylvania Academy of the Fine Arts in 1861, she commented that copying second-rate art bored her. In 1866, she traveled to Paris and studied privately. By 1873, she had become an established artist exhibiting at the Paris Salon. She believed that art should honestly reflect life, and she began exhibiting with the Impressionists in 1877. She evolved a distinctive style in the 1880s, using strong patterns and clear outlines. She never married and was a feminist and humanist who hated war and the dissonance of the twentieth century.

 This aquatint is one of the series Cassatt was inspired to do after seeing an exhibition of Japanese prints in 1890. The etchings in this series are some of her finest works. They illustrate both her lifelong concern with the daily life of women and her interest in Japanese design and composition. The woman is washing her face and upper torso using a washbowl and water pitcher of the sort common in nineteenth-century households. The print is enriched by the pink and green stripes of her dress and the patterned blue carpet. The drawing and perspective are visibly influenced by eighteenth-century Japanese woodblock prints by such artists as Harunobu.

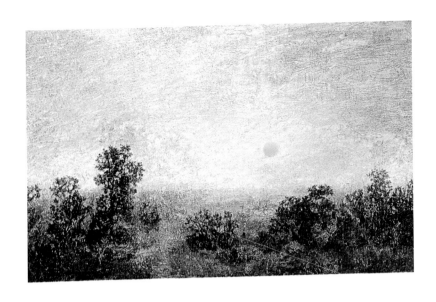

RALPH ALBERT BLAKELOCK, 1847–1919
Harvest Moon, no date
Oil on canvas, 16" x 23"
27.18 Gift of Lauren Chase Eastman

Blakelock's career began with great success when, at age twenty, he started exhibiting his realistic work at the National Academy of Design. Essentially a self-taught artist, he studied for three semesters at the Free Academy of the City of New York (now City College) in 1865–1866. During 1869–1871, Blakelock took trips through the Indian country to California and down the Isthmus of Panama. These trips changed his style of painting from traditional realism to semi-abstract images painted in thick layers that build a complex tonality. This extreme departure from the accepted academic mode did not sell well, and dire poverty eventually beset Blakelock and his growing family. Under the stress of increasing hardship, Blakelock went insane. He was placed in an asylum in 1899. By 1916, Blakelock's work had begun selling for high prices. During that year, ironically when he was still destitute and incarcerated, he was elected to the National Academy of Design.

This painting of a glowing pink moon ascending a pale sky reflects Blakelock's interest in the atmosphere of the landscape rather than the visible details. Working between the academic and modern styles of painting, Blakelock almost completed the transition to total abstraction.

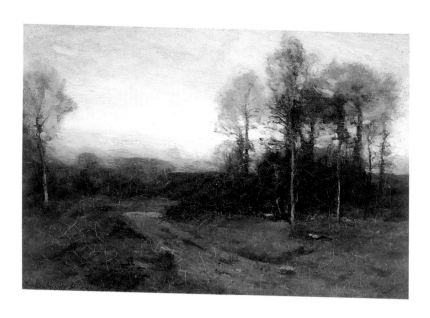

CHARLES MELVILLE DEWEY, 1849–1937
Landscape, Sunset, no date
Oil on canvas, 15½" x 23½"
25.1 Museum Purchase

Dewey, a New Yorker, studied briefly at the National Academy of Design
before he traveled to Paris to study with Carolus-Duran from 1876 until 1878.
Like John Singer Sargent before him, Dewey learned from Carolus-Duran the
chiaroscuro treatment of light and dark. After his return to America, Dewey
was a close friend of Albert Pinkham Ryder and served as the executor of his
estate.

This painting of a sunset's late moments demonstrates Dewey's understanding
of the transitory effects of natural light. The composition is evenly divided
between a pale sky and the ground area, which is plunged into dark shadow. A
dimly lighted dirt path curves behind a grove of trees on the right, while the
sun, a line of orange in the distance, slips below the horizon.

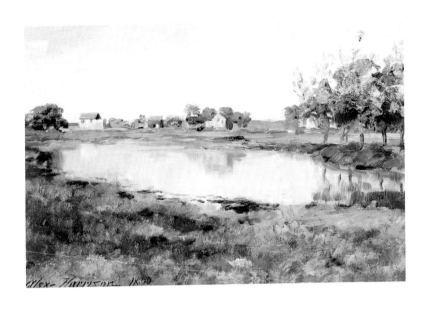

Thomas Alexander Harrison, 1853–1930
Mirror Lake, 1890
Oil on canvas, 17" x 25"
34.15 Gift of Nina Eastman Rogers

Harrison was born in Philadelphia and studied at the Pennsylvania Academy of the Fine Arts. He achieved recognition for his marine paintings. His early work with the United States Coast and Geodetic Survey may have inspired his interest in the sea. Harrison maintained his studio in Paris from 1879 until his death in 1930. During that time, he studied for two years at the École des Beaux Arts. Many Americans sought him out as a teacher. When he died, the *New York Times* described Harrison as the dean of American painters in Paris.

 Like many Americans of the nineteenth century, Harrison loved the outdoors. He once said, "I have always loved big nature and the sky and the feeling of space." This painting of a perfectly still lake shows his understanding of natural light and its effects upon water. The lake stretches horizontally across the picture plane and is framed by a flat, loosely painted landscape. The light blue and white sky overhead contrasts with the intricate brushwork. A line of rural dwellings in the background separates sky and water and adds interest.

JOHN FRANCIS MURPHY, 1853–1921
November Sunset, c. 1880
Oil on canvas, 11" x 13½"
26.54 Museum Purchase

Murphy was born in Chicago to Irish immigrant parents. He was self-taught and in his youth worked as a sign painter. By the late 1870s, he was living in New York City and had married a landscape painter, Ada Clifford. Murphy achieved recognition during the 1880s and 1890s for his landscape paintings, which were usually small and somber or brooding in tone. He had become a member of the National Academy of Design by 1887, and his work was being acquired by museums and collectors. At this point, Murphy possessed the financial wherewithal to build a studio in the Catskill Mountains of New York. He was the first artist since Thomas Cole to live in the Hudson River school region. Murphy set an auction record in 1918 when one of his small landscapes brought $15,000 at a sale.

 This painting, a small landscape that is austere and undisturbed by man, is typical of Murphy's work. The turbulent breakers in the ocean and the leafless tree attest to the time of year. The composition is enriched by the pond at the lower edge and the meticulous brushwork. The reds and yellows of the ground cover sharpen the strong contrasts and provide visual warmth.

John Henry Twachtman, 1853–1902
Hemlock Pool, c. 1890s
Oil on wood panel, 18" x 22"
26.52 Museum Purchase

Twachtman began his career in Cincinnati, Ohio, in 1853, where he painted floral window shade designs for his father's business. He met Frank Duveneck at the Cincinnati School of Design in 1875 and accompanied him to Munich for two years of study at the Munich Academy. He returned to America for eight years and then traveled to Florence, Italy, to teach for a year in Duveneck's school. During this time, his painting style was solid and dark, with direct brushwork reflecting Duveneck's influence and that of German art. In 1883, Twachtman studied in Paris and was exposed to Impressionism, which changed his style dramatically. He returned to the United States in 1885, still under the influence of Impressionist brushwork, Whistler, and Japanese prints. His paintings of the 1890s are light and stress a poetic atmosphere rather than realistic rendering of detail. Twachtman's increasing anger about American attitudes toward art prompted him to form with his friends a group called Ten American Painters in 1897. This group exhibited together in an attempt to promote modern American art.

Hemlock Pool is probably a scene on his farm in Connecticut, which he frequently painted. A creek fed the pond, which was called the "hemlock pool." The painting has the abstract quality that made Twachtman one of the most original and important of the American landscape painters. A palette of blue, green, and yellow with strong brushwork recreates a hilly landscape and a small clear pool of water at the lower edge of the composition.

JOHN SINGER SARGENT, 1856–1925
Les Chênes, 1883
Oil on canvas, 21¼" x 25½"
60.1 Museum Purchase **Gift of Jane Rogers Hynson**

Sargent was born in Florence, Italy, to American parents. His talent manifested itself early and was nurtured by his mother. He began formal studies in art at age twelve. In 1870, Sargent enrolled in the Academia delle Belle Arti in Rome; he went to Paris in 1874 to study at the École des Beaux Arts. He quickly changed his education plans by switching to private study with Carolus-Duran, a fashionable and daring portraitist. Carolus-Duran's concern with meticulous realism and his dashing spirit profoundly affected Sargent, who began working from life. At the same time he absorbed the color theories of Whistler and the Impressionists and was studying the composition of works by Degas. By 1883, Sargent was a recognized portraitist in Paris, but in 1884 the controversy over his *Portrait of Mme. X*, which accurately depicted an exotic American beauty, ended his career there. He settled in London, where he flourished, and he traveled frequently to America, which by the late 1880s harbored much of his clientele. After 1908, Sargent restricted his work in portraiture and concentrated on watercolors and murals. In addition to being a first-rate portraitist, Sargent was, with Winslow Homer, a leading exponent of watercolor.

This painting is a loosely painted landscape. Using a monochromatic color scheme of green, Sargent has composed a wooded scene with a meandering brook at midsummer. He was fond of painting landscape, and the seeming spontaneity of this example illustrates his ability to observe accurately and his skill with color and light. The estate is that of M. and Mme. Gautreau, the latter of whom modeled for *Madame X*.

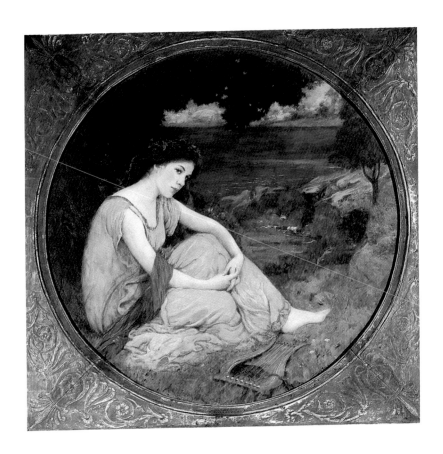

STEPHEN A. DOUGLAS VOLK, 1856–1935
Voice of the Sea, 1908
Oil on canvas, Diam. 38" (tondo)
83.102 Gift of Robert C. Hynson

Stephen Volk was the son of the sculptor Leonard Volk. He was born in
Massachusetts and grew up in Chicago. He was named for Stephen A.
Douglas, a distant relative. From 1873 until 1879, Volk studied with Jean-
Léon-Gérôme in Paris at the École des Beaux Arts. He was trained for
history painting in the salon manner. Volk, a popular artist, won awards
and prizes. He lived in New York City (1879–1884), moved to Minneapolis,
where he founded the Minneapolis School of Art, and then moved back to
New York City in 1893.

 Volk drew extensively on classical subject matter, including mythology.
This painting, circular in shape and called a tondo, depicts a young woman
clad in a yellow-green gown with a scarf of deep blue and pale crimson
around her right arm that hints at the attire of the classical Greeks and
Romans. She sits on the ground with a six-stringed lyre at her side and a
circlet of flowers on her hair. In the background is a calm blue sea. Volk
was fond of painting imaginary mythological figures in isolated settings. In
this case the woman appears to be one of the Nereids, the daughters of the
mythological sea-god, Nereus, who entertained their father with music.

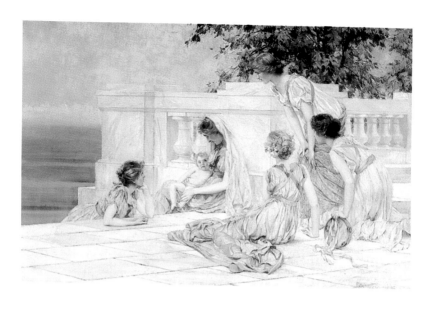

Francis Coates Jones, 1857–1932
Admiring the Child
Oil on canvas, 20" x 30"
84.13 Museum Purchase

Jones was born in Baltimore, Maryland, and is remembered as a figure painter who specialized in genre scenes. In 1876, Jones traveled with his brother, the landscape painter H. Bolton Jones, to Brittany, where he spent a year at the artists' colony in Pont-Aven. He subsequently studied in Paris at the École des Beaux Arts and spent five more years touring Italy, Switzerland, and France. Jones returned to the United States in 1892. He worked first as an illustrator for *Scribner's* and then, beginning in 1895, a mural painter. He taught at the National Academy of Design and spent his summers painting in the Berkshire Mountains of Massachusetts. Jones worked with compositions rich in detail that included elaborate furniture, decorative objects, and costumes. His precise style of painting was eventually influenced by Impressionism.

Admiring the Child, a painting of five women gazing upon a nude baby, has a classical Greek setting. The idealized female figures with their intricately draped costumes, the tambourine with its ribbons, and the white marble architecture are rendered here in the academic style for which Jones was known.

Bruce Crane, 1857–1937
Landscape by the Sea, no date
Oil on canvas, 17" x 25"
26.139 Gift of Lauren Chase Eastman

In the early years of his career, Crane painted landscapes in literal detail that reflected his training as an architect's draftsman. Painting in his spare time, Crane received formal training from Alexander H. Wyant, who encouraged him to follow the Barbizon style of landscape painting. In 1881, after returning to New York from eighteen months of study in Paris, Crane achieved success as a painter of "plein-air" landscapes. His greatest fame came in the late 1890s when he won the Webb Prize of the Society of American Artists. In 1915, Crane joined with Emil Carlsen and J. Alden Weir to establish Twelve Landscape Painters. This organization exhibited the work of artists working in popular representational styles.

Crane loved to sketch outdoors and once said that he did so "to fill the memory with facts."[6] *Landscape by the Sea* depicts a country farm scene and in the distance a village that includes a white church with a tall spire. A figure surveys a pumpkin patch sandwiched between two haystacks on the far left as chickens peck at the ground along a dirt path. Crane has established a sight line in this painting that extends from the lower left corner back to the shoreline and to the right where the village is located.

CHARLES FREDERICK NAEGELE, 1857–1944
September Forenoon, no date
Oil on canvas, 26½" x 28"
84.14 Museum Purchase

Naegele, a native of Knoxville, Tennessee, was indentured as an apprentice
to a tombstone carver and earned additional money by painting signs.
Through a chance encounter with Colonel Charles Myles Collier, a marine
artist, Naegele began studying art under Collier. His ability was such that
he was sent to New York City to study under William Sartain and William
Merritt Chase. He gained a reputation as a portraitist and exhibited at the
National Gallery in Washington, D.C., between 1892 and 1905. Naegele
also designed medals for the National Numismatic Society and actively
supported the concept of public art collections.

 This landscape painting indicates the strong measure of influence by the
American Impressionists, especially William Merritt Chase, in Naegele's
work. The viewer looks through a leaf-strewn orchard—one tree on the left
has three apples—early on a September afternoon. A woman clad in white
stands in the distance, talking to a kneeling figure in what appears to be a
garden. The picture is composed to direct the eye through the trees and
between two farm buildings to the figure, whose elegance contrasts sharply
with the country setting.

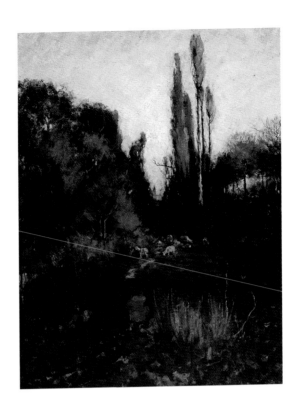

GAINES RUGER DONOHO, 1857–1916
Bords de Forêt, 1880
Oil on canvas, 28½" x 21"
2000.4 Purchased with funds given in memory of Jean C. Lindsey

Gaines Ruger Donoho was born in Church Hill, Mississippi, but moved as a young boy to Washington, D.C. He was trained at the Emerson Institute in preparation for a military career, but opted for work as a draftsman and then as a painter. His formative training took place at the Art Students League and was followed by eight years in France studying at the Académie Julien. He spent the last twenty-seven years of his life in East Hampton, Long Island, which at the time was a rural farming and ranching community. It reminded him of his beloved Barbizon, the region in the north of France that had much inspired him during his years abroad.

Bords de Forêt is, scholars believe, the first of Donoho's paintings to be accepted in the Paris Salon. It was also exhibited in the Cotton Centennial Exhibition in New Orleans in 1885. The work is typical of Donoho's early years in France, strongly influenced by the Barbizon painters in its rural subject matter and dark palette.

JRC

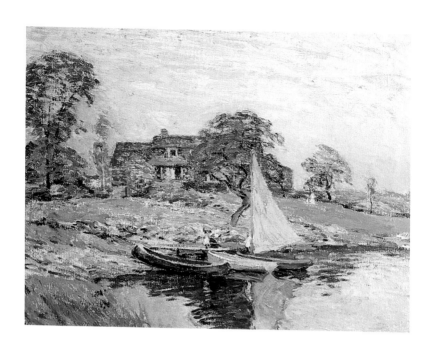

WILLARD LEROY METCALF, 1858–1925
Homestead in Connecticut, c. 1917
Oil on canvas, 16" x 20"
25.3 Museum Purchase

Metcalf was a popular painter of New England landscapes and was recognized as an American Impressionist during his lifetime. He was born in Lowell, Massachusetts, and began formal training in art at the age of seventeen. He attended classes at the Lowell Institute and the School of the Museum of Fine Arts in Boston. He traveled to the American Southwest during 1881–1883, where he painted Indians and desert life. He sold the resulting illustrations to *Harper's Magazine* and spent the proceeds for a trip to Europe. Metcalf was one of the first Americans to visit the French Impressionists at the village of Giverny, but he did not incorporate their style into his own until the early 1900s. A "teaching artist," he worked at the Cooper Union and also continued to accept commissions as an illustrator. After 1903, his paintings began to convey a specific sense of place and atmosphere, and he used the broken brushstrokes of Impressionism. Metcalf was a founding member of the Ten American Painters and the art colony of Old Lyme, Connecticut.

 This painting was made as a gift for his wife's aunt, Mrs. McCrea, after a visit to her home in Waterford, Connecticut. The house stands on a promontory in the background with a canoe, a dinghy, and a sailboat in the water at the shoreline in the foreground. A man stands in the sailboat talking to two figures on the shore nearby. On the lawn at the right, a woman dressed in white is walking with a child. The sail's reflection in the water continues a strong vertical line in the composition which guides the eye upward past the house and trees to the pale summer sky.

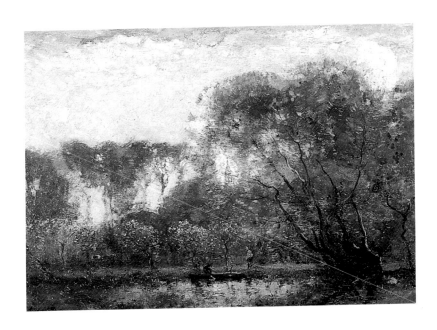

Henry Ward Ranger, 1858–1916
Landscape, 1893
Oil on canvas, 18¾" x 26¼"
23.500 Gift of W. B. Rogers

Ranger, a native of Syracuse, New York, and the son of a commercial photographer, received formal training in Paris at the École des Beaux Arts. He was most influenced by Anton Mauve's romantic realism, and Ranger's landscapes represent the American adaptation of the Barbizon style. Landscape painting was popular in America at the turn of the century, and Ranger became successful. He founded the American Barbizon school in Old Lyme, Connecticut, which had a strong effect upon the early twentieth-century landscape painters and photographers. Ranger began his compositions by working directly outdoors on site, but in the true academic manner, he finished the paintings in his studio.

This painting is an example of Ranger's mature style. The sense of abstraction stems from the broken-line brushwork. The scene depicts a lake with a small boat and two figures, one sitting in the boat and one standing next to it. On the left, cows can be seen grazing among the trees and another figure is located deep within the trees. The bell tower of a church is visible directly above the trees in the dead center of the painting; a village is nearby. This idyllic landscape has the distinct European flavor of the Barbizon school.

Ranger's will established a fund for the National Academy of Design to be used specifically for the purchase of art by young artists.

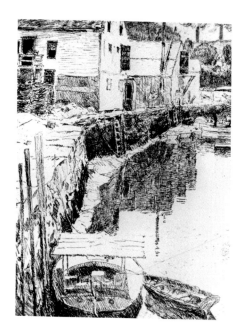

CHILDE HASSAM, 1859–1935
Cos Cob, 1915
Etching, 7" x 5"
69.2 Museum Purchase

Frederick Childe Hassam was born into a family that arrived in America in the seventeenth century. A native of Massachusetts, Hassam received his early training in Boston and became an illustrator for *Scribner's* and *Harper's*. He studied at both the Boston Art Club and the Lowell Institute. In 1886, he moved to Paris for three years and studied at the Académie Julien. In Paris, Hassam fell under the spell of the Impressionists, specifically Monet and Pissarro. He returned to America and emerged as one of the most successful of the American Impressionists. He disliked the term "Impressionism" and never acknowledged his debt to the French style of painting. Instead he spoke of his devotion to the work of the English watercolorists Turner and Constable. But the work of Hassam is unmistakably that of Impressionism. His work evolved into Post-Impressionism, and during 1917–1918 he began devoting time to printmaking. He joined the Ten American Painters and was honored by a number of institutions, including the National Academy of Design.

 This small etching of Cos Cob is typical of Hassam's drawing style and of his work as a printmaker. The composition divides the format diagonally from lower left to upper right, using the cliff-like water's edge to lead the eye back into the scene. The upper third of the picture is filled with buildings that face the water. The waterfront is busy with people working on the land and in the boats, which are moored close to ladders that must be climbed to reach ground level. This New England landscape sensitively documents a way of life that disappeared with the advent of World War I.

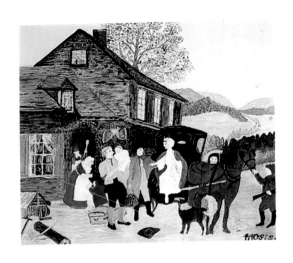

The Daughter's Homecoming, 1947
Oil on pressed wood, 12" x 14"
76.14 Museum Purchase with the support of the Steber Foundation
Copyright © 1972, Grandma Moses Properties Co., New York

Anna Mary Robertson Moses, perhaps the best known American folk artist, was inspired by the work of Currier and Ives and in her seventies began painting primitive scenes of her youth. She was born in upstate New York and worked in neighboring households until age twenty-seven, when she married a farmhand, Thomas Moses. They moved to Virginia, rented a farm, and had ten children, five of whom died in infancy. She led the hard life of a farm wife. After eighteen years, she and her family moved back to New York and purchased a dairy farm. In 1927, Thomas Moses died. Anna remained on the farm, which was operated by one of her sons. When age prevented her from doing strenuous farmwork, Grandma Moses stitched worsted-yarn pictures. Arthritis made stitching too difficult, and at the suggestion of her family, she began painting. Her career was launched when a knowledgeable collector saw three of her paintings on display in a drugstore in 1938. By the 1940s, she had developed her style and painted landscapes with rolling hills populated with many busy figures. She produced an estimated 1,600 paintings and worked until a few months prior to her death at age 101.

The Daughter's Homecoming shows a young woman arriving with her husband and two children at the home of her parents. This scene of the late nineteenth century accurately depicts the life of that time. The clothing, horse and buggy, trunk resting on the ground, and servant woman on the porch add detail that is readily understood. A turkey presumably intended for a festive dinner hangs from the porch. Anna Mary Robertson Moses's lack of formal art training did not prevent her from painting in an authentic narrative style. She is a genuine primitive artist because the lack of technical skills did not lessen the power of her visual expression.

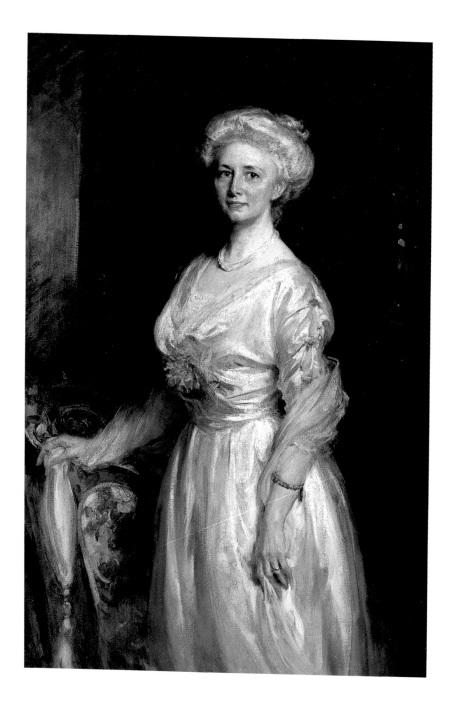

SIR JAMES JEBUSA SHANNON,
1862–1923
Portrait of Catherine Marshall Gardiner, 1908
Oil on canvas, 60" x 41"
73.74 Gift of Catherine Rogers Exnicios

Shannon was born in Auburn, New York. At the age of eight, he moved to Canada with his parents. He was sent to England when he was sixteen to study at the South Kensington School, where he won the gold medal for figure painting. Shannon remained in England and became a distinguished portraitist. His work won many awards in Europe and America. He was a founding member of the New English Art Club, in 1897 was elected an associate of the Royal Academy, and gained full status as a member of that body in 1909. In 1923, Shannon was knighted.

Shannon's portrait of Catherine Marshall Gardiner, an excellent example of his style, manifests the soft grace and luminous colors that we associate with Sir Joshua Reynolds. James Creelman wrote in *Munsey's Magazine* in November 1895 that Shannon "is to Whistler and Sargent what Reynolds was to Rembrandt."[7] Mrs. Gardiner stands looking at the viewer with her right hand resting on the back of an ornate chair. She is wearing a pale ivory gown with a blue flower at the "V" of the bodice and a silk gauze stole draped across her arms. Her silver gray hair is styled in a soft pompadour that frames her lively brown eyes and slight smile. The brushwork shows the influence of the Impressionists and imparts a rich texture to the picture surface. The subject stands in full light against a background plunged in shadow, and the portrait strongly contrasts dark and light, not color. Particularly noteworthy is the fine drawing of the left hand, which grasps a fold of her skirt. The ring finger is highlighted with her gold wedding band, and the hand is particularly expressive of her personality. Catherine Marshall Gardiner, the great-aunt of Lauren Rogers, donated her vast collection of baskets and artifacts to the museum in 1923.

ROBERT HENRI,
1865–1929
The Brown Wrap, 1911
Oil on canvas, 32" x 26"
76.15 Museum Purchase

Robert Henri was born Robert Henry Cozad and was given the surname of
Henri by his father, a gambler who, after shooting a man in a fight, had to
flee from a lynch mob. Henri admired his father and emulated his daring
manner. His artist's studio was a lecture hall and a beer hall where he and
his followers played poker and held indoor scrimmages with pots of
spaghetti when they were not violating the traditional academic styles of
art.

Henri studied at the Pennsylvania Academy of the Fine Arts. There he
was influenced by Thomas Eakins, whose realistic style Henri adopted in his
painting. He combined Eakins's visual honesty with his own personal idiom,
which stressed the personality rather than the anatomical facts of the sitter.
After studying in Paris in 1888, Henri rejected the Impressionists'
techniques, choosing instead to use the darker palette favored by
Rembrandt and Velázquez. Henri's portraits are emotional responses to the
spirit of life. He was the leader of the Ashcan school, originally called the
Eight, which shocked the art world with its potent realism. Henri inspired
two generations of American artists from 1920 until World War II.

This portrait of Henri's wife, Marjorie, shows that he could handle brush
and paint in a fluid and dramatic manner. The subject is swathed in brown
and is wearing a hat ornamented with a brooch. The focal point of this
painting is her face, which gazes composedly at the viewer.

PAUL KING, 1867–1947
Big Creek Church, 1926
Oil on canvas, 26" x 30"
26.49 Museum Purchase

Paul King, born in New York, became an accomplished lithographer while
he was still in his teens. He took art courses at the Art Students Leagues of
Buffalo and New York before studying in Europe. From 1908 until 1921,
King served as the vice president of the Philadelphia School of Design for
Women. During World War I, however, he worked in the camouflage unit
of the U.S. Army.

 Big Creek Church is the oldest church in Jones County, Mississippi; the
building in the painting, which no longer stands, was the second built on
that site. King painted it on a visit to Laurel, which was initiated by an
invitation from W.B. Rogers, the father of Lauren Rogers. The light palette
and brushy style of King's work lead most historians to associate him with
the American Impressionist school.

JRC

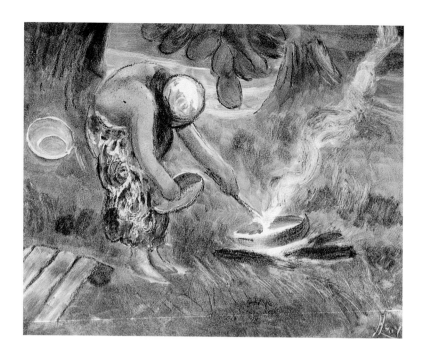

GEORGE OVERBURY (POP) HART, 1868–1933
The Hostess, Tahiti, 1924
Color monotype, 6⁷/₈" x 8³/₄"
71.2 Museum Purchase

Hart was born in Cairo, Illinois, and had two much older brothers who
were also artists and who are believed to have motivated him to become
an artist. He left home at an early age and studied briefly at the
Chicago Art Institute and the Académie Julien in Paris. Between 1907
and 1912, Hart painted amusement park signs in the New York City
area. Until 1920, he painted stage sets for motion picture studios
located in Fort Lee, New Jersey. Between jobs, he traveled extensively
in Europe, Egypt, Mexico and South America, and Polynesia, sketching
and painting wherever he went. Hart was the epitome of the bohemian
wanderer. He recorded genre scenes with a deft technique and a lot of
local color. Not until 1922 did his work attract the attention of art
critics and the buying public. From then until his death in 1933, his
reputation grew.

Hart preferred watercolors to oils. When he was past fifty he turned to
printmaking. This monotype, inspired by a trip to Tahiti, is an excellent
example of his representational style, which focused on the revealing
gesture. A Polynesian woman, turned away from the viewer, serves food
from a container sitting on an open fire. She is dressed in the style of
the South Sea islands in a bright blue print that leaves her shoulders
bare. She is barefoot but wears a light-colored hat. Her long hair is
draped across her right shoulder. In the background is the sea, and in
the lower left corner is a slatted wood object, perhaps a walkway.

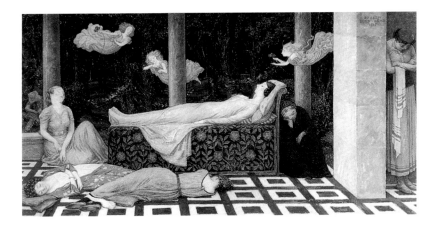

Bryson Burroughs, 1869–1934
The Sleeping Beauty in the Wood, 1917
Oil on canvas, 18" x 36"
84.10 Museum Purchase

Burroughs was born in Boston and reared in Cincinnati, Ohio, where he received art instruction at the Cincinnati Museum of Art. He studied in New York City at the Art Students League and then in Paris at the Académie Julien. Upon his return to America in 1905, Burroughs opened a studio in New York City. In 1906 he became a curator of paintings at the Metropolitan Museum of Art.

Burroughs greatly admired the painting of the French academic master Puvis de Chavannes and was influenced by his style, which combined salon painting in the grand manner with late nineteenth-century symbolism. This symbolic painting was completed at the time America entered World War I. On the left, a uniformed American doughboy is sleeping beneath a tree. The sleeping beauty, who symbolizes all events as yet unrecorded, sleeps upon a bed covered with a cloth embroidered with the splayed Tudor Rose and the sign of the Crown of England. Female figures fly above her, each holding a red poppy, a symbol of continued life amid the ravages of war. The poppy is also apt because it is the source of opium. The battles of Beaulieu and Ardennes, sites of heavy American action, were fought in the woods. The painter seems to be saying that the war is not yet won and that the outcome will not be known until the sleeping beauty awakens.

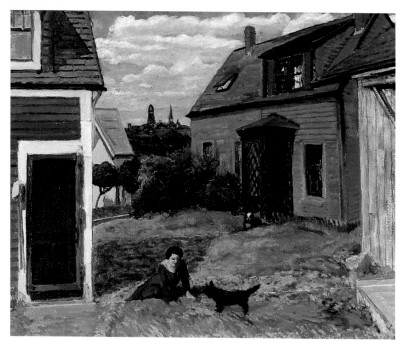

Dolly by the Kitchen Door

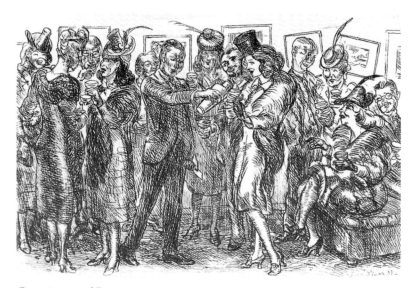

Connoisseurs of Prints

JOHN SLOAN, 1871–1951
Dolly by the Kitchen Door, 1917
Oil on canvas, 26" x 32"
68.1 Museum Purchase

Connoisseurs of Prints, 1939
Etching, edition of 100, 5" x 7"
69.3 Museum Purchase

John Sloan was the most politically minded member of the Ashcan school. Born in Lock Haven, Pennsylvania, Sloan left the Pennsylvania Academy of the Fine Arts in 1892, the same year he met Robert Henri. Sloan settled in New York City in 1904 and continued to record life around him in etchings, drawings, and paintings. His work was the first of its kind in America and was not well received for a long time. He did not sell a painting until he was past forty years of age. Sloan once remarked, "The only reason I am in this profession is because it's fun."[8] He supported himself by teaching at the Art Students League. Sloan attained prominence after the 1908 exhibit of the Eight, when he was praised as an "American Hogarth."

 This painting belongs with the body of work that Sloan produced during the summers of 1914–1918, when he and his family rented a house at Gloucester, Massachusetts. Sloan wrote of this painting, "Each year we moved into our little red and white cottage, and each day was passed in painting the dunes, the sky, the rocks, the bay and sea. This picture of homely interest is handsomely forthright in color." Contrast this painting of a private moment between the blue-clad woman and her dog with the etching *Connoisseurs of Prints*. Sloan was sharply critical of this reception at a New York gallery, as his forthright drawing and composition make plain. The people in the crowd, whose carelessness is evident from the two pictures askew on the right, are interested only in the cocktails and conversations and ignore the art hanging on the walls.

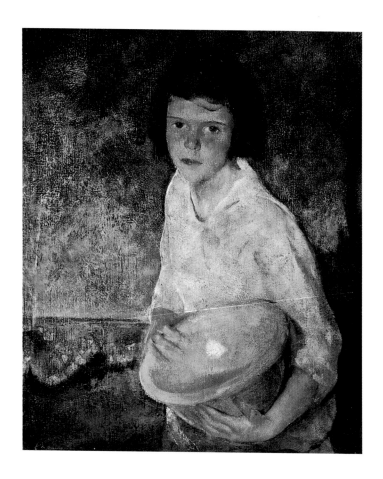

CHARLES W. HAWTHORNE, 1872–1930
Girl with Bowl, 1925
Oil on canvas, 29¹/₂" x 24¹/₂"
36.2 Gift of Mr. and Mrs. Charles H. Worcester

Hawthorne was born in Illinois but grew up in Maine. His father was a sea
captain. Hawthorne spent his life among the seafaring people and later
used them as subject matter. He studied at the Art Students League in
New York and with William Merritt Chase. In 1898, he went to Holland,
where he was strongly influenced by the style of Frans Hals. He is known
for his carefully executed paintings, primarily of women and children, that
show people sadly struggling to make a living from the sea. Hawthorne was
not one of the New York realists; it is said that Henri rejected him from
the Eight. Hawthorne was nevertheless rebuked by the critics for his
realistic paintings of seafaring men and their families.

 Girl with Bowl is typical of Hawthorne's works and shows a young girl
whose father is a fisherman. She carries an empty earthenware bowl and
appears to be walking along the water's edge. Her facial expression reflects
the hardship of the life into which she was born, which she will probably
not leave.

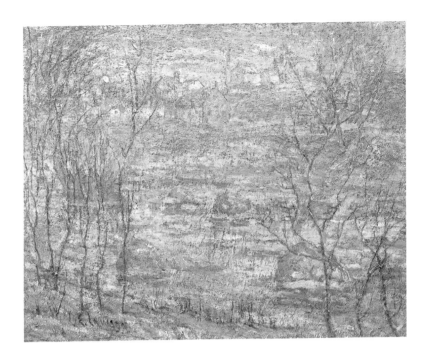

ERNEST LAWSON, 1873–1939
Spring Landscape, Harlem River and Houses, c.1910
Oil on canvas, 20" x 25"
92.5 Museum Purchase

Ernest Lawson was born in Halifax, Nova Scotia, and trained as an artist in Kansas City, in the Northeast under the tutelage of John Twachtman, and in Europe. He was the only landscape painter to exhibit with The Eight in 1908, alongside Henri, Sloan, Luks, and others.

In 1910, Lawson was living in Washington Heights in Harlem at the northern tip of Manhattan. Near his home, the Harlem River and Hudson River joined together. Hence, this picture no doubt depicts a spot near his home in Harlem, which at the time consisted of many rural homesteads, mixed in with newer homes. The image is of a landscape in transition; the fresh colors of spring peep out from a landscape that was recently devoid of color. His thick painterly style led contemporary critics to say that his work appeared to have been made with a "palette of crushed jewels."

JRC

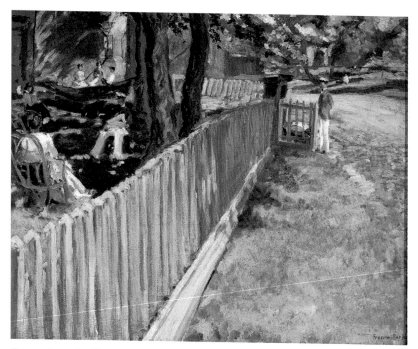

Return from the Shore

KATE FREEMAN CLARK, 1875–1957
Return from the Shore, c. 1910
Oil on canvas, 28¾" x 23"
96.1 Gift of the Kate Freeman Clark Art Gallery

Kate Freeman Clark, a native of Holly Springs, Mississippi, was one of William Merritt Chase's most successful and promising students in the first years of the 20th century. She studied with him for six years at his Shinnecock summer art school on Long Island, and then proceeded to exhibit widely and successfully from about 1904–1914. During those years, she signed her name "Freeman Clark" so that viewers would not judge her work based on her gender. Her style was much influenced by Chase's painterly stroke and bright palette, as well as the people and places of New York City and Long Island, her residences during those years. Though she regularly returned to Mississippi to fulfill family obligations, she is only known to have painted two pictures of Mississippi subjects.

Sadly, Clark gave up her painting career in the early 1920s after suffering the loss of her mentor, Chase, in 1916 and then her beloved grandmother and mother in quick succession. She returned to Holly Springs and took up the lifestyle of the genteel Southern lady so fully that many of her friends and acquaintances in her later years were unaware that she had been an accomplished and successful artist during her years in the Northeast.

When Clark painted *Return from the Shore*, she was at the height of her powers and her success. It is a scene of summer leisure, full of well-dressed figures relaxing in the shade after a morning on the Long Island shore. The diagonal line of the fence draws the eye toward the white-hatted gentleman in the background, and then a splash of red draws the viewer all the way into the composition. The virtuoso painting is spontaneous and free without sacrificing clarity of composition and subject.

JRC

WALT KUHN, 1877–1949
Dressing Room, c. 1925
Lithograph, 8/50, 10½" x 7¾"
70.14 Museum Purchase

Walt Kuhn was born in Brooklyn, New York, and spent his early adult
years operating a bicycle shop and barnstorming as a bike racer at county
fairs. In 1899, he worked as a cartoonist in San Francisco. Kuhn studied in
Paris and Munich from 1901 until 1903 but was influenced by Cézanne
alone among the artists whose work he saw. He responded in particular to
Cézanne's use of black outlines and flat planes of color. Kuhn spent his
time on a variety of pursuits other than painting. He loved the theater and
circus and designed not only costumes and sets but also the interiors of
railway cars. In addition he advised the wealthy about art collecting. With
Arthur B. Davies, he selected the art to be displayed in the New York City
Armory Show, which created a sensation when it opened because of its
radical content. As he grew older, Kuhn became more eccentric. He
suffered a nervous breakdown a year before his death.

 Dressing Room is representative of Kuhn's mature work. A pensive female
performer still in her costume and heavy 1920s makeup is in a dressing
room rich with detail and pattern. Behind her on the right is a wicker
chair with a striped seat cushion that rests against a boldly patterned
drapery. The left side of the composition shows a dresser and clothing
stand topped with hats. A partly obscured sign on the wall makes it plain
that this is not a private bedroom.

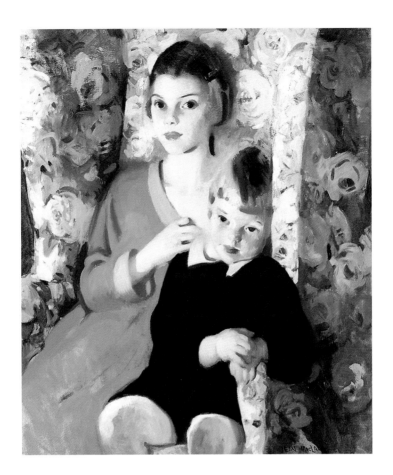

Jean MacLane, 1878–1964
The Chintz Chair, no date
Oil on canvas, 36" x 30"
85.3 Museum Purchase

Jean MacLane, a portrait painter, graduated from the Art Institute of Chicago in 1897. She studied under Frank Duveneck in Cincinnati and William Merritt Chase in New York. In 1905, she married fellow painter John Christen Johansen, and they had adjacent studios in New York City. She was a successful portraitist. With very few exceptions, her work depicts women and children. In 1912, MacLane and her husband established with twenty-seven other artists the National Association of Portrait Painters. She continued to paint until she was in her sixties.

This painting most likely shows her daughter and son. They sit together in the wingback chair upholstered in a bright chintz pattern of large flowers on a blue ground. The young girl has a thoughtful, reserved expression, while the little boy seems to be ready to leave the scene. MacLane's Impressionist style and skillful use of decorative pattern are evident in this painting, as is the resemblance of her work to that of Mary Cassatt.

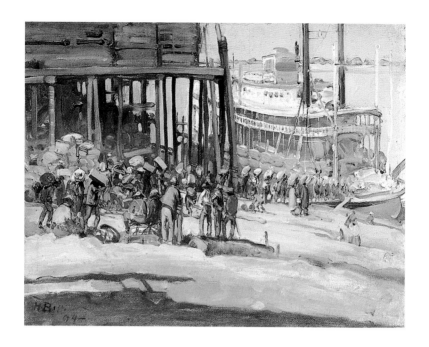

HAROLD HARRINGTON BETTS, 1881–after 1931
Loading the Steamboat, 1904
Oil on canvas mounted on board, 20" x 26"
84.9 Museum Purchase

Betts, a member of the Chicago family of artists, was known for his
paintings of the Grand Canyon and the Pueblo Indians. During the early
years of the nineteenth century, he traveled the Mississippi River to the
Natchez and Vicksburg areas and painted scenes inspired by these trips.

 Loading the Steamboat is a painting of the South at the turn of the
century. The steamboat is docked in the Mississippi River adjacent to a
cotton warehouse. Bales of cotton are being loaded by hand. The intensity
of the natural light depicted in this painting indicates midday late in
summer, when cotton is ready for shipping. The predominant yellow ochre
is relieved by the bright colors of the workers' clothing, which form a band
across the middle of the composition. Betts's painting captures a moment
in the history of the South that disappeared with the advent of modern
technology.

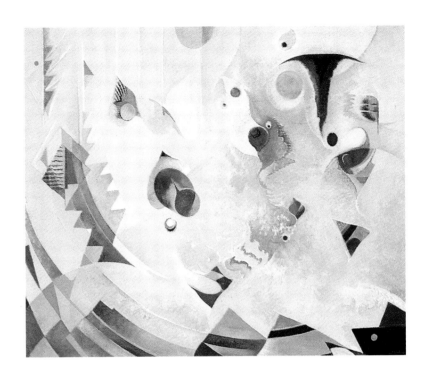

WILL HENRY STEVENS, 1881–1949
Painting 39-12, 1947
Oil on canvas board, 28" x 34"
84.15 Museum Purchase

Stevens, a native of Vevay, Indiana, received formal art instruction at the Cincinnati Art Academy, where he participated in critiques conducted by Frank Duveneck. He worked for the Rookwood Pottery Company and moved to New York when the company was commissioned to install tiles in the city's subway. He studied at the Art Students League and remained in New York City until 1912. Between 1912 and 1921, when he joined the faculty of Newcomb College of Art at Tulane University in New Orleans, Stevens lived the life of an itinerant artist. His paintings followed two separate paths, the abstract and the representational, and he used different dealers for each. As a teaching artist, he exhibited regularly. He had a solo exhibit at the Lauren Rogers Museum of Art in 1929. He retired from teaching in 1948 and died in Vevay, Indiana, in 1949 of leukemia.

 Stevens absorbed the modern theories of art and translated them into his work. This painting reveals his interest in Surrealism and the work of Wassily Kandinsky. Biomorphic forms are combined with the geometric on a neutral ground. The picture could be interpreted as the microcosm that exists within the greater world of the macrocosm.

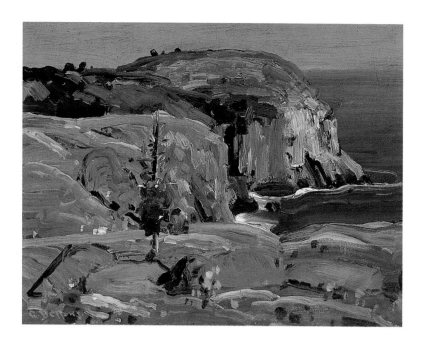

GEORGE BELLOWS, 1882–1925
Blackhead, Evening Gray, 1911
Oil on wood panel, 10¾" x 14¾"
25.6 Museum Purchase

Bellows, an affiliate of the Ashcan school of early twentieth-century realism, believed that one should paint what one knows and that art should reflect images of society. A native of Ohio, he could have been a professional athlete but preferred to pursue a career as an artist. Many of his paintings reflect his interest in sports, particularly those of boxing subjects. Bellows was the youngest member of the National Academy of Design when he was elected in 1909. He was Robert Henri's star pupil and close friend. Bellows's career was cut short when he died of a ruptured appendix at age forty-two.

In August of 1911, Bellows summered on the island of Monhegan, Maine, with fellow painters Robert Henri and Randall Davey. There he produced thirty small paintings using oil paint on wood panels. The museum's *Blackhead, Evening Gray*, is one of those pictures. This title lets us know with a high degree of specificity that Bellows was observing a particular place at a particular time of day. During that painting trip, he also made paintings in Monhegan with titles like *Afternoon, Whitehead* and *Breaking Sky in Maine*. Clearly Bellows, like his French contemporary Claude Monet, was interested in recording the way light and color changed according to different times of day and changing weather conditions.

JRC

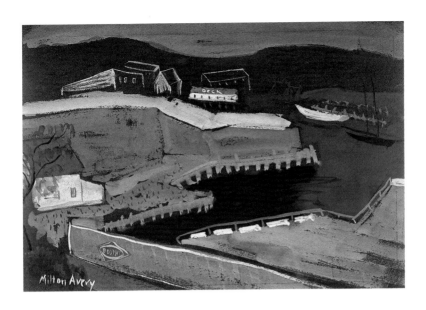

MILTON AVERY, 1885–1965
Boothby Fisheries, 1934
Gouache on paper, 11½" x 18"
98.1 Museum Purchase

Milton Avery was born in upstate New York and raised in Hartford, Connecticut. He began art school at eighteen and shortly thereafter spent some time at the artists' colony in Gloucester, Massachusetts. Like many American artists of the time, he moved to New York City but spent his summers sketching in the countryside. Although he often associated with other New York artists (from the Social Realists to the Abstract Expressionists), his Matisse-inspired modernism was never really affiliated with any of the trends in New York art. He was inspired by nature, but, he said, he tried to "construct a picture in which shapes, spaces, colors form a set of unique relationships, independent of any subject matter."[9]

Boothby Fisheries was no doubt inspired by one of Avery's trips to the Eastern seaboard. American artists have long been inspired by the seashore but have only occasionally depicted scenes of industry and commerce at the shore. Here, Avery joins his contemporaries Sheeler and Demuth in portraying the stuff of American commerce, a subject popular with the Precisionists of the 1930s. As in a Precisionist work, no humans inhabit this space, and the linearity of human construction is imposed on a natural setting. While Avery's typical thinly painted, carefully composed technique is similar to that of the Precisionists, his style is not entirely in sync with the Precisionists. It is neither highly finished nor excessively sketchy; neither precise nor imprecise; it neither praises nor condemns the commercialization of this stretch of shore. Avery's work is characterized by careful balance, and *Boothby Fisheries* is no exception.

JRC

JOSEF ALBERS, 1888–1976
I-Se, 100/125, 1970
Serigraph on paper, 13¾" x 13¾"
72.17 Museum Purchase

Albers, an influential artist and teacher, came to the United States from
Germany to escape Hitler's oppression of the 1930s. He was educated at
the Royal Art School in Berlin, the Applied Art School in Essen, the Art
Academy in Munich, and the Bauhaus in Weimar. In 1933, Albers arrived
in America and assumed the chairmanship of the Art Department at Black
Mountain College in North Carolina. Albers's primary interest, much like
that of Mondrian and Cézanne, lay in reducing the pictorial images to
their basic form. In 1949, Albers began his seminal work, entitled *Homage
to the Square*, in which he systematically explored color relationships
within the restricted format of a square. In 1963, his work on color theory
was published in the book *The Interaction of Color*. Albers was chairman of
the Design Department at Yale University during 1950–1958, a position
that enabled him to elaborate his artistic philosophy before a wide
audience. He continued to work until his death in 1976.

 This serigraph is one of the prints that Albers completed as part of the
investigative series *Homage to the Square*. Albers used the theories of
individual perception of colors to create this work, showing that the
subject merges science and subjectivity. This print shows the optical effects
of color and the interaction of the pure yellow square with the two neutral
tints that are superimposed upon it.

THOMAS HART BENTON, 1889–1975
Sunday Morning, 1939
Lithograph, 9¹/₂" x 12³/₄"
70.10 Museum Purchase
© T. H. Benton and R. P. Benton Testamentary Trust / Licensed by VAGA,
New York, NY

Thomas Hart Benton was one of America's staunchest supporters of realism during the 1920s. He, Grant Wood, and John Steuart Curry formed a trio of Regionalist artists who rejected the modern art movement as well as all European influences. Benton, a farm boy from Missouri, studied art at the Corcoran Gallery in Washington, D.C., at the Chicago Art Institute, and at the Académie Julien in Paris. Until World War I, when he served as a draftsman in the navy, Benton experimented with modern theories of art. He described this period by saying, "I wallowed in every cockeyed 'ism' that came along, and it took me ten years to get all that modernist dirt out of my system."[10] He then turned to realistic scenes of American life, for which he is best known today. Benton is responsible for the acceptance of the regional genre as art, and he contributed to the establishment of an indigenous American art aesthetic.

Sunday Morning shows a scene of the sort that Benton liked to depict. The people of the rural African-American community are going to church. The drawing of the figures and the rolling countryside is characteristic of Benton's style, which stresses individuality. On the left, behind a tree, a young couple pursue their courtship while the very young and very old enter the ramshackle building.

Claude Buck, 1890–1974
My Family, c. 1925–1930
Oil on canvas, 30" x 40"
27.26 Gift of W. B. Rogers

Buck was an artist who rejected abstraction and the myriad "isms" that formed modern art during the first half of the twentieth century. The child of British immigrants who lived in abject poverty, he lived in the Bronx. Buck enrolled in the National Academy of Design in 1904, where he studied under both Francis Coates Jones and Emil Carlsen. After marrying in 1918, he moved to Chicago, where his work sold well. He remained opposed to modern art all of his life and even accused many of his fellow artists of Communist leanings because of their abstract styles.

Buck's wife, Estrid, whom he divorced in 1934, is pictured here with their twins, Robert and Juel. The three figures are carefully delineated with black lines. Strong highlights are cast by the curtained window in the background. The daughter, Juel, holds her doll, while her brother, Robert, stares solemnly at the viewer. Robert died in 1971, and as Buck had asked that no news of death be communicated to him, Juel kept the sad news of her brother's death from her father for the rest of his life. She maintained the deceit by writing Buck letters signed "Robert" for three years.

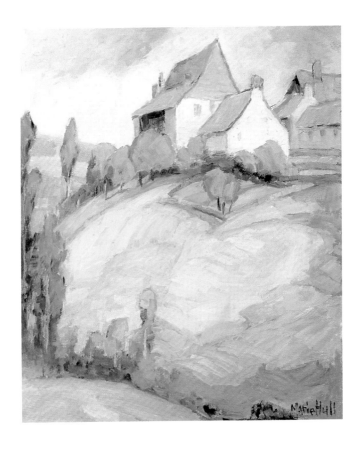

MARIE ATKINSON HULL, 1890–1980
Hilltop, Farmhouse, 1929
Oil on canvas board, 24" x 20"
84.3 Museum Purchase

Marie Hull, a Mississippi artist, trained at the Pennsylvania Academy of Fine Arts, the Art Students League in New York, and the Colorado Springs Art Center. She traveled extensively during her long career in America, Europe, Mexico, and Canada. She said that she believed an artist must remain attuned to the art world and view the work of other artists. She was a determined woman who became a professional artist during an era that did not encourage southern ladies to venture from their homes. Her work was influenced by the early twentieth-century realists and by such European colorists as Henri Matisse. She had twenty-seven solo exhibitions and was included in the 1931 Spring Salon in Paris. Hull won numerous awards for her painting. In 1970, Louis Dollarhide of the *Jackson Daily News* called her "the grandmother of art in Mississippi."[11]

This landscape painting was completed in Cordes, France, and shows Hull's debt to Matisse and the French Fauves. The lavender roofs and bright yellows and greens of the hillside are painted with strong brushstrokes. The painting has universality in the sense that it could exist anywhere, not just in France.

GRANT WOOD, 1892–1942
Seed Time and Harvest, 1937
Lithograph, edition of 250, 7½" x 12"
71.11 Gift of Annie Louise D'Olive
© Estate of Grant Wood / Licensed by VAGA, New York, NY

Grant Wood, born in Iowa, was known as a painter of the American scene. Like others in the Regionalist school, he depicted Americans in rural settings, but his work stands apart for its biting commentary on Americans and their daily habits. In an essay he wrote in 1935, he said, "Your true regionalist is not a mere eulogist; he may even be a severe critic."[12]

Wood was educated at Iowa State University and the Art Institute in Chicago. After World War I, during which he served in the army, he attended the Académie Julien in Paris in 1923. He returned to Iowa and taught public school art. Wood received his first national recognition for the 1930 painting *American Gothic*, a humorous view of midwesterners for which his sister and his dentist posed. Underlying all of his work was a profound respect for rural life. Wood died of cancer at the height of his fame in 1942.

This lithograph shows that Wood's style was heavily influenced by sixteenth-century Flemish art with its painstaking realism and by Chinese art with its rounded contours. The composition is simple, with crisp edges and subtle grays. The farmer carries his basket of corn into the barn, which has three rows of ears hanging above the entrance. The fields roll gently to the horizon and are dotted in regular rows with the harvest. Wood has captured the rhythm and sweep of the American Midwest as well as its air of isolation.

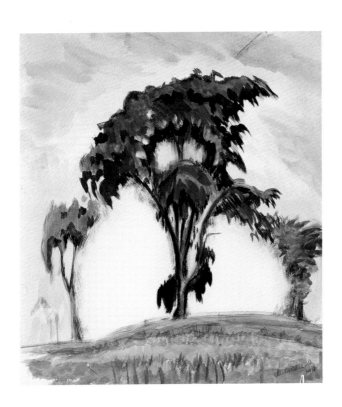

CHARLES BURCHFIELD, 1893–1967
Three Trees, 1918
Watercolor on paper, 17½" x 15½"
98.3 Museum Purchase

Charles Burchfield was born and raised in Ohio, where he studied at the
Cleveland School (now Institute) of Art. In 1921, he moved to Buffalo,
New York to work as a graphic designer and remained in Buffalo for the
rest of his life. His work can be divided into three phases. In the first brief
phase, 1915–1918, he engaged primarily in nature studies and landscapes.
In the second, from 1918–1943, he turned to rural townscapes and scenes
of middle-American life. These works are the precursors of the Regionalist
and American Scene works of the 1930s, exemplified by artists like Grant
Wood and Thomas Hart Benton. Finally, in 1943, he went back to the
material of his early years, treating natural images as a kind of private and
mystical vocabulary.

The museum's *Three Trees* dates to the transition period between his first
and second periods, 1918. It is likely the product of much previous study,
in both drawing and watercolor, as Burchfield consistently planned and
sketched out each finished painting. The repeated curving lines in the
foliage of the middle tree are typical of Burchfield's style during this period,
which evolved from his many interests, including Chinese painting,
graphic design, and abstract art.

JRC

YASUO KUNIYOSHI, 1893–1953
Grapes in a White Bowl, 1935
Oil on canvas, 16" x 12"
85.22 Gift of Alan Temple
© Estate of Yasuo Kuniyoshi /
Licensed by VAGA, New York, NY

Dead Willow Near Cemetery, 1940
Pencil drawing, 11" x 15"
46.1 Gift of the Childe Hassam
Fund of the American Academy of
Arts and Letters
© Estate of Yasuo Kuniyoshi /
Licensed by VAGA, New York, NY

Kuniyoshi arrived in America in
1906 from Japan. He studied at the
Los Angeles School of Art and Design from 1907 until 1910. He then
moved to New York, where he continued his studies with Robert Henri and
at the Independents School of Art and the Art Students League. He began
exhibiting regularly in 1921. After trips to Europe in 1925 and 1928, his
painting became more representational. He was known for his still lifes and
for nudes that were reflective and somber. Kuniyoshi participated in New
Deal art projects and traveled to Mexico and Japan on a Guggenheim
Fellowship in 1935. In the United States he was classified an enemy alien
during World War II, although he felt loyal to his adopted country. The
delicacy of his style gave way to a sense of desolation. Kuniyoshi died the
year that Japanese aliens were allowed to become United States citizens.

This still life painting and landscape drawing show that Kuniyoshi's work
was both representational and abstract. *Grapes in a White Bowl* is rich with
painterly effects and uses nuance of tone rather than pure color for visual
contrast. The drawing with its dead tree in the center of a desolate
landscape reflects the mood of the artist in 1940.

THEORA HAMBLETT, 1895–1977
Transfiguration, 1969
Oil on canvas, 24" x 50"
86.19 Gift of the Betty Parsons Foundation

Theora Hamblett, a primitive painter, was born on a farm in Paris, Mississippi. She taught school intermittently during the period 1918–1936. After her attempts to start a chicken farm failed, she moved to Oxford and studied art briefly in 1949 at the University of Mississippi. She began painting seriously and gained a reputation not only as an artist but also as a visionary. The Betty Parsons Gallery in New York became her dealer in 1954. The majority of Hamblett's work deals with biblical themes and her visions. She left most of her work to the University of Mississippi upon her death.

Transfiguration uses one of Hamblett's favorite formats, a series of horizontal scenes all of which relate to one event. On the left, Christ and three apostles pray on Mount Hermon, as recorded in the New Testament of the Bible. Immediately adjacent is the scene in which Elijah and Moses appear as radiant figures who in the next scene, followed by Christ, enter their aura and ascend to heaven. The final scene on the right shows the apostles alone on the mountain. Hamblett's love of trees is apparent in the border at the lower edge of this painting.

REGINALD MARSH, 1898–1954
East River, 1952
Oil on Masonite, 16" x 20"
98.2 Museum Purchase

Reginald Marsh was born in Paris but raised in Nutley, New Jersey. He studied painting with his artist parents at Yale and, most formatively, at the Art Students League under the guidance of Luks, Sloan, and Miller. He began his career as an illustrator, expanding into painting by the 1930s. He is best known for his scenes of everyday life in contemporary New York City, especially the tawdrier side of that life. While his subject matter was entirely modern, his artistic inspiration was more traditional: he particularly admired artists like Rubens and Delacroix and has been compared frequently to Daumier and Hogarth.

East River is typical of Marsh's subject matter; it is a gritty urban scene. New York's East River was, and is, full of commercial and industrial traffic, such as the military tugboat that dominates the middle distance. While many Marsh compositions are crowded to the point of claustrophobia, *East River* has only a few figures: two of his typically buxom women who seem to be walking in different directions and a man who leans on the seawall looking at the river. The figures don't communicate even though they are in close quarters, which is typical in a crowded city. Marsh, as always, is a draftsman first and a painter second; the underlying linear structure always remains visible beneath his translucent washes of color.

JRC

ALICE NEEL, 1900–1984
The Bather, 1982
Color lithograph, 38" x 22¾"
85.17 Museum Purchase

Alice Neel was born in Pennsylvania and studied at the Philadelphia
School of Design for Women (now the Moore College of Art) until 1925.
She moved to New York after her marriage to a Cuban in 1927. Her life
was marked by a series of personal disasters, including the death of a child
in infancy, a nervous breakdown, and attempted suicide. Neel participated
in the New Deal Public Works of Art Project in 1933 and the WPA Easel
Project in 1935. She settled permanently in Spanish Harlem in 1938. She
is known for her portraits of prominent people in the art world and for
pictures of her two sons and their families. Her work shows that she had an
unflinching eye and empathized with her subjects. In a speech given at the
Moore College of Art in 1971, she remarked, "Injustice has no sex and one
of the primary motives of my work has been to reveal the inequalities and
pressures as shown in the psychology of the people I painted."[13]

The Bather is representative of Neel's style, which is painterly with a
strong, expressive use of color. The prepubescent girl stands on the beach
with waves breaking on the shore behind her. She is brightly attired in
floppy hat and bikini and, with her hands on her hips, challenges the
viewer. Neel was an outspoken advocate of women's rights. This young
member of the next generation makes a clear visual statement of the artist's
point of view on the female.

RICHMOND BARTHÉ, 1901–1989
Stevedore, 1937
Bronze, 3/8, 30⅝" x 20" x 14½"
99.6 Museum Purchase

A native of Bay St. Louis, Mississippi, Barthé was exhibiting paintings in New Orleans by the age of twelve. Barthé studied at the Chicago Institute of Art, funded partly by collections taken up by the congregation of his church. Although he began by studying painting and sculpture, he soon abandoned painting after an early exhibition of sculpture garnered high praise. After receiving two Rosenwald Fellowships, Barthé moved to New York City and quickly became affiliated with the Harlem Renaissance artists and poets. There his career flourished, and he received many honors, including two Guggenheim Fellowships.

After the rise of abstract art in the post–World War II era, Barthé's realistic work fell out of favor. Prompted by a friend, Barthé moved to Jamaica. For a time the artist enjoyed the anonymity and lack of deadlines, as well as the relatively undeveloped state of Jamaica. Eventually, the growing violence in Jamaica unnerved Barthé, and he grew overwhelmed by commissions. As a result, he moved to Europe, where he divided his time between England, Italy, and Switzerland. He finally settled in Pasadena, California, to work on his memoirs and produce editions of his works. Disturbed by the public's disregard for the sculptor, actor James Garner befriended Barthé and assisted him financially with the production of these editions.

For more than sixty years, Barthé remained focused on sculptural portraits of African-Americans. He believed that his art was a spiritual vehicle that enabled him to discover God within each of his subjects. The museum's *Stevedore* is a portrait of a working man; the stevedore is responsible for loading and unloading ships in port. The subject was undoubtedly inspired by Barthé's experiences in Louisiana and along the Mississippi Gulf Coast. *Stevedore* is a good example of Barthé's gift for depicting the figure in a natural and convincing manner. His style has origins not only in his training in America, but also in the classical sculptural forms of Europe and the elongated forms of African Somali art.

MDB

WALTER INGLIS ANDERSON, 1903–1965
Robinson Crusoe on Horn Island, no date
Watercolor on paper, 8½" x 11"
67.4 Museum Purchase

Anderson was born in New Orleans, attended the Parsons Institute in New York City in 1923, studied at the Pennsylvania Academy of the Fine Arts from 1924 until 1928, and then traveled in France on a Cresson Fellowship for two years. In 1933 he married Agnes Grinstead, who had majored in art at Radcliffe College. He had a nervous breakdown, his first of several, in 1937. During the ensuing years, Anderson was in and out of hospitals. In 1940, he moved with his family to his wife's family home, Oldfields, near Gautier, Mississippi, which provided him with inspiration for his painting. By 1947 Anderson had become a recluse, and he went to live alone in a cottage near Ocean Springs, on the Mississippi Gulf Coast. During this time he traveled to China (1950) and Costa Rica (1952) and completed a mural for the Ocean Springs Town Hall. The last fifteen years of his life he devoted to watercolors of the uninhabited Horn Island and to eighty-five journals in which he recorded his experiences on this island. When he died of lung cancer, a twelve-by-fourteen-foot room in his cottage was found to contain a mural presenting an integrated view of life on Horn Island.

This watercolor, one of approximately 2,000 that Anderson painted on Horn Island, shows Robinson Crusoe finding a footstep in the sand. The picture is composed in Anderson's abstract style, which translated flora and fauna into intricate combinations of shape and color. Anderson was obsessed by the relationship between nature and art, and he created a colorful and complex imagery to interpret nature.

ADOLPH GOTTLIEB, 1903–1974
Chrome Green, 1972
Serigraph, 47/150, 24" x 18"
74.6 Museum Purchase
© Adolph and Esther Gottlieb Foundation / Licensed by VAGA, New York, NY

A native New Yorker, Gottlieb studied at the Art Students League under
John Sloan and Robert Henri in 1920. He traveled to Europe and studied
in Paris at the Académie de la Grande Chaumière. When he returned to
New York City in 1923, Gottlieb finished his academic work at the Parsons
School of Design. He exhibited with the Ten during the late 1930s, lived
briefly in Tucson, Arizona, where he developed an interest in primitive art,
and was increasingly drawn to the avant-garde world of art. Gottlieb held
fast to the principle that "it was not what one painted, as long as it was
painted well." He expressed in this statement what can be considered the
prevailing attitude in American abstract art at the time.

 This serigraph is part of the work Gottlieb accomplished after a major
change in his style in 1957. His format changed to the vertical, and he
called works such as this one "bursts," since they were dominated by
exploding shapes. Representing his most refined work in color, they ranged
from precisely defined forms carefully arranged to images that were almost
blurred. *Chrome Green*, with its complementary color combination of red
and green, has a controlled red-within-red burst at the top and a splash of
blue-green at the bottom, all contained on a yellow-green ground.

PAUL CADMUS, 1904–1999
Mobile, edition of 75, 1953
Color serigraph, 15½" x 18¼"
74.5 Museum Purchase

Cadmus is a painter and printmaker best known for his satirization of American manners. He studied at the National Academy of Design from 1919 until 1926 and at the Art Students League in 1928. He traveled extensively in Europe during the early 1930s and studied the work of the European masters. He also produced a large body of nonsatirical work that was mild in tone and devoid of caricature. His drawings have been associated with the advent of photorealism in America after World War II.

Mobile shows Cadmus's interest in the human figure and mundane objects coupled with sensitive drawing. A young man holds in his left hand a mobile constructed from natural objects including shells, driftwood, and a bird's skull. He is waiting to see whether the mobile is properly balanced and will move as it should. This is a portrait of Cadmus's contemporary, the American artist George Tooker.

PETER HURD, 1904–1984
Pennsylvania Quaker, no date
Lithograph, 31/50, 13" x 10"
55.1 Gift of Roy McLeod

Landscape, no date
Watercolor and ink on paper,
9" x 13½"
83.3 Given in Memory of James H.
McLeod by His Family

Peter Hurd, a native of New Mexico,
attended West Point for two years
before deciding that he would rather
be an artist than a cadet. He attended
the Pennsylvania Academy of the Fine
Arts and studied with N. C. Wyeth for several years. Hurd married Wyeth's
oldest daughter and stayed at Chadds Ford for twelve years as part of a
family of artists who had a profound influence on the world of art. Hurd
was an accomplished portraitist and illustrator. During World War II, *Life*
magazine commissioned him to record wartime activities. His work was well
known in America by the 1930s and he returned to New Mexico, where he
remained the rest of his life. He described the creation of art as a "religious
experience," saying, "What motivates me is a constant sense of wonder."[14]

The lithograph of the dour Quaker in his black hat and vest over a
homespun shirt shows N. C. Wyeth's influence. The portrait exemplifies the
minute detail and austere presence that is a hallmark of the Wyeth family.
The watercolor of the landscape is freer in technique and bright with color.
Hurd's background as a representational artist is evident in his need to
delineate the forms of trees and buildings more fully in pen and ink.

FAIRFIELD PORTER, 1907–1975
The Tennis Game, 1972
Oil on canvas, 72" x 62"
73.78 Purchased in part with funds
provided by Mississippi Arts Commission

Porter, born in Winnetka, Illinois, graduated from Harvard College and
studied at the Art Students League under Thomas Hart Benton in
1928–1930. He had a reputation as a realist artist who took landscapes
and interiors as his subject matter. He was also a writer and published
art criticism in the major art journals during the 1940s and 1950s. A
monograph he wrote on Thomas Eakins was published in 1959. He was
described as "a modernized American Impressionist,"[15] since his work
combined a pastel palette with broad brush-strokes. Porter's work did not
tackle the social issues of the time or pose problems for the viewer to solve.
He lived at Southampton, Long Island, and his paintings reflect the
tranquility of his life in the country.

 This painting shows the country life of the affluent. *The Tennis Game*
uses paint laid on in strong strokes to establish the four figures and their
environment. There is no attempt at detailed realism in the modeling.

JOHN KOCH, 1910–1978
The Telephone, 1972
Oil on canvas, 20" x 12"
74.1 Purchased in part
with funds provided by
the Mississippi Arts
Commission

Koch, a self-taught artist, traveled in England and France and established a
summer studio in Paris. Originally from Toledo, Ohio, he gained his
reputation as a portraitist of prominent art patrons in New York City. He
taught at the Art Students League and served as chairman of the school
committee of the National Academy of Design.

Koch posed his figures in elegant interiors and used a technique that
employed egg tempera as underpainting and a glaze of oils. *The Telephone*
shows his preference for the interior setting and soft, luminous colors. The
picture is not a portrait but rather a painting of a private moment. The
man, talking on the telephone, has a half-finished drink near him. On the
piecrust table in the foreground lies an open book, a container holding two
cigarettes, and a drink on a porcelain plate. Perhaps the man was waiting
for a guest to arrive when he was interrupted by the telephone. The
strange point of view, most evident from the tabletop, only heightens the
mystery surrounding the situation depicted in this small painting.

Ida Kohlmeyer, 1912–1997
Circus Series 90-2, 1990–94
Mixed media on canvas, 49" x 49"
97.9 Museum Purchase

New Orleans native Ida Kohlmeyer began her studies in English literature
at Tulane's Newcomb College in 1929, but it was not until a few years later
that she realized her enthusiasm for the visual arts. She received an M.F.A.
degree in painting from Newcomb Art School in the 1940s, which led to a
career as a teacher and a studio artist.

As a painter, she absorbed the influences of other artists and teachers
such as Hans Hofmann, Clyfford Still, and Mark Rothko. Of these three
artists, she was most influenced by Rothko. This influence is apparent in
her early and mid-career color-field paintings, adopting Rothko's cloudlike
shapes and muted colors.

Kohlmeyer's work evolved from this style of painting, and eventually
she developed her own style. She worked on large, stretched canvases and
experimented with placement of hieroglyphic-like shapes in a grid format,
thus eliminating all reference to space. The colors intensified, shapes
became bold, and the appearance of black outlines provided a heightened
sense of theatricality.

LRMA's *Circus Series 90-2* is exemplary of Kohlmeyer's style in her
later years; her paintings from this phase exhibit a childlike whimsy and
creativity. The artist's exploration of color, arbitrary shapes, and flatness
of surface displays her awareness of the aesthetic pleasure created by the
combination of these elements.

Philip Guston, 1913–1980
The Street, 1970
Lithograph, 63/120, 20" x 26"
73.23 Gift of Mr. and Mrs. Samuel Dorsky

Guston, a Canadian of Russian ancestry, moved to Los Angeles with his family in 1919. In 1927, Guston and Jackson Pollock became friends in high school and were expelled together for circulating a satirical pamphlet. Guston supported himself as a movie extra while studying art at the Otis Art Institute. He painted murals for the WPA Federal Art Project from 1935 until 1942. His work up to this point was political and controversial. After he returned from a trip to Europe and settled in New York City in 1950, Guston turned to Abstract Expressionism. During the next two decades, his work increased in size and became heavily textured in its abstraction. An abrupt change took place in the 1970s, when Guston returned to literal subject matter featuring city slums and menacing figures. He taught at Columbia, Yale and Boston universities. He was a prominent figure in the Boston art world from 1973 until his death in 1980.

 The Street belongs to Guston's final phase of work, and the imagery is strong and brutal. The arm and fist grasping a stick at the viewer's left are apparently responsible for the devastation. The buildings in the background mark the scene as urban, and the space is filled with falling bricks and building debris, with ankles and feet protruding from the pile. The consistent linear style of heavy lines and dark textures matches the violent imagery to create a powerful social commentary.

ROMARE BEARDEN, 1914–1988
Still Life, 1970
Mixed media collage, 20" x 30"
72.21 Gift of the Edward John Noble Foundation
© Romare Bearden Foundation / Licensed by VAGA, New York, NY

Bearden was born in Charlotte, North Carolina, and moved as a young child to New York City's Harlem. He studied at the Art Students League under George Grosz and founded the 306 Group in the 1930s for black artists living in Harlem. After serving in World War II in the army, Bearden established his reputation. His style combined African symbolism with a stylized realism. He studied at the Sorbonne in Paris in 1950–1954, during which time his work became more abstract. Returning to New York, Bearden began using oils like watercolor, combining thin washes with collage. His mature work mingled abstract shapes with realistic images drawn upon his memories of his childhood in the South. During his career, Bearden received numerous awards, including the medal of the State of North Carolina and five honorary doctorates.

Still Life is a painted collage. A young black man stands beside a table on which sits a pitcher containing foliage. The myriad colors and shapes form an intricate composition that balances subjective and objective imagery.

ELIZABETH CATLETT, b. 1915
Mother and Child, 1972
Bronze, 21" x 7" x 9"
99.7 Museum Purchase
© Elizabeth Catlett / Licensed by
VAGA, New York, NY

From early childhood, Catlett spent much of her time alone drawing and painting while her widowed mother worked. She attained a bachelor's degree in painting from Howard University, studying under Lois Malou-Jones and other prominent faculty. When Catlett decided to pursue the master's degree, she was supervised by the Regionalist Grant Wood, then department head at the University of Iowa. Wood recognized her potential and put her through a rigorous training in a variety of media. In 1940, Catlett became the first student to receive an M.F.A. in sculpture from the University of Iowa.

Catlett's 1945 Rosenwald Fellowship afforded her the opportunity to travel to Mexico to study with artists like Diego Rivera and Francisco Mora. Rivera and Mora were both considered controversial as they were affiliated with leftist politics. During the 1950s "Red Scare" led by Senator Joseph McCarthy, Catlett was arrested as an undesirable alien due to her politics and her residence in Mexico. Shortly thereafter she gave up her United States citizenship and became a citizen of Mexico. From 1958 to 1976, she was Professor of Sculpture at the National University of Mexico; since her retirement, she has resided in Cuernavaca, Mexico.

Mother and Child shows strong evidence of Catlett's early Cubist influences as well as aesthetics reminiscent of the Mexican muralists. In this piece, Catlett addresses issues of the black female on a personal and holistic level. Grant Wood instilled in Catlett a need to address personal issues; as a result, she seldom deviated from the theme of the black woman. Perhaps because Catlett lost her father early in life, the recurring theme of mother and child remains important to her; in fact her M.F.A. thesis sculpture in 1940 was titled *Mother and Child*.

MDB

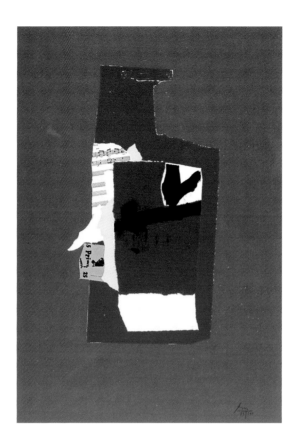

ROBERT MOTHERWELL, 1915–1991
The Redness of Red, 1985
Color lithograph with collage, 83/100, 24" x 16"
85.16 Purchased in part with funds provided by museum docents
© Dedalus Foundation, Inc. / Licensed by VAGA, New York, NY

Motherwell, an abstractionist from the beginning of his career, has
primarily worked with collage, often in combination with oils, drawing
media, and printmaking. Born in Aberdeen, Washington, he studied at the
Otis Institute and the California School of Fine Arts. While still a young
man, he moved permanently to the East Coast. Motherwell studied
philosophy at Harvard and art history at Columbia. At the age of twenty-
six, he decided to be a painter. During his long career, he assimilated
elements of various modern trends and is perhaps best known for his series
of 100 works titled *Elegies to the Spanish Republic*. Collage became a
mainstay of his work beginning in 1943 when he was asked by Peggy
Guggenheim to participate in the first all-collage exhibition in America.

 The Redness of Red is Motherwell's style at its purest. The centrally
organized composition in shades of red with high contrast provided by
white and yellow collage elements and a bold black stroke of paint is pure
abstraction. The only visual link to the representational world is the scrap
of sheet music.

Jacob Lawrence, 1917–1999
Forward Together, 1997
Serigraph, 9/11, 34" x 43"
2001.4 Museum Purchase

Jacob Lawrence was born in New Jersey and moved to Harlem by the
time he was thirteen. He arrived in Harlem in 1930, during the Harlem
Renaissance, and benefited from after-school art education. He also found
mentors who aided him in furthering his art education and in getting a job
with the WPA Federal Arts Project. Lawrence was influenced by the
European tradition of painting, especially genre and social realist painting,
and also by African colors and compositions. His subject matter is almost
always African-American history, heroes, or heroines. He tells the stories
in narrative series of paintings and prints, some of which include more
than sixty images. In addition to his prolific and successful career as a
painter and printmaker, Lawrence had a great deal of influence as a teacher
in half a dozen universities, including the influential Black Mountain
College, as well as many years at Washington State University in Seattle.

 Lawrence's *Forward Together* can be viewed as a metaphorical image of
African-Americans moving forward, united, in a field of flowing color. The
ideas of movement, unity, and progress refer to the struggles of the African-
American race since the beginnings of slavery and specifically to Harriet
Tubman's Underground Railroad. Tubman, in red at the lower right, shows
fleeing slaves the way to freedom as they run through the woods,
presumably toward Canada.

JRC

PHILIP PEARLSTEIN, b. 1924
Two Nudes on a Rug, 1971
Lithograph, 63/120, 22" x 30"
73.9 Gift of Mr. and Mrs. Samuel Dorsky

Born in Pittsburgh, Pennsylvania, Pearlstein was a precocious artist who
received early encouragement in special art programs and by taking classes
at the Carnegie Institute. The early influence of the social realist painter
Samuel Rosenburg and Roy Hilton, a direct realist, established Pearlstein's
direction. He made his only foray into Abstract Expressionism during the
1950s. He labels himself a "postabstract realist." Pearlstein uses the human
figure as a compositional element in his work. His intent, as he describes it,
is simply to create dynamic compositions that happen to involve nude
people.

 This lithograph is representative of Pearlstein's mature style. The
reclining nude figures of two females on a striped rug are meticulously
drawn in minute detail. The composition is horizontal. By cutting off the
lower figure's head, Pearlstein shifts the viewer's eye to the upper portion of
the print.

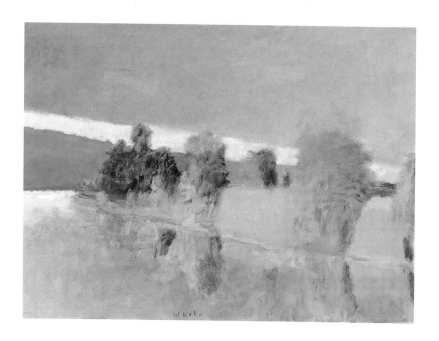

Wolf Kahn, b. 1927
Near Dummerston, 1994–96
Oil on canvas, 30" x 42"
99.5 Museum Purchase
© Wolf Kahn / Licensed by VAGA, New York, NY

A native of Germany, Wolf Kahn emigrated to the United States as a child, arriving in 1940 on the brink of World War II. He studied art with Hans Hofmann in New York City and at the University of Chicago, where he received his B.A. in 1951. He returned to New York just as Abstract Expressionism was reaching its peak and shortly thereafter founded the artists' cooperative Hansa Gallery. Hansa was one of the first of many cooperative galleries founded in the post-war era and one of the most important. Today, Wolf Kahn divides his time between his studios in New York City and Vermont. Although his career was founded in the Abstract Expressionist milieu, his work remains representational. He chooses to explore color and composition within the framework of fields, barns, and forests, yet claims that the subject is not in fact those same fields, barns, and forests. *Near Dummerston* is an image of trees, sky, and a foreground of water near the small town of Dummerston, Vermont. The expressionistic colors—lavender sky, yellow ground—are typical of Kahn's bright palette and vivid composition.

JRC

HELEN FRANKENTHALER, b. 1928
The Red Sea, 1978–1982
Lithograph, 19/58, 24" x 28"
85.14 Purchased in part with funds provided by museum docents
© copyright Helen Frankenthaler / Tyler Graphics Ltd. 1982
Printed and published by Tyler Graphics Ltd.

Frankenthaler, born in New York City and the daughter of a New York
Supreme Court justice, received her education at the progressive Dalton
School and at Bennington College, where she studied under Paul Freeley.
Always attracted to abstraction, she met Jackson Pollock in the early
1950s. She was inspired by his habit of painting on unprimed canvases and
developed a new movement in modern art called "stain painting," using
sailcloth and highly diluted pigments. Some of her works were as much as
ten feet high. Recognition did not come until she won a prize at the 1959
Paris Biennial. Her later work has become denser and incorporates islands
of opaque color but continues the totally nonobjective idiom.

 The Red Sea, printed on pink deckle-edged paper, is representative of
Frankenthaler's more recent work. Both the title and the composition
suggest abstraction from the natural world.

Sam Gilliam, b. 1933
Reds, Towering Stack, 1996
Acrylic, birch, anodized aluminum, 60" x 30" x 4"
2002.3 Museum Purchase

Sam Gilliam was born in Tupelo, Mississippi, and trained as an artist at the University of Louisville, Kentucky, where he received his B.A. and M.A. in painting. He lives today in Washington, D.C., and is one of America's most honored painters. He began his career in the 1960s, during the waning years of Abstract Expressionism and the high years of Pop Art, and continues today as an active artist.

Gilliam has continually explored the boundary between painting and sculpture and is actually best known for his "drape" paintings: unprimed canvas, painted but not stretched on a frame, hung on the wall or from the ceiling. In the 1990s he began to explore more rigid formats, as in *Reds, Towering Stack*. The work incorporates the flat and the sculptural, the painterly and the geometric, shiny surfaces and rough surfaces; in other words, it crosses boundaries and defies definition at many levels.

JRC

ROBERT GORDY, 1933–1986
The Wall, c. 1982
Serigraph on paper, 29/75, 24" x 47½"
83.79 Museum Purchase

Robert Gordy was born on Jefferson Island and was raised in New Iberia,
Louisiana. He completed undergraduate and graduate work in visual art at
Louisiana State University and continued his education at Yale. He also
studied with Hans Hofmann in Provincetown, Massachusetts. Before Gordy
died in 1986, he exhibited throughout the United States. His work had
been acquired by the Whitney Museum of American Art, the Corcoran
Gallery, and the National Collection of Fine Arts.

Gordy continued the Western tradition of the female nude in art and was
inspired by both Henri Matisse and Paul Cézanne. He integrates his stylized
figures in decorative landscapes using flat, bright colors. This composition
with five anonymous figures placed in front of a wall uses a positive-
negative spatial balance to form an overall pattern.

John Winslow, b. 1938
In Marcella's Studio, 1982
Oil on canvas, 80" x 80"
84.16 Museum Purchase

Winslow is the son of portraitist Marcella Comes and was born in
Washington, D.C. He enrolled in Princeton University in 1960 but did
not study art. He earned undergraduate and graduate degrees in visual art
at Yale University. Winslow has taught at Yale and at Catholic University
in Washington, D.C.

 In Marcella's Studio is both a self-portrait of the artist and a portrait of
his mother's studio. Working in the realism that resurfaced in the 1970s,
Winslow uses a painterly style and presents the facts of the scene
dispassionately. He has said of this painting, "It has to do with the press
and release of a planar space about the human figure, something I have
been investigating in my paintings for many years."[16] The artist, in his
tee shirt and shorts, stands before his easel, brush in hand, and examines
the viewer as if the viewer were the subject of the work in progress. The
interior is filled with many objects that may represent artists in general
and his mother in particular.

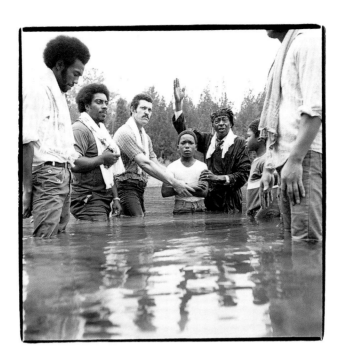

BIRNEY IMES III, b. 1951
Baptism, Crawford, Mississippi, 1983
Gelatin silver photograph, 9½" x 9½"
84.22 Gift of the artist

Mississippi photographer Birney Imes has been inspired by the people and the
places of the Mississippi Delta throughout his career. Imes received a degree in
history in 1973 from the University of Tennessee and shortly thereafter set about
teaching himself the art and craft of photography. He has documented the
religious events, the juke joints, the people and the buildings of the Delta,
focusing mainly on the African-American residents.

Baptism, Crawford, Mississippi is an image of a traditional outdoor baptism in
which a young man is about to be fully immersed in a local body of water. One
might be tempted to read this photograph as a strictly documentary image, but
the structure of the image refutes this interpretation. The water comes up so
close to the lens that the photographer is clearly in the water with these people;
they have come to know and trust him enough to allow him to participate in an
important religious event. Furthermore, the photo is printed beyond the edges
of the image; along the left-hand border the word "KODAK" and other lettering
are visible. This calls attention to the medium and the act of printing, marking
the presence of the photographer and reminding the viewer that this image is
not simply a window into another world, but a mediated act of representation.

JRC

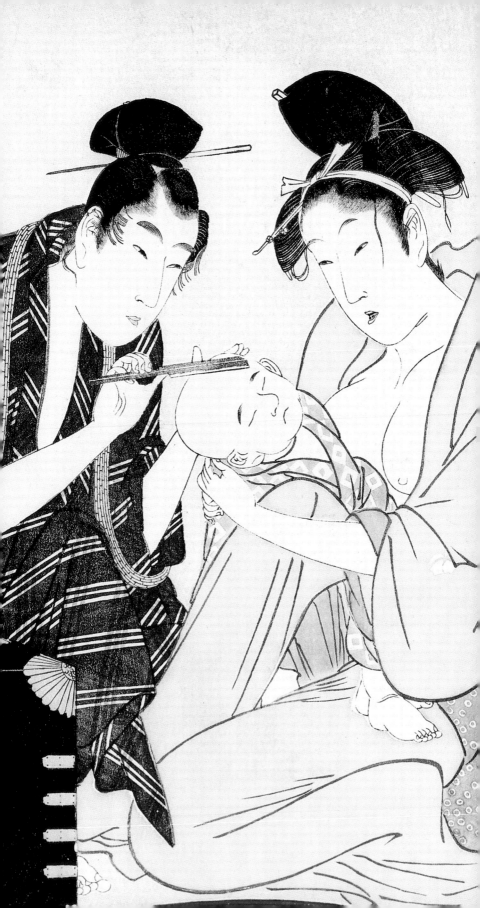

JAPANESE
WOODBLOCK
PRINTS

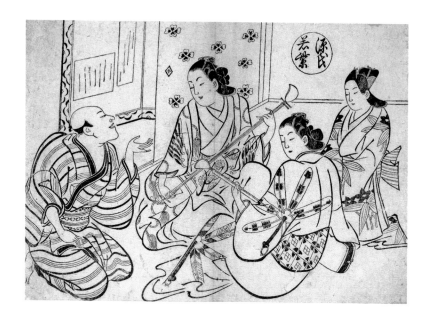

OKUMURA MASANOBU, 1751–1781
Genji: Waka Murasaki
Series: Ukiyo-e Genji, c. 1710
Publisher: No imprint.
Oban 10¼" x 14" Sumizuri-é
JP 45 Gift of W. B. Rogers

Masanobu lived in Edo and was a painter, printmaker, and publisher.
Although he was largely self-taught, he was an innovator who influenced
the entire *Ukiyo-e* school. He may have been the first to change from
hand coloring to color printing after the process was invented in 1741.
He set the fashion for *bijin-ga*, single-sheet portraits of famous beautiful
women rendered with great elegance.

 The subject of this print is a *metate-yé*, or transformed version, of
the classic tale "Young Violet," by Lady Murasaki from her book, *Genji
Monagatari*, written in the eleventh century. The print shows a *taikomochi*
(professional buffoon) singing while two of the women accompany him on
samisen. The buffoon is singing a travesty of the song "The Temple of
Toyora," which relates the story of how Genji saw Murasaki, the daughter
of Prince Hyobukyo, at a temple on Mount Kurama. This chance meeting
eventually led Genji to take Murasaki to Kyòto, where he brought her up
as his ward and later married her as his second wife.

 This very early print in black and white sets the stage for the progression
through hand coloring (*beni-é*) to the full-color printing process, which
culminated in 1764 and used separate woodblocks for each color.

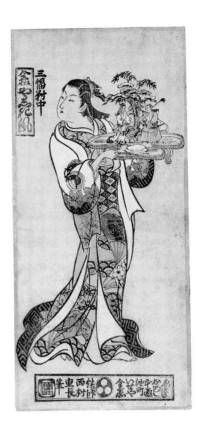

NISHIMURA SHIGENAGA,
1697?–1756
A Woman Bearing a Shimadai,
c. 1730
Publisher: Ise-Ya
Hosoban 12⅝" x 6" Urushi-é
JP 47 Gift of W. B. Rogers

Masanobu was one of the first artists to use bird's-eye views and to depict partly nude figures. He also was one of the first of the *Ukiyo-e* artists to produce triptychs. His best-known student was Harunobu. Shigenaga forms a bridge between the primitive *sumizuri-é*, the *benizuri-e*, and the full-color period, initiated by Harunobu in 1764.

The shimadai is an ornamental stand used on formal occasions such as weddings. The one in this print bears a dwarf pine and a bamboo branch, emblems of longevity. The two dolls, which represent Jo and Uba, the spirits of the pine trees, are emblematic of connubial bliss. They flank the pine tree to show that it is for a wedding.

ISHIKAWA TOYONOBU, 1711–1785
A *Wakashu*, 1745
Publisher: Urokogata-ya
Hashira-é 28" x 6" Benizuri-é
JP 84 Gift of W. B. Rogers

The identity of this artist is the subject
of dispute, since he used many names,
including Toyonobu, whose style was
elegant, and Shigenobu, who used
the Torii style, which provided for
elongated bodies and small heads.
One theory states that Shigenobu
never existed and was simply a name
created by a publishing house as a
signature for prints like those made by
Masanobu. Toyonobu's subjects included
lovers, *bijin-ga*, and marionette players.
He is considered a master of design for
hashira-é and displayed remarkable
technical skill.

Wakashu means "comely young man
of fashion." The one depicted in this
hashira-é print carries a parasol made
of oiled paper and a collapsible Ōdawara
lantern (so called because it was
manufactured in the city of Ōdawara).
Note the extremely high *geta* (clogs),
which were fashionable at this time.
The asymmetrical composition makes
full use of the pictorial space, as is
characteristic of Toyonobu's work.

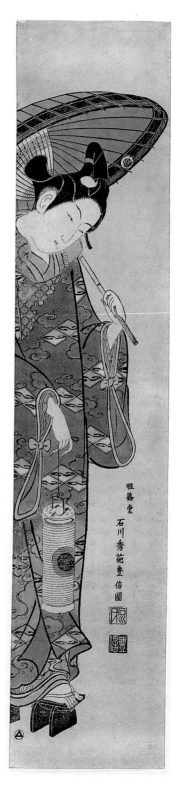

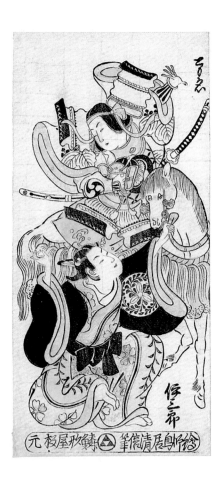

Torii Kiyomasu II, 1706–1763
Scene from a Drama, c. 1730
Publisher: Urokogata-ya
Hosoban 12⅝" x 6" Urushi-é
JP 78 Gift of W. B. Rogers

The generally accepted theory about Kiyomasu II is that he and Kiyonobu II are the same person: a son of Kiyonobu, who on his father's death in 1729, assumed his father's name. Numerous prints primarily of actors and theatrical scenes bear both names, and all were produced between 1728 and 1752.

The actor Ogino Isaburō (1694–1748) is shown as a young man seated on the ground, holding the bridle of a horse upon which the famous woman warrior Tora-gozer, impersonated by Ogino Sawamosuko, is riding.

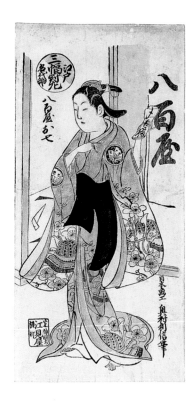

OKUMURA TOSHINOBU,
active 1717–1750
Sanjo Kantaro II as "O Shichi," c. 1738
Series: Edo Nadai-hime
Publisher: Emi-Ya of Yoko-Cho
Hosoban 12³/₈" x 6" Urushi-é
JP 54 Gift of W. B. Rogers

The pupil of Okomura Masanobu and perhaps his adopted son, Toshinobu specialized in *bijin-ga*, beautiful women of great charm. His prints were usually colored by hand (*beni-é*), incorporated glue in the pigments for a lustrous finish, and were often sprinkled with metallic dust to make what is termed a lacquer print (*urushi-é*).

O Shichi was the daughter of a grocer whose store and house were burned in one of the many and frequent fires that devastated Edo. She was sheltered in a temple and fell in love with Kichisaburō, one of the temple pages. After her home had been rebuilt, she was so eager to return to her love that she set a fire to burn down the house again and inadvertently caused another conflagration of Edo. When it was discovered that she had started the blaze, she was executed.

This print is part of the series "Edo Nadai-Hime" ("Famous Young Ladies of Edo"), which by implication means "actors of women's roles in the Kabuki Theater." The series is a set of three; this print is the sheet on the left.

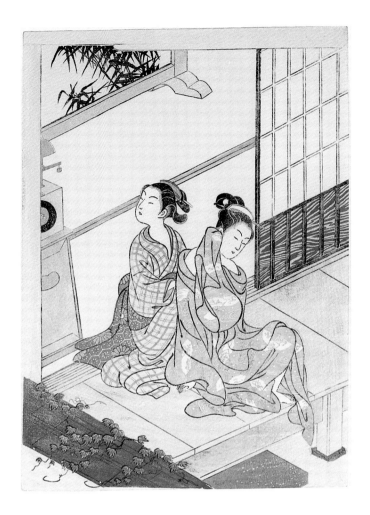

Suzuki Harunobu, 1724–1770
The Evening Bell of the Clock, 1765
Series: Eight Parlor Views (impression of second edition)
Publisher: Shokakudō
Chūban 11³/₈" x 8¹/₄" Benizuri-é
JP 100 Gift of W. B. Rogers

Harunobu began his career as an artist who printed actors' portraits, but in 1765, taking full advantage of the newly invented technique of polychrome printing, he began issuing full-color prints of the courtesans of Edo. He published more than 500 prints during the remaining five years of his life. Harunobu was one of the most influential members of the *Ukiyo-e* school.

In this print, a maid, seated upon an *engawa* (veranda), massages the back of her young mistress, who is wearing a bathing robe. The maid turns to listen to the striking of the clock, which is visible on the left in the open room behind the two figures.

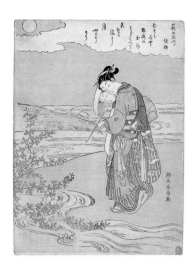

Suzuki Harunobu, 1724–1770
Hagi no Tamagawa, 1768
Series: Six Tama Rivers
Publisher: No imprint
Chūban 11" x 8³/₈" Benizuri-é
JP 48 Gift of W. B. Rogers

The Noji Tama River is celebrated for the *hagi* (bush clover) that grows on its banks. Two young women stand by the river with their arms around each other. They are looking down at a hagi bush that has one of its branches dipping into the water. The woman in the foreground is gesturing toward the branch with her long, slender pipe. Through a rift in a cloud above, the full moon is visible. On the cloud is inscribed a famous ode by Toshiyori:

Tomorrow I shall come again
To the Noji Tama River
Where o'er the hagi flowers
In a ripple of colors
The moon doth stay. [17]

In his search for original pictorial themes, Harunobu often sought to recreate the classical lyricism of the *waka* (31-syllable Japanese poem) in Edo urban culture.

The six Tama Rivers were each located in a different province. They shared the name *tama*, which means "crystal," for their supposed limpidity. Each river had an associated poem and secondary attributes, which are usually present in the prints to identify the river. The rivers and their attributes are: (1) Kinuta or Toi (autumn pines and mallets for pulling cloth); (2) Noji (moonlight and hagi); (3) Ide (a yellow rose); (4) Chobu (bleaching cloth); (5) Noda (salt maidens and plovers); (6) Koya (Koya temple or waterfall with pilgrims).

Suzuki Harunobu, 1724–1770
Chrysanthemums and Autumn Full Moon, 1764/65
Publisher: No imprint
Chūban 11¼" x 8½" Benizuri-é
JP 49 Gift of W. B. Rogers

Dwarf chrysanthemums are growing in a large blue and white jardinière. A gray cloud with the disc of the full moon rising above it forms the almost abstract background. The background contrasts sharply with the intricate pattern of the flowers and porcelain pot. Note that the feet of the jardinière are *shishi* dogs, the traditional guardian figures found on the entablature of Japanese architecture. The parallel in Western architecture would be the gargoyles on cathedrals.

The brilliant color combinations of the new full-color prints recalled the Chinese Sung-chiang brocades, which were being imported to Japan during this period. The new *Ukiyo-e* prints were introduced as "brocade" pictures.

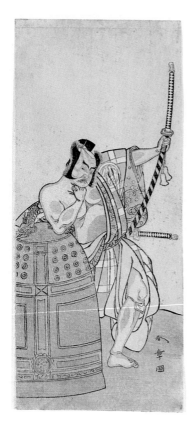

KATSUKAWA SHUNSHŌ, 1726–1792
The Actor, Nakamura Sukegoro II,
as a Samurai, c. 1774
Publisher: No imprint
Hosoban 12½ " x 5⅝"
JP 4 Gift of W. B. Rogers

Shunshō taught many students (all the artists with "Shun" in their names—
Hokusai changed his later—are usually grouped as the Katsukawa school),
including Hokusai. He abandoned a career as a painter, began designing
color prints, and became one of the great *Ukiyo-e* print designers. His
greatest contributions were his actor prints, which are among the finest of
his day. He was a prolific artist and maintained high standards in all of his
work.

In this print, the actor Sukegoro II portrays a samurai (the specific role
has not been identified) standing beside and leaning upon a huge temple
bell that sits upon the ground. He holds his sheathed sword in his raised
left hand and is prepared for a fight: his kimono is caught in his waistband
to give him greater ease of movement. Another indication of impending
conflict is that he has dropped his kimono from his right shoulder, leaving
the upper part of his torso bare.

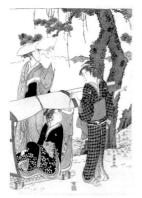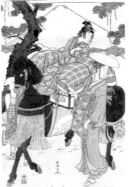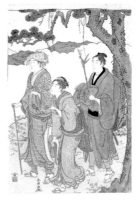

KATSUKAWA SHUNCHŌ, active 1780–1795
Returning from an Outing in the Hakone District, 1788
Publisher: Nishimura Yohachi
Triptych, each print 14½" x 9¾" Benizuri-é
JP 55 Gift of W. B. Rogers

Originally a student of Katsukawa Shunshō, Shunchō is said to have
quarreled with his teacher and to have changed the spelling of his *gō* (the
pseudonym used by artists). In about 1790, he was influenced by Utamaro
and specialized first in actor prints and then in prints showing *bijin-ga*
(beautiful women) composed with a subtle sense of light and color.
Shunchō was known for producing well-composed diptychs and triptychs.

This triptych shows a young girl in the middle sheet riding upon a horse
that bears most of the luggage of a group leaving for a holiday excursion.
The horse is led by a bare-headed groom. Two women following in the
right sheet are talking to the women ahead of them. A male servant at the
end of the procession on the far right carries a piece of lighted firerope
attached to a bamboo branch for the convenience of the smokers. On his
back is a green box, and against his chest is a package tied in a red *furoshiki*
(wrapping cloth). Both hang from a cord across his shoulder. On the left
sheet, a woman flanked by two other women is shown seated in a *kago*
(portable chair) that rests on the ground. The woman on the far side of the
kago shades her eyes with her fan as she looks at the advancing group. The
woman in the foreground holds a pipe in her right hand. The road is
perhaps the Tōkaidō and is bordered by ancient pine trees. Mount Fuji rises
in the distance above a bank of low-lying clouds.

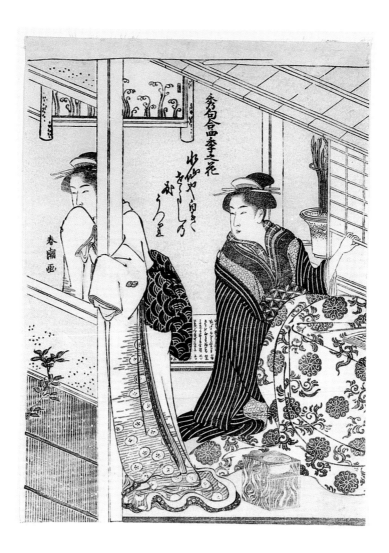

KATSUKAWA SHUNCHŌ, active 1780–1795
Narcissus, c. 1790
Series: Prize Poems on the Flowers of the Four Seasons
Publisher: No imprint
Chuban 10" x 7³/8" Bene-girai
JP 14 Gift of W. B. Rogers

This print was originally printed in gray, black, pale violet, and pale yellow.
The violet color has faded to white. The artist titled this print, and the
viewer can see a partly hidden pot of narcissus behind a *shōji* (screen) at
the upper right. A woman on the right is seated by a *kotatsu* (covered pine
box), and another woman stands looking out into the garden. She covers
her mouth with the sleeve of her kimono, and her expression indicates that
she sees something unusual in the garden.

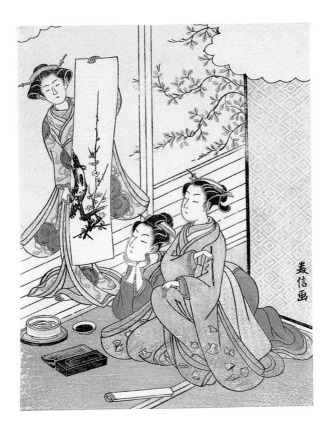

YAMAMOTO YOSHINOBU, active 1745–1758
Examining the Painting, c. 1755
Publisher: No imprint
Chuban 9¾" x 7¾" Benizuri-é
JP 81 Gift of W. B. Rogers

Little is known about Yoshinobu's life except that he was possibly a student of Nishimura Shigenaga. He produced *benizuri-é* (multi-color prints) and illustrated various books.

 In this print, a particularly fine example of his work, a young woman who has just completed an ink drawing of a flowering plum branch is seated on the floor of a parlor. Another girl is reclining on the floor, with her hands supporting her chin, and a third is holding up the drawing for their inspection. On the floor before them are the ink stone and brushes, a saucer containing some of the black ink, a bowl of water, and a roll of paper. The artist, who is still holding her brush, and her friend are looking at the drawing with critical expressions on their faces that contrast greatly with the expression on the face of the woman holding the drawing. The branches of the tree in the right background have embossed white flowers that are extremely subtle and difficult to see.

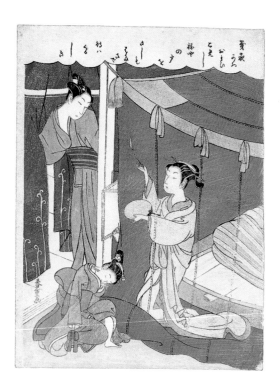

SHIBA KŌKAN, 1747–1818
Who Comes?, 1770
Chūban 11¼" x 8½" Benizuri-é
JP 80 Gift of W. B. Rogers

Kōkan, known earlier in his life as Harushige, was born in Edo and studied under Harunobu. In 1783, he became the first Japanese artist to try copperplate engraving. The title of his engraving is *View of Mimeguri*. He was restless by nature and believed that his native culture was artistically exhausted. Kōkan became interested in Western art, on which he wrote an essay, the first such article in Japan, pronouncing it superior to Chinese and Japanese art because it depicted light and shade. When he was using the *Ukiyo-e gō* (artist's pseudonym) of Harushige during the period 1769–1775, he skillfully imitated Harunobu's style, adding the master's name to his own after the master's death. The forged works were accepted as genuine by his contemporaries. This print is one of the few he issued during this time and is signed Harushige. It is considered one of his finest prints.

A woman kneeling beside her bed, under a *kaya* (mosquito net canopy), holds up a lighted taper to see who has lifted the portière and is entering the room. Her *kamuro* (female attendant) is seated outside the kaya and has fallen asleep with her head bent forward and resting upon her hand. The intruder is male, as indicated by his hairstyle, and may be her lover. The border at the top in the design of a conventional cloud contains a lyric poem.

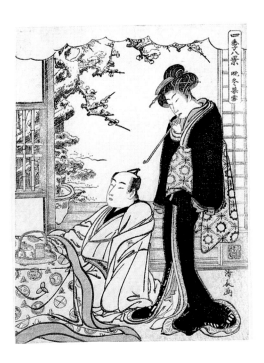

TORII KIYONAGA, 1752–1815
Evening Snow in Late Winter, c. 1778
Series: Eight Views of the Four Seasons
Publisher: Nishimura-ya Yohachi
Chūban 9³/₄" x 8¹/₂" Benizuri-é
JP 11 Gift of W. B. Rogers

Kiyonaga was born in Uraga, the son of a publisher and bookseller. He moved to Edo in 1765 and became the pupil of Torii Kiyomitsu. He was adopted into the Torii family upon the death of his teacher and inherited the Torii estate. He was the last master of the Torii school and, during 1778–1788, the great *Ukiyo-e* master and a major influence upon all of the artists during the final fifteen years of the eighteenth century. Kiyonaga was a prolific artist. His prints depict the late eighteenth-century teahouses, shops, and streets of Edo, with the *bijin*, stylish young men, and actors with their musicians and chanters. Kiyonaga's style is graceful with carefully rendered details.

In this print, a woman attired in a rich black kimono and dull yellow *obi* (sash) with a diaper pattern in black and pink stands beside a man who sits by a *kotatsu* (covered firebox) with his legs under a *futon* (quilt). Visible through the open *shoji* (screen) in the background is a snow-laden plum tree. Beside it, on the *engawa* (veranda), is a potted pine tree, also snow laden. Note the details of the woman's pipe smoking and the tea tray on the firebox. The design of a conventional cloud has a top border in which a poem could be written.

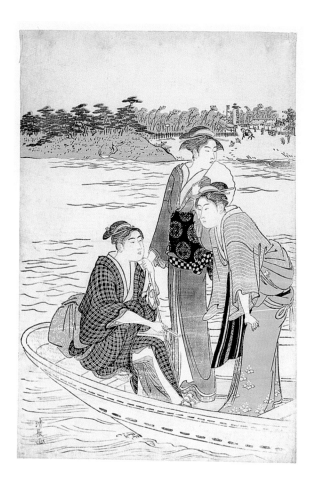

Torii Kiyonaga, 1752–1815
The Hashiba Ferry Boat Crossing the Sumida River, c. 1784
Publisher: No imprint
Oban 15" x 10" (Lefthand sheet of a triptych) Benizuri-é
JP 12 Gift of W. B. Rogers

Kiyonaga designed two triptychs on this subject, and this print is from
the earlier one. There are three women in the stern of the boat, one
seated and two standing. The seated woman has assumed a relaxed
position, with her right foot propped on the seat while she smokes her
pipe. In the background is the shoreline, which is busy with activity.
Two *kago* (portable chairs) rest on the ground to the right, and a laden
horse stands waiting patiently while small figures move around the area.

 This print visually describes the attire of women quite different from
the *tayu* (courtesan) or the affluent women of urban Edo. The kimonos
shown here are not as elaborate and lack the complicated *obi* (sash). The
high *geta* (clogs) worn by tayu and fashionable young men are not part of
the wardrobes of these women.

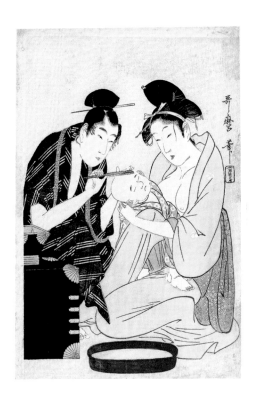

KITAGAWA UTAMARO, 1754–1806
Shaving His Head, c. 1798
Publisher: Omi-ya
Oban 15 3/8" x 10 1/4" Beni-é
JP 23 Gift of W. B. Rogers

Utamaro lived and worked in Edo. He was the student of Toriyama
Sekien (and may have been his son) and was influenced by Masanobu
and Kiyonaga. Little is known of Utamaro's life other than that he was
arrested and imprisoned in 1804 by the shogunate for publishing a triptych
that violated a government prohibition. He was one of the first Japanese
artists to be known in Europe, and his work had considerable influence on
Western artists such as Henri Toulouse-Lautrec.

Utamaro is best known for his mature work, which depicts the lives of
women (*bijin*) both in the home and in the licensed quarter of Edo. His
style, characterized by bright and clear colors, is elegant. His women have
tall and graceful figures and small facial features. Utamaro designed many
okubi-e (bust portraits), and his work dominated the print world for a
generation.

This print shows a seated bare-breasted woman holding her infant son.
She has finished nursing and he has fallen asleep. The father shaves the
boy's head. A pan of water for rinsing the razor sits in the foreground.

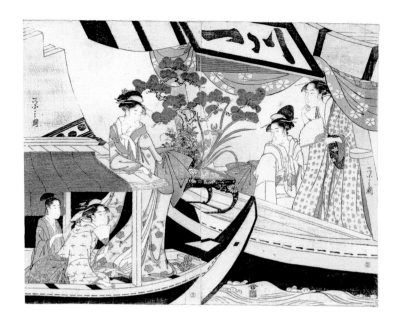

HOSODA EISHI, 1756–1829
Boating Parties on the Sumida River in Summer, c. 1792
Publisher: No imprint
Oban diptych 14½" x 19" Beni-girai
JP 21 Gift of W. B. Rogers

The pleasure barge *Ichikawa* displays an elaborate flower arrangement of lilies, iris, and a dwarf pine tree placed on a lacquer stand. One woman is seated while a second woman holding a pipe greets two women and a young man in another boat that has pulled up alongside the barge. This diptych is two sheets of a pentaptych (five panels). The small red seal is that of a Parisian dealer, Tadamasa Hayashi

In about 1790, Eishi began using the restricted colors of the *beni-girai* (color prints using only pale pastel tints) with great success.

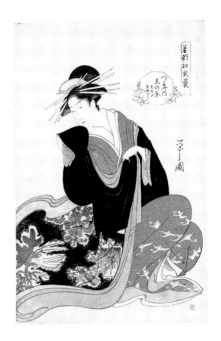

HOSODA EISHI, 1756–1829
The Tayu, Shinowara, c. 1793
Series: The First New Dress
of the Year
Publisher: No imprint
Oban 14½" x 9½"
Beni-girai
JP 18 Gift of W. B. Rogers

Eishi was born into a wealthy samurai family of the Fujuwara clan. He
studied with Kano Eisen and Torii Bunryusai and was appointed to high
court rank. He worked in the style of the Kano school until he was about
thirty years of age. During that period, he was granted the artist's name
of Eishi, which he retained after he changed to the *Ukiyo-e* style. His
prints specialized in *bijin-ga* of great refinement and even surpassed those
of Utamaro in elegance and elongation. He was always more of a painter
than a printmaker and abandoned the print medium completely about 1800.

The *tayu* (courtesan) Shinowara of the house of Tsuru-ya is seated in this
print, turning to the viewer's left. She is dressed in a green kimono with a
pattern of white herons in flight and wears a black *uchikake* (overdress) with
irregular white patches on the skirt. These white patches are the emblems
of the five festival days, of which three are shown: New Year's Day, the Doll
Festival (third day of the third month), and the Chrysanthemum Fête
(ninth day of the ninth month). Eishi frequently used a yellow background.

The series of twelve prints, of which this is one, depicted *tayu* wearing
their beautiful New Year apparel. For this reason, great attention was paid
to the minute details of each courtesan's attire. The small red seal is that of
the Parisian dealer, Tadamasa Hayashi.

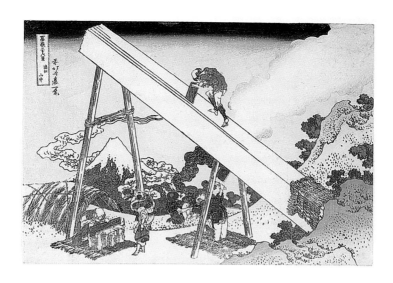

KATSUSHIKA HOKUSAI, 1760–1849
Totomi Sanchu, c. 1828–1833
Series: Thirty-Six Views of Fuji
Publisher: Nishimura-ya
Yoko-Obân 10" x 15" Aizuri-é
JP 72 Gift of W. B. Rogers

Hokusai was the adopted son of the mirror maker Nakajima Ise. He trained
as an engraver and was apparently the only artist of his time to learn how
to cut woodblocks for prints. During his lifetime, Hokusai used more than
fifty gō (artist's pseudonyms) and did not begin using the gō Hokusai until
1797. He began as an artist learning how to design actor prints from
Katsukawa Shunshō at age eighteen. During his long and prolific career,
he produced more than 30,000 prints, paintings, and drawings and taught
many students. Hokusai led an unsettled life. He changed his place of
residence frequently and was married twice. Hokusai was one of the great
draftsmen and worked in many styles, always being inventive and daring
in his compositions.

Mount Fuji is seen from the mountains in the province of Totomi in this
print from the series "Thirty-Six Views of Fuji." In the foreground, a huge
squared log is set up on trestles, and sawyers cut it into planks. On the
ground below a woman carrying an infant upon her back watches a man
file a saw. Farther back, another man is seated beside a fire from which a
great cloud of smoke arises and drifts away to the right. At the left is the
woodsmen's low thatch-roofed shelter.

The series "Thirty-Six Views of Fuji," to which this print belongs,
represents the epitome of Hokusai's mature style and is considered one
of his masterpieces.

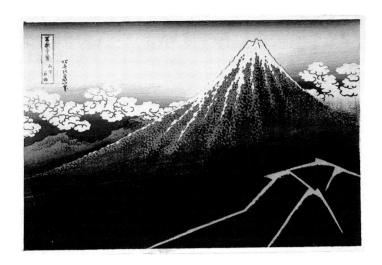

KATSUSHIKA HOKUSAI, 1760–1849
Yamashita Haku-u, c. 1828–1833
Series: Thirty-Six Views of Fuji
Publisher: Eijudo
Yoko-Obân 9³⁄₈" x 15" (Originally 10" x 15") Aizuri-é
JP 29 Gift of W. B. Rogers

This print from Hokusai's famous series "Thirty-Six Views of Fuji"
depicts a thunderstorm below the summit of the "peerless mountain."
The mountain was an integral part of the lives of the Japanese, who
carry on their mundane tasks in the shadow of its symmetrical beauty.
 The title "Thirty-Six Views of Fuji" notwithstanding, the series
encompasses forty-six prints. The last of the thirty-six prints carries
an inscription: "New edition. Thirty-six Fuji completed," presumably
indicating that there is a supplement of ten prints. The nickname of
this print is "Red Fuji."

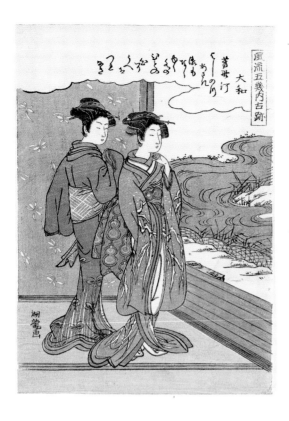

Isoda Koryūsai, active 1764–1788
The Yoshi River in the Province of Yamato, c. 1774–1775
Series: Stylish Views of Historic Places in the Go-Kinai
Publisher: No imprint
Chūban 10¹/₂" x 7¹/₂" Benizuri-é
JP 8 Gift of W. B. Rogers

Koryūsai was born a samurai in the service of the lord of Tsuchiya. He gave up his rank to become an *Ukiyo-e* artist and moved to Edo. He was apparently a student of Harunobu, who gave him the name of Koryūsai when he himself no longer used it. Koryūsai produced an enormous number of prints and book illustrations specializing in *bijin-ga* (beautiful women) and *kachō-ga* (flowers and birds) in the format of *hashira-é* (pillar prints). His work is characterized by a vivid orange color. It is believed that he devoted himself entirely to painting after 1780. He was granted the honorary rank of *hokkyō* in 1781.

 This print bears a fanciful title. Two young women are shown standing in a parlor looking out through the open *shoji* screen at the meandering Yoshi River. A conventional cloud border at the top of the print contains a poem. *Ukiyo-e* printmakers frequently inscribed lyric poems on their prints to complement the pictorial theme. "Go-Kinai" refers to the five provinces nearest the ancient capital of Japan.

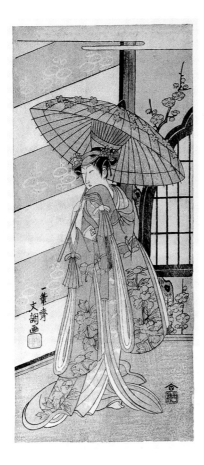

IPPITSUSAI BUNCHŌ,
active 1765–1792
*The Actor, Onoe Tamizō, as a
Young Woman,* c. 1770
Publisher: Nishimura-ya Yohachi
Hosoban 12½" x 6" Benizuri-é
JP 7 Gift of W. B. Rogers

Bunchō, a samurai who lived in Edo, first studied Kano painting and was
later influenced by Harunobu. He was a designer of *hosoban* and *chuban*
formats who specialized in *bijin-ga* (beautiful women) and actors. Bunchō
was an individualist with a style characterized by delicate line and subtle
color. In later life, his samurai friends persuaded him to abandon
printmaking.

This print depicts the actor Onoe Tamizō. He is holding an open parasol
decorated with plum blossoms and dressed in a *furisode* (long-sleeved
kimono) that is printed in a striking pattern of peonies and butterflies. It is
believed that the actor is performing the *shosa* (mimetic dance peculiar to
the theater) "Schichi Mai Kisho," as he did with Ichimura Uzaemon IX
during an interlude in the play *Fuji no Yuki Kaikei Soga* at the Ichimura
Theater in Edo in February 1770.

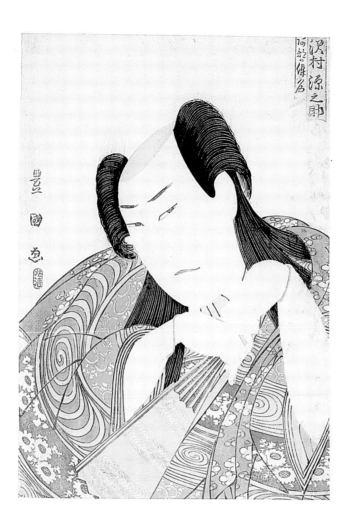

Utagawa Toyokuni, 1769–1825
The Actor Sawamura Gennosuke, c. 1800
Publisher: Maru-Sei
Oban 15" x 10" Benizuri-é
JP 26 Gift of W. B. Rogers

Toyokuni was the son of a sculptor of puppets and lived and worked in
Edo. An eclectic artist, he was influenced by almost all of the recognized
contemporary printmakers. He nevertheless developed many personal
mannerisms in his work. He is known for his prints of actors, whom he
depicted not only in their roles but also in private life. About 1805, his
work began to diminish in quality, but at his best, Toyokuni was a brilliant
draftsman and designer.

This *okubi-e* (bust portrait) shows the actor Sawamura Gennosuke in the
role of Abe no Yasuna. His fan has an embossed design, and the bright
yellow pattern of the kimono keeps the composition from becoming static.

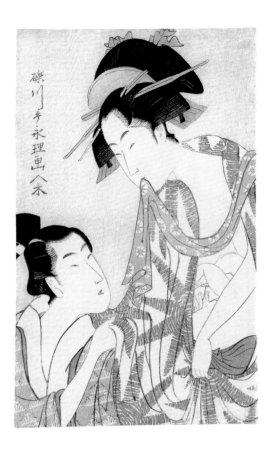

Rekisentei Eiri, active 1790–1800
A Love Missive Secretly Given, 1796
Publisher: Echigo-ya Chohachi
Oban 15" x 9¼" Bene-Girai
JP 70 Gift of W. B. Rogers

There is much confusion as to which artist created this print. Either there were three men using this particular *go* (artist's pseudonym) with different first names, or the same artist successively changed the first name of his *go* while retaining the Eiri. Using the name Rekisentei, which appears on this picture, Eiri produced charming prints of *bijin* (beautiful women) and portraits.

In this picture, a young man kneels by the side of a woman who has just come from a bath. He slips his hand beneath her *yukata* (bathrobe) to give her, unobserved by others, a folded love letter. Her yukata is of white cotton and has a pattern in light blue of long-pointed stars. She holds her robe together with her left hand and has between her teeth a towel, one end of which is flung over her shoulder.

It is noteworthy that the dealer from whom Mr. Rogers purchased this print, Frederick W. Gookin, had himself bought it from Frank Lloyd Wright, the noted American architect.

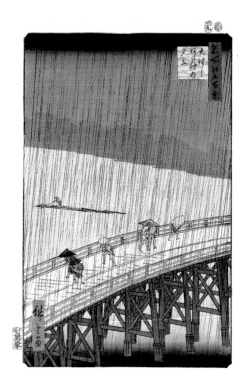

ICHIRYŪSAI HIROSHIGE, 1797–1858
A *Sudden Shower at the Great Bridge*, October 1857
Series: Famous Places in Edo: One Hundred Views
Publisher: Uo-ya Eikichi
Oban 13½" x 8½"
JP 41 Gift of W. B. Rogers

The son of an official of the fire department assigned to Edo Castle,
Hiroshige was a student of Utagawa Toyohiro and studied *nanga* painting
under Ooka Umpo. Hiroshige was also interested in Western art. He gave
his hereditary position in the fire department to his son so that he himself
would be free to pursue his career as an artist. He took the name Hiroshige
in 1812, and the two *gō* (artist's pseudonyms) he used most frequently were
Utagawa Hiroshige, the name signed to this series, and Ichiryūsai Hiroshige.
He traveled frequently and realistically depicted Japanese life and topography.
Hiroshige had an enormous production of more than 8,000 single sheets,
prints in series, paintings, and drawings. His style displays technical virtuosity
and a naturalistic viewpoint.

This print is from the last series Hiroshige produced, which contains at
least a dozen of his masterpieces. It is characterized by vivid colors and is in
excellent condition. It attests to Hiroshige's ability to continue to draw fresh
inspiration from scenes he had portrayed very often. He designed more than
1,200 prints of Edo alone.

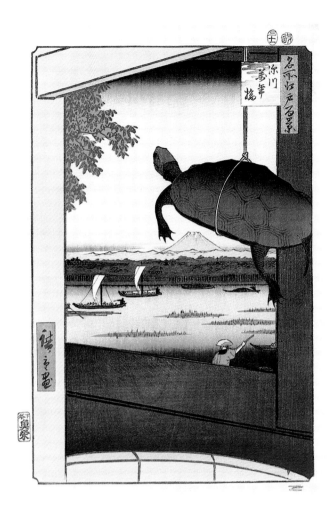

ICHIRYŪSAI HIROSHIGE, 1797–1858
View from the Mannen (10,000 Years) Bridge,
11th month of the Snake Year, 1857
Series: Famous Places in Edo: One Hundred Views
Publisher: Uo-ya Eikichi
Oban 13½" x 8¾"
JP 118 Gift of W. B. Rogers

This print, produced at the end of Hiroshige's life, shows the influence of
Western art. To give an illusion of depth, he has placed a prominent object
in the foreground. A mammoth turtle is suspended by a rope from one of the
timbers of the Mannen Bridge. Hiroshige used such visual devices in many
of his final prints. They were frequently a way of giving interest to an
otherwise dull scene.

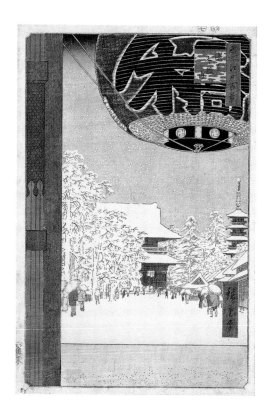

ICHIRYŪSAI HIROSHIGE,
1797–1858
*Kinryûzan Temple
at Asakusa
(Asakusa Kinryûzan)*, 1857
Series: One Hundred
Famous Views of Edo,
view 99 (Meisho Edo
hyakkei)
Ink and color on paper,
14½" x 9½"
Seal of publisher: Uoei
(Eikichi)
Censorship seal: Aratame
Date seal: Hebi-7
(seventh month of 1857)
Signature: Hiroshige ga
JP 94
Gift of W. B. Rogers

Published between 1856 and 1859, *One Hundred Famous Views of Edo* by
Ichiryūsai Hiroshige is considered to be one of this artist's finest achievements.
The series comprises 118 prints which highlight Hiroshige's mastery of bold
compositional devices, varying climatic effects, and intimate, personal scenes.
Shortly after completion of the work for this series, Hiroshige died in the
cholera epidemic of 1858.

This particular print shows the Kinryûzan, a popular Buddhist temple also
known as the Sensô-ji, situated in the northern part of Edo (modern Tôkyô)
near the great pleasure district of the Yoshiwara. The temple houses a famous
image of Kannon, the Buddhist deity of mercy, and is a popular pilgrimage
site for believers even today. Hiroshige shows the temple in mid-winter,
with thick, heavy snowflakes slowly falling, enveloping the temple in a
cold stillness. A huge paper lantern is suspended over the viewer from the
Kaminarimon, or Thunder Gate, looking into the central compound of the
temple. The large character on the lantern reads *hashi* and is thought to be
part of the place name *Shinbashi*, an area of Tôkyô in which perhaps the
donors of the lantern lived. A number of people scurry through the temple
under the darkening sky in the chill winter air, huddled under umbrellas to
protect them from the falling snow.

DAW

ICHIRYŪSAI HIROSHIGE,
1797–1858
*New Year's Eve
Foxfires, at Nettle
Tree, Ôji (Ôji,
Shôzoku-enoki,
omisoka no kitsune-bi)*,
1857
Series: One Hundred
Famous Views of Edo,
view 118 (Meisho Edo
hyakkei)
Ink and color on
paper, 13³/₄" x 9⁵/₈"
Seal of publisher:
Uoei (Eikichi)
Date seal: Hebi-9
(9th month of 1857)
Signature: Hiroshige ga
JP 97
Gift of W. B. Rogers

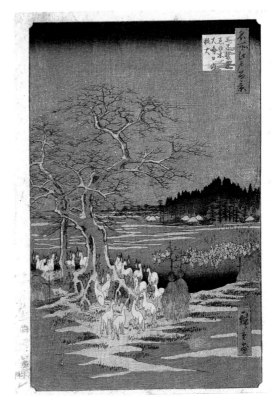

In Japanese folklore the fox is considered to be a most mischievous animal.
The wily fox is thought to have the ability to change form, usually into that
of a beautiful woman, playing tricks and pranks on unlucky people. Foxes
are also believed to be able to breathe fire and to make fire by rubbing their
tails together. Legends abound in Japan of men, oftentimes priests, who
wander through mist-filled moors late at night, and see a distant flicker of
flame and think it is a lone hut that will provide a welcome refuge from the
cold and dark. In truth, the flame is that produced by the fox to lure the
hapless wayfarer to mischief or worse.

 In this print, Hiroshige depicts a popular legend in which foxes gather
on New Year's Eve beneath the Nettle trees in Ôji, northern Edo (modern
Tôkyô). Ôji is the site of a famous shrine, dedicated to Inari Daimyôjin,
the Shintô god of rice. Inari is one of the most popular Shintô deities, and
shrines dedicated to him are always guarded by statues of foxes, who are
believed to be the messenger of this particular god.

 The print survives in two states. The first shows the landscape in shades of
gray, black, and blue with orange foxes and flames. In the second state, the
landscape is black and blue, while the foxes are white and the flames black.

DAW

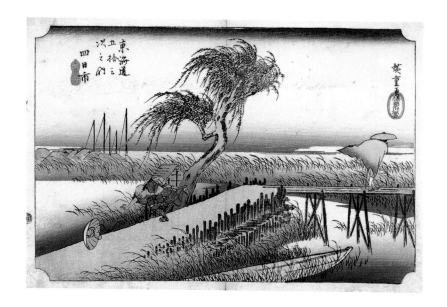

ICHIRYŪSAI HIROSHIGE, 1797–1858
The Mie River near Yokkaichi (Yokkaichi Miegawa), c. 1834
Series: Fifty-Three Stations of the Tôkaidô, station 44 (Tôkaidô
gojûsantsugi no uchi)
Ink and color on paper, 9⅝" x 14⅜"
Seal of publisher: Hoeidô (Takenouchi)
Signature: Hiroshige ga
JP 33 Gift of W. B. Rogers

When the *Fifty-Three Stations of the Tôkaidô* series of prints first appeared in
1834, it instantly rocketed the print artist Ichiryūsai Hiroshige to stardom.
The popularity of this series was so great that it quickly ran through several
editions and was copied by numerous artists. *The Mie River near Yokkaichi* is
considered one of the masterpieces of this series.

Yokkaichi is a port city on the Mie River in present day Mie prefecture.
Founded around a castle built in 1470, the city quickly developed into an
important trade center with markets on the fourth day of each month; *Yokka*
means "fourth day of the month" and *Ichi* means "market."

Hiroshige is at his best depicting man struggling against inclement weather.
Here, in a wind squall, a man chases vainly after his tumbling hat, which is
blown down a pathway at an oblique angle out of the picture. Counterbalanced
by the horizontal of the bridge on which a man with a billowing cape struggles
against the headwind, the composition of this blustery scene is masterful. In
first editions such as this, the billowing cloak of the gentleman to the right
is shaded in color.

DAW

ICHIRYŪSAI HIROSHIGE, 1797–1858
Night Snow at Kambara (Kambara yoru no yuki), 1834
Series: Fifty-Three Stations of the Tôkaidô, station 16 (Tôkaidô
gojûsantsugi no uchi)
Ink and color on paper, 9" x 13⅞"
Seal of publisher: Hoeidô (Takenouchi)
Signature: Hiroshige ga
JP 139 Gift of W. B. Rogers

Kambara is considered the star among the *Fifty-Three Stations of the Tôkaidô*
series and perhaps Hiroshige's greatest work. In this masterpiece, he depicts
the village of Kambara on a cold winter night with the hills, trees, and
houses covered by a heavy blanket of snow. Strong diagonals focus the eye
on the village at the center of the composition, which is outlined by the
snow-laden mountains and trees to the left and right. The stark contrast of
the gradations of gray in the sky heightens the sense of the snowy silence
that shrouds the scene. It is interesting to note that in actuality it rarely
snows in Kambara. Over the years, scholars have tried in vain to locate the
exact point in Kambara that inspired this print; this superb work appears to
be the product of Hiroshige's inspired genius.

 This print survives in two states. In the early impression, the sky is
darkest at the top, fading out to a pale gray above the mountain and
rooftops. In the later impression, the gradation of the sky is reversed, with
the darkest areas shown at the horizon, then shading to gray at the top of
the print. Minor variations in small details also exist between the earlier
and the later states. Given the number of later impressions that survive, it
appears that this was the more popular of the two states.

DAW

ICHIRYŪSAI HIROSHIGE, 1797–1858
Evening Snow on Mount Hira (Hira no Bosetsu), c. 1835
Series: Eight Views of Lake Biwa, view 1 (Ōmi hakkei)
Ink and color on paper, 10" x 14⅞"
Seal of publisher: Kawashō (Kawaguchi Shōzō)
Signature: Hiroshige ga
JP 87 Gift of W. B. Rogers

The "Eight Views" originally referred to eight views of the Xiao and Xiang rivers in central China renowned for their beauty. A scenic area long celebrated in art and poetry, these views were adopted and adapted by the Japanese to depict the eight most famous views in and around Lake Biwa in Ōmi province (modern Shiga prefecture). The subject for the eight views is the same whether in China or Japan:

1) Snow	5) Boats returning at evening
2) Evening rain	6) Geese flying to rest
3) Autumn moon	7) Sunset
4) Vesper bells	8) Clearing weather after rain

Situated to the west of Lake Biwa near the city of Ōtsu, Mount Hira was an important landmark along the great Tōkaidō highway that connected the capital city of Edo (modern Tōkyō) with the ancient capital of Kyōto. Laurence Binyon translated the poem in the cartouche to the upper left of this print as follows:

He who would see the beauty of the evening on the peaks of Hira,
Must behold it after the snows have fallen,
And before the flowers are fully blown.

The earliest impressions of this print have embossed bamboo groves that are heavily laden with snow between the village and the foothills of Mount Hira. Most impressions of this print, however, have areas of gray inserted between the foothills, making the separation between the foothills and the mountain more distinct. Even later editions have added areas of green and brown colors to the composition.

DAW

ICHIRYŪSAI HIROSHIGE, 1797–1858
The Snow Gorge of the Fuji River,
c. 1840
Publisher: No imprint
Kakemono-e 28³/4" x 9¹/2" Aizuri-é
JP 85 Gift of W. B. Rogers

On the river are two heavy barges
designed for shooting the rapid in
its course from the mountains to the
sea. These boats were hauled back
to the starting point high in the
mountains by towlines pulled by the
boatmen, who slowly toil upward
along the riverbank. They usually
stay close to the river's edge, but
when the footing by the water is
poor, they must work the towlines
from high above the river.

This print is in excellent condition. This artist, more than most of the
Ukiyo-e designers, had to rely on his printers' and publishers' concern with
producing high-quality prints. Because his work was immensely popular,
many of his prints were reprinted too often, using inferior pigments, and
the blocks became worn.

EISHOSAI CHŌKI, active late 18th
and early 19th centuries
*The Courtesan Otowaji of
Nakamanji-ya*, c. 1794
Publisher: Tsuta-ya Jūzaburō
Oban 14³/8" x 9¹/2" Benizuri-é
JP 76 Gift of W. B. Rogers

Chōki used two names, Eishosai Chōki and Shikō II. He also worked in two
distinct styles. The work of Chōki shows the influence of Torii Kiyonaga,
with an added heaviness of form. The Shikō II style is an elegant one
developed in the manner of Utamaro. (Differences between the two have
led some critics to believe that two artists are involved.) Chōki was a
Ukiyo-e painter and printmaker who may have been the student, if not the
son, of Toriyama Sekien. His best work possesses great delicacy of design
with superb color.

In this print, the *tayu* (courtesan) Otowaji walks on a snow-covered
street in the Yoshiwara, the licensed entertainment and brothel quarters of
Edo. The Yoshiwara was a walled enclave entered through a single guarded
gate with a long avenue planted with flowering cherry trees more than half
a mile in length. There were more than 100 brothels, about 400 teahouses,
and shrines and living quarters for several thousand prostitutes plus all of
the attendants and entertainers who inhabited this enclosed town.

It was a popular and common practice for the courtesans to parade
accompanied by their attendants. Otowaji and another woman and two
kamuro (young girls being taught the social graces) are followed by a
manservant who holds a parasol over her head. Otowaji is identifiable as a
tayu from the high *geta* (clogs) worn only by courtesans in the winter and
the *obi* (sash) tied in the front. It is customary for an inscription naming
the courtesan and her brothel to appear on the print.

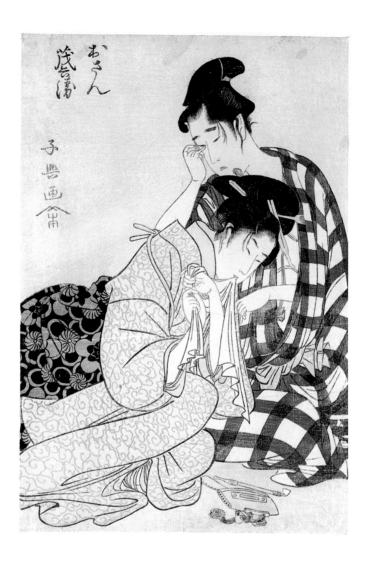

MOMOKAWA SHIKŌ II, active late 18th and early 19th centuries
Disconsolate Lovers, c. 1798
Publisher: Ōmi-ya
Oban 15" x 10"
JP 25 Gift of W. B. Rogers

The artist who created this print also used the *gō* (artist's pseudonym) of
Eishosai Chōki. Under the signature of Shikō II, his work shows the
influence of Utamaro.

 O San is seated beside her lover, Mohei, who is wiping a tear from his
eye. Both are dejected and are contemplating *shinju* (double suicide) to end
their sorrow. This was frequently a last resort of lovers in old Japan when
marriage was impossible. On the floor is a pipe and a device used for the
styling of hair.

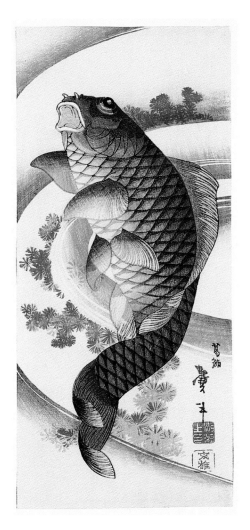

KATSUSHIKA TAITO II,
active 1810–1853
Leaping Carp, c. 1840
Publisher: No imprint
Hosoban 14" x 6½"
JP 59 Gift of W. B. Rogers

Taito was born in Edo of a samurai family from Kyūshū He was a student of
Hokusai, who gave him his *gō* (artist's pseudonym) of Taito in 1820. He
collaborated with Hokusai and lived in Edo until 1843, when he moved to
Ōsaka. He was a prolific book illustrator and at one point forged Hokusai's
name. He was found out and was thereafter called Inu Hokusai (Dog
Hokusai).

 This print depicts a carp leaping out of a stream in which water weeds are
growing. Such Chinese-inspired subjects were rarely used by the
commercial print artists in Edo.

 Frederick Gookin, the dealer who obtained this print for W. B. Rogers,
called it "the finest impression that has ever come under my observation."[18]

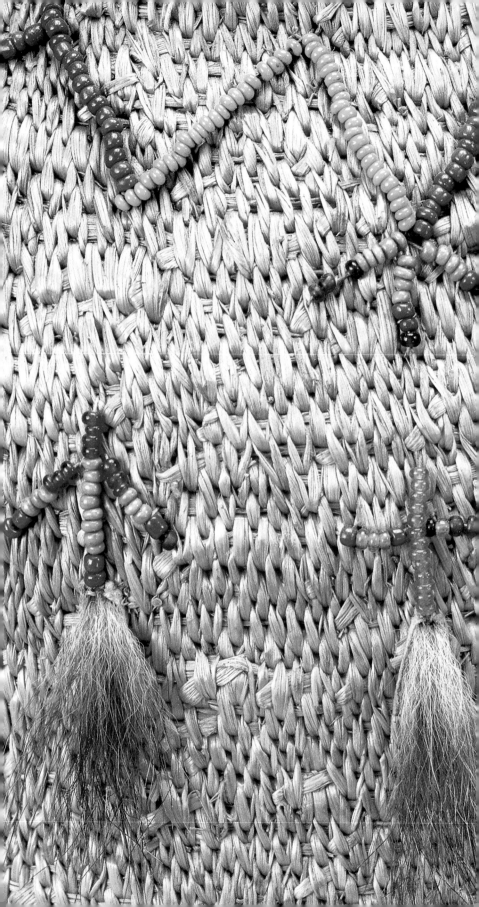

NATIVE AMERICAN
BASKETS

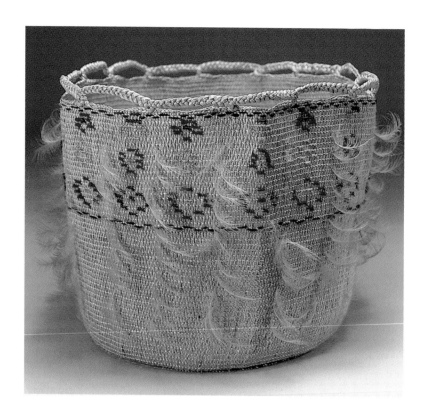

ALEUT BASKET, no date
Eskimauan Family (probably Bristol Bay or Attu)
H. 9" x Diam. 9" at bottom
9 stitches to the inch, 6 rows to the inch
23.122 Gift of Catherine Marshall Gardiner

This basket, used as a gift, is made of rush-like grass with the woof strands
twined over two warp strands, upon which the succeeding rounds are
divided. The bottom is twined in the same manner, with the warp
radiating from the center. The upper half of the basket is decorated with
false embroidery in black, red, rose, and dark and light blue worsteds
ornamented with small white feathers. It is finished at the top with a
heavy braid of grass set in loops attached to the body of the basket at
two-and-one-half-inch intervals. This specimen is a superb example in
excellent condition. Influenced by the eighteenth-century Russian
settlers, Aleut basketry is woven as fine as linen and makes moderate use
of delicate, stylized patterns.

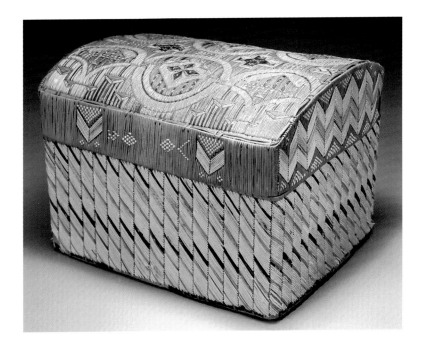

ALGONQUIAN BIRCHBARK TRUNK, before 1923
Algonquian Family
H. 8" L. 11" W. 9"
23.259 Gift of Catherine Marshall Gardiner

The Algonquian language family consists of tribes living in the Northeast, Great Lakes, and adjacent portions of Canada. Many of these groups did not make baskets, but those in more western and northern locales produced birchbark containers that served similar functions.

This early, exquisite small trunk, made of birchbark on a white pine foundation, is entirely covered in porcupine quill work. The quill work on the lid is an elaborate geometric design in blue, brown, black, and white, with the ends in a herringbone pattern. The sides and end panels of the trunk box are covered with quills laid in diagonal stripes. This trunk was found in Newburyport, Massachusetts, where it had been in one family for several generations.

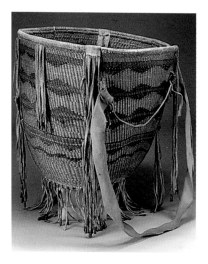

SAN CARLOS APACHE BURDEN
BASKET, c. 1880
Athabascan Family (San Carlos
Reservation, Arizona)
Diam. 14½"
23.29 Gift of Catherine Marshall
Gardiner

The Western Apache used burden
baskets for packing cactus fruit,
mesquite beans, acorns, and other
foodstuffs. Their burden baskets
were some of the finest in
existence, such as the one
illustrated here. This basket was
twined on a vertical stick warp
that radiated out from a circular center. Four heavy sticks woven into
place changed the shape from round to square and provided rigidity. The
encircling pattern contrasts twined-in black triangles of devil's claw with
painted red bands. The chief ornamentation is buckskin fringes with
cone-shaped "tinklers" of tin.

JH

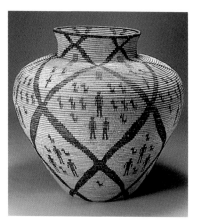

WHITE MOUNTAIN APACHE JAR,
c. 1900
Athabascan Family (Eastern
Arizona)
H. 21½", Diam. 11" at neck
and 21" at shoulder
14 stitches to the inch,
5¼ rows to the inch
23.137 Gift of Catherine Marshall
Gardiner

This large bottleneck coiled granary
jar, or *olla*, is a classic example of
the large coiled baskets of the Western Apache bands that became avidly
sought by collectors at the turn of the century. Only a few basketmakers
could make such a large piece with perfect shape and smooth texture. The
coil is made of willow strips sewn with willow and martynia, or "devil's
claw," for the black. The design consists of shaded spirals crossing to form
diamond-shaped spaces filled with small crosses, men, and dogs.

JH

ATAKAPA or CHITIMACHA
BASKET, c. 1910–1923
Atakapan Family,
(Avery Island,
Louisiana)
H. 2¾" Diam. 5½"
10 warps to the inch
23.308 Gift of
Catherine Marshall
Gardiner

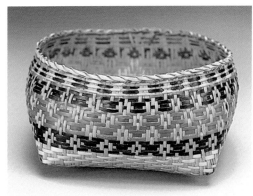

According to museum
records, Mrs. Gardiner
acquired this small, single-weave basket as an example of the work of the
Atakapas, a North American Indian tribe that once lived in South Louisiana.
They are now believed to have been extinct by the early nineteenth century,
but the basket was probably bought new and/or unused much later. This and
similar examples were acquired by major museums between the 1890s and
1910s, and all were attributed to anonymous Atakapa basketweavers. However,
the technique of weaving, material preparation, size, type of basket, design, and
rim finish on this basket are identical to those employed in Chitimacha baskets
common to the period and locale. We may never know if this work (and
similar "Atakapa" baskets) was incorrectly attributed, or made by a woman of
some Atakapa ancestry living among the Chitimachas.

BJD

COAHUILLA "RAMONA" BASKET,
1906
Ramona Lubo
Shoshonean Branch,
Uto-Aztecan Family
H. ⅝" Diam. 15½"
6 rows to the inch
23.85 Gift of
Catherine Marshall Gardiner

This flat tray is called the "Ramona"
basket because its creator was one of the
models for the Cahuilla Indian heroine of the famous romantic novel *Ramona*,
written in 1884 by Helen Hunt Jackson. Just as the fictional Ramona's husband
was tragically murdered, so was basketweaver Ramona Lubo's husband mistakenly
killed. In 1899 or 1900 she wove a basket like this as a memorial to her husband
and as a "wish basket" in hopes of joining him in heaven. The large star represents
her husband Juan and the small dots or stars represent the heavens. In 1906
Catherine Gardiner commissioned a copy of the original "Ramona" basket from
Ramona Lubo. Again she coiled grass and sewed with three-leaf sumac and natural
golden juncus, but in this tray she achieved even finer texture and a more exact
pattern of stars.

CHILKAT APRON,
c. 1875
Koluschan Family
L. 28" W. 38"
23.59 Gift of Catherine
Marshall Gardiner

This dance apron is
made on a warp of
mountain goat wool and
yellow cedar bark with a
weft of pure mountain
goat wool that hangs

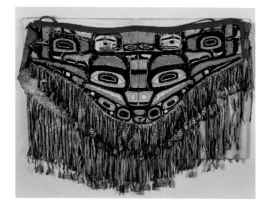

over a buckskin. Both are finished with a fringe of 172 sea parrot or puffin
beaks and deer hooves. The apron is decorated with a killer whale pattern.

The Chilkat tribe is part of the Tlingit or Koluschan family and is
located along the coast of Alaska. Chilkats developed a high degree of skill
at basketmaking before coming into contact with Euro-Americans in the
eighteenth century.

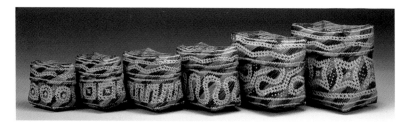

CHITIMACHA NESTED BASKETS, c. 1910–1923
Chitimachan Family (Avery Island, Louisiana)
Largest basket: H. 5" L. 4⁵/₈" W. 3¹/₄"
Smallest basket: H. 2⁵/₈" L. 2¹/₂" W. 1³/₄"
23.309-23.314 Gift of Catherine Marshall Gardiner

Descendants of the historic Chitimacha tribe, still located in a portion of
their original homeland in southern Louisiana, continue to make intricately
patterned baskets from river cane. Their basketry designs have evolved from
prehistoric Mississippian period iconography and basketry (A.D. 900–1500s),
some of which were common in variant forms to historic tribes throughout
the Southeast and others which were unique to the Chitimachas.

These six nested baskets are woven from very finely split cane in the
difficult double-weave technique. Historic Chitimacha basketweavers used
closely guarded formulas to obtain red and black natural dyes from plants,
while later basketweavers have switched to commercial dyes. Six of the many
geometric designs and combinations used by the Chitimachas are represented
in this nest, left to right: *Cous-pi-se-on* (Muscadine Rind); *Nesh-tu-wa-ki*
(Alligator Guts); *Chish-mish* (Worm Track); *Cars-ops-to-man* (Same Thing
Over Again); *Cars-ox-oxun* (Something Around); *Wash-ti-kani* (Beef Eye).

BJD

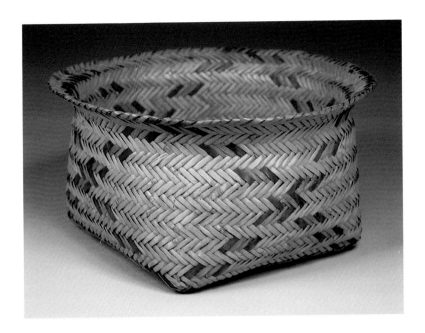

CHOCTAW BASKET, c. 1880–1900
Muskhogean Family (Mississippi)
H. 6" Diam. 12"
6 canes to the inch
23.39 Gift of Catherine Marshall Gardiner

While most Choctaws were forced by the Indian Removal of the 1830s
to relocate to Indian Territory (now Oklahoma), a number of Choctaw
villages, some with several hundred inhabitants each, managed to
remain in their homeland in Louisiana and Mississippi. Women from
these Choctaw communities have depended heavily on production and
sale of baskets to non-Indians to help sustain their families.

 This round basket, woven from cane splints on a square base, uses a
twill weave executed in the double-weave technique, which the
Mississippi Choctaws rarely used in the late nineteenth century. There
is little color except for a few splints of yellow and brown, which cross
diagonally on each side.

BJD

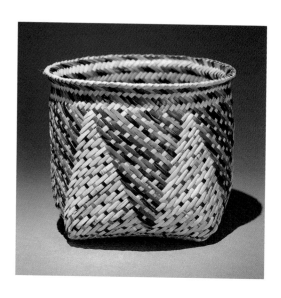

CHOCTAW DOUBLEWEAVE BASKET, 1996
Francine Alex, b. 1950
Swamp cane, H. 5⅝" Diam. 6"
97.10 Museum Purchase

A doubleweave basket is essentially two baskets, one woven inside the other with a single, common rim. The weaver starts on the bottom of the interior basket layer, weaving up to the rim of the basket. Next, the weaver folds over the rim of the interior basket and weaves down and over the outside of the interior basket and around the bottom. To finish, the ends of the cane pieces are then woven underneath each other, creating the exterior bottom in a seamless fashion. Doubleweave baskets are among the most difficult and time-consuming baskets to make, but the result is one of the finest Native American baskets available today.

In 1992, a probable nineteenth century doublewoven Choctaw basket was discovered in an old log chicken house in Kemper County, Mississippi. This basket was acquired by Melvin Tingle, who, upon showing it to a number of older Choctaw basketmakers, discovered that it was a pattern which no one remembered how to weave. The pattern has large triangles, woven in a "float-weave" technique, going around the body of the basket.

Francine Alex, a member of the Conehatta Community of the Mississippi Band of Choctaw Indians, studied this old basket and taught herself how to duplicate this lost pattern. She is now making her own interpretations of this basket, some of which use the natural-dye colors of the original and some using a variety of modern artificial dye colors. Today she is considered one of the best doubleweavers among the Choctaw basketmakers of Mississippi.

KHC

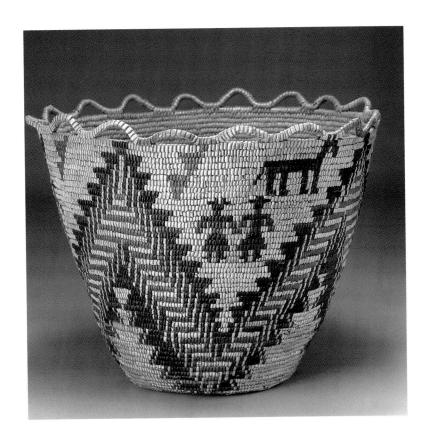

COWLITZ BURDEN BASKET, before 1923
Southwestern Coast Salishan Family (Washington)
H. 11¼" Diam. 12" x 14½" at top
8 stitches to the inch, 4¾ rows to the inch
23.6 Gift of Catherine Marshall Gardiner

The Southwestern Coast Salish Indians were a group with approximately four language sub-groups and thirteen sub-names, of which Cowlitz is one tribe. The Southwestern Coast Salish region extends from the Olympic Peninsula to the Columbia River. Salish basketry was primarily made from red cedar using the coil method.

 This oval burden basket is made on a coil of cedar root sewn with grasses and covered with an imbricated design of squaw's grass. Imbrication is accomplished by introducing a strip of colored bark or straw to be caught under and folded back on each stitch of the coiling. The figures contained within four points are men, women, and horses, and the color scheme is white, brown, yellow, and black. The top of the basket has an imbricated loop finish.

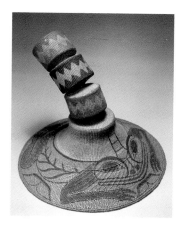

HAIDA POTLATCH HAT, before 1923
Skittegetan Family (Queen
Charlotte Islands)
H. 6¼" Diam. 15" at brim
6½ stitches to the inch at brim
11 stitches to the inch at crown
23.22 Gift of Catherine Marshall
Gardiner

The Haidas live on the Queen Charlotte Islands, located off the coast of British Columbia, and in Southeast Alaska. Unlike their Tlingit neighbors, they have a reputation for making not baskets but hats. They use the technique of twining with design variations. This hat was made for the potlatch, a ceremonial feast marked by the host's lavish distribution of gifts. The hat is woven of spruce root with a slug track pattern in a skip stitch on the brim. The frog depicted on the brim is itself wearing a ringed crest hat.

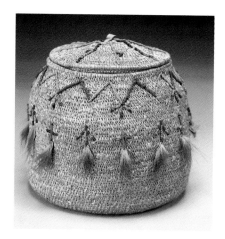

INUPIAQ BASKET WITH HINGED
COVER, before 1923
Inupiaq, Northern Alaska
Eskimo Family
H. 5⅜" Diam. 6¼" at bottom
and 4⅝" at top
11 coils to the inch
23.121 Gift of Catherine
Marshall Gardiner

Inupiaq baskets are typically made of wild rye or lyme grasses; the technique varies with location and teacher. This round basket with a hinged cover is constructed of grass coils sewn with rush. Each stitch is sewn over two coils, and the basket is adorned with colored trade beads and tufts of fur applied in a simple design. The use of fur and beads is rare in Inupiaq basketry.

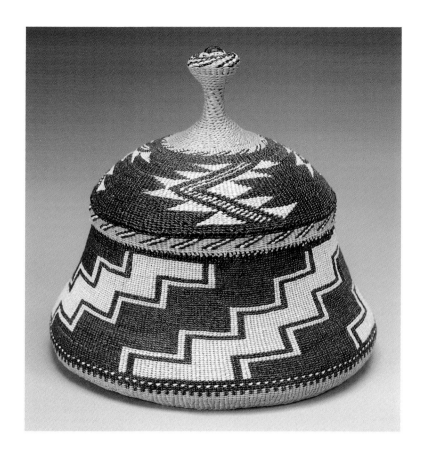

KARUK LIDDED TRINKET BASKET, c. 1912–1914
Elizabeth Hickox (1873–1947)
Karuk (Hokan) Family (Northern California on the Lower Klamath River)
H. with cover 7¼" Diam. 5¼" at bottom
17 stitches to the inch
26.43 Gift of Catherine Marshall Gardiner

The basketry of the lower Klamath River tribes—the Hoopa, Karuk, and Yurok—are of the same general type. The women wove finely twined hats and used cooking bowls made by the same weaving technique. They often used California hazel as the warp, with the split root of the sugar pine or yellow pine as the weft.

This "fancy basket" is woven of myrtle shoot foundation twined with Oregon grape root wefts. The glistening surface consists of false-embroidered black maidenhair fern stems for the background and porcupine quills dyed yellow with wolf moss for the design.

The famed weaver Elizabeth Hickox learned basketmaking from her Wiyot mother but lived in Karuk country and wove in individualized Karuk style. Her twining may represent some of the finest ever done. This example features the "long worm" mark. It is a masterpiece of technique, design, and vision.

JH

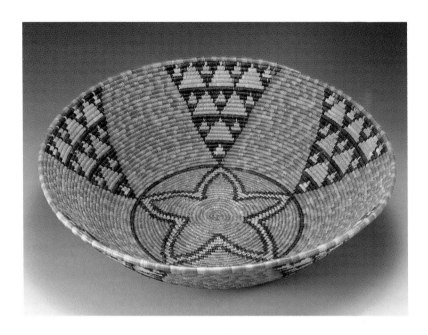

KUMEYAAY (DIGUEÑO) TRAY, c. 1875
Yuman Family (San Diego, California)
H. 5" Diam. 18³/₄"
9 stitches to the inch, 6¹/₂ rows to the inch
23.453 Gift of Catherine Marshall Gardiner

The Indians along the Pacific Ocean were the first to be influenced by contact with Europeans. The descendants of the people who came under the influence of the Mission of San Diego are now known as the Kumeyaay. Their basketmaking tradition survived this contact without great change in the materials and techniques.

This large tray of coiled splints is a fine example of Kumeyaay basketry. It is sewn with multihued juncus stems and decorated with a feather pattern made with black-dyed juncus.

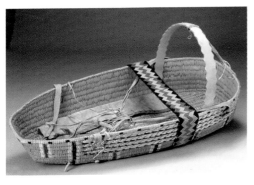

LILLOOET BABY BASKET,
before 1923
Salishan Family
(Northern Interior
Washington)
H. 4½" L. 25¼" W. 12"
23.12 Gift of Catherine
Marshall Gardiner

Cedar wood, sewn with roots, was used to make this baby carrier. The head covering is supported by a wood arch and is decorated using imbrication and glass beads. The baby was held in place with buckskin flaps that lace together. The carrying strap is of cedar bark woven with colored worsteds. This artifact has its tumpline (a carrying strap slung across the forehead or chest) still intact.

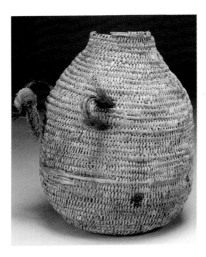

EARLY NAVAJO WATER BOTTLE,
c. 1800
Athabascan Family
(Chaco Canyon, New Mexico)
H. 9¾" Diam. 7⅝"
23.267 Gift of Catherine Marshall
Gardiner

This well-used, weathered water jar was found among ancient Pueblo ruins, yet the horsehair in the loop handles marks its date as post-1539, when the Spaniards first brought horses to the Southwest, and long after the Pueblo abandonment of Chaco Canyon. From the late 1700s, early Navajos in the Chaco area coiled baskets in this shape using sumac splints over a foundation of split sumac twigs and yucca leaf. The pine pitch coating that sealed the bottle has fallen off the outside and loosened on the inside. Braided loops are woven in on one side to form a handle, and a fragment of hemp rope is still attached to one of the loops.

JH

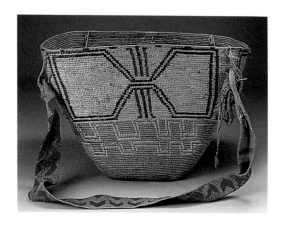

NTLAKYAPAMUK BURDEN BASKET, before 1923
Salishan Family (Northern Interior Thompson River in British Columbia)
H. 12" L. 17³/4" W. 12¹/2"
10 stitches to the inch, 6¹/2 rows to the inch
23.27 Gift of Catherine Marshall Gardiner

The Ntlakyapamuks were part of the large Shalishan family, which was located in a vast area of the northwestern United States and southern Canada. This is a typical Salish burden basket made of cedar splints sewn with roots, with a carrying strap of cotton cord woven with colored worsteds. The upper half is completely imbricated with a stone hammer pattern on both sides. The flared rectangular shape and fully imbricated upper half are typical of Thompson River basketry.

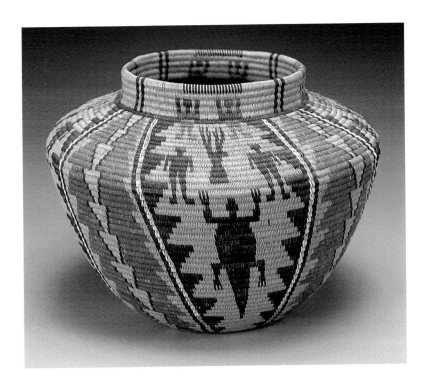

PANAMINT SHOSHONE BOTTLENECK BASKET, c. 1900–1915
Shoshonean Family (Death Valley, Inyo County, California)
H. 5" Diam. 4" at neck and 7⅝" at shoulder
33 stitches to the inch, 8 rows to the inch
23.228 Gift of Catherine Marshall Gardiner

The Panamints' home area was one of the harshest areas in America.
Because of their location, their culture remained undisturbed longer than
that of some other tribes. They used willow shoots or grass stems for the
baskets' foundations. This basket is made on a coil of year-old tough
willow shoots. The design is woven with martynia, the root of the yucca
tree, and white quills. It consists of eight panels in two patterns. One
contains a large lizard, four men, and a deer. The second has a design that
most likely shows a rattlesnake. The ticked rim design is a Panamint
signature.

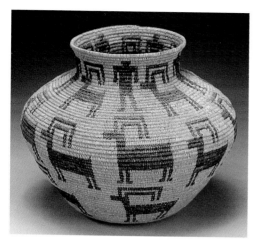

PANAMINT SHOSHONE JAR,
before 1923
Shoshonean Family (Inyo
County, California)
Diam. 4⁵/₈" at neck and 9³/₈"
at shoulder
20 stitches to the inch
7 rows to the inch
23.133 Gift of Catherine
Marshall Gardiner

This bottle-necked basket is
woven of fine wood splints
that are coiled and sewn with
martynia, or devil's claw. The
basket is ornamented with twenty mountain sheep and four men. The bighorn
sheep was a popular motif used by the Panamint Shoshone on their coiled
baskets, but they seldom used the male figure in the decoration. In the early
twentieth century the Panamint made many decorative baskets like this to
sell to travelers.

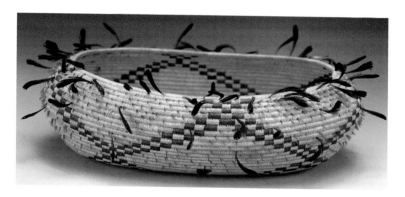

POMO GIFT BASKET, c. 1900
Pomo (Hokan) Family (Lake County, California)
H. 2¹/₂" L. 9⁵/₈" W. 6¹/₄"
30 stitches to the inch, 6¹/₂ rows to the inch
23.127 Gift of Catherine Marshall Gardiner

The Pomo Indians produced some of the most versatile and beautiful baskets
made in North America. The feathers and shells that they used for decoration
take months to gather, and consequently, many of their baskets required
several years for completion. Pomo baskets were often destroyed during
mortuary rites.

This canoe-shaped basket is woven in the *Shi-bu*, or coiled, weave, with a
pattern of crossing bands of small rectangles that form four diamonds. On two
of the diamond shapes are arrowheads, and the sides are powdered with red
woodpecker feathers and an occasional quail plume. Around the top edge, set
in at regular intervals, is a band of plumes.

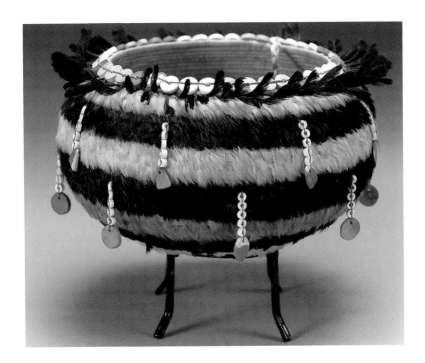

Pomo Jewel Basket, c. 1895
Pomo (Hokan) Family (Lake County, California)
H. 3⁵/₈" Diam. 6¹/₂"
24 stitches to the inch, 30 stitches at the edge to the inch,
6¹/₂ rows to the inch
23.234 Gift of Catherine Marshall Gardiner

This rare gift basket is a round globular bowl woven in the *bam-tsu-wu*
weave, three-rod coiling. It is covered in feathers in nine concentric
circles, each from half an inch to three-quarters of an inch wide. The
feathers used are those of the robin, mallard duck, oriole, meadowlark,
and blue jay. There are sixteen gold and silver pendants made from
magnesite, a rare stone found at Clear Lake, California, and clamshell
disc beads, suspended from the basket sides. Along the top edge is a row
of the silver and gold stone beads, beneath which is a row of quail crests.
A handle of stone beads is attached on each side. This basket is said to
have required three years for completion.

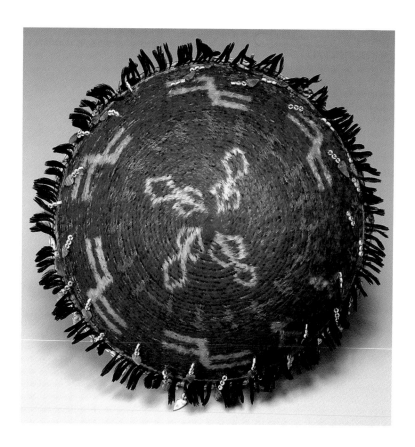

Pomo Sun Basket, c. 1899 or 1900
Warrace's Wife, possibly Alice Warris
Pomo (Hokan) Family (Lake County, California)
H. 2³/4" Diam. 11"
32 stitches to the inch, 7¹/2 rows to the inch
23.236 Gift of Catherine Marshall Gardiner

This saucer-shaped basket, called a *ta-pi-ca*, is woven in the *shi-bu* weave,
or coiling, and is entirely covered with feathers. The background is a solid
field of red woodpecker feathers with a figurative design in meadowlark
feathers. A circular pattern of blue jay feathers with a second ring of
meadowlark feathers surrounds the figures. A fringe of 210 quail plumes
held by a close row of *kaia*, or clamshell beads, runs along the rim of the
basket. Three rows of pendant kaia and abalone shell hang from the
featherwork. This basket took three years of work and has been called
the best in the collection.

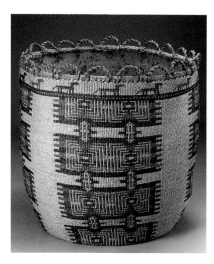

SKOKOMISH BURDEN BASKET,
before 1923
Probably made by Sarah Curly
Southern Coast Salish Family
H. 16" Diam. 15" at top
8 stitches to the inch
12 rows to the inch
23.191 Gift of Catherine
Marshall Gardiner

The Skokomish tribe is one of
the estimated thirty-eight in the
Salishan family of the north-
western United States and
Canada. The south coastal tribes
commonly used the twining
technique to make carrying baskets. The characteristic border design
involved wolves or dogs. This basket was made on a warp of rushes twined
with squaw grass that was dyed brown, black, and yellow to form the
pattern. The geometric "seal roost" design is one of four panels created by
rectangles connected with bars. There are four rectangles in each panel,
and the top border has a row of wolves. The border is finished with a
series of loops of twisted Indian hemp.

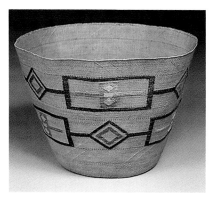

TLINGIT (HOONAH KOW TRIBE)
BASKET, before 1923
Koluschan Family
(Alaska on Cross Sound)
H. 6½" Diam. 9¾" at top and
5¾" at bottom
21 stitches to the inch
23.124 Gift of Catherine
Marshall Gardiner

The Tlingit Indians live in southeastern Alaska on the shelf of land
between the mountains and the sea. The usual weave was twining, with
beautiful patterns and openwork. The baskets gradually became smaller, as
they were in great demand among the Russian traders and needed to be
produced in greater quantities.

 This basket is made of undyed spruce roots twined with skipstitch near
the top and bottom. There are bands of false embroidery of wild rye and
of maidenhair fern stems. The design is a lozenge pattern alternating with
a cross pattern. This type of basket was called a "hat crown" due to its
flaring sides.

WASHOE BOWL, c.1895
Washo (Hokan) Family
(Western Nevada)
H. 3³/4" Diam. 8" at top and
3³/4" at bottom
18–24 stitches to the inch
11¹/2 rows to the inch
23.128 Gift of Catherine
Marshall Gardiner

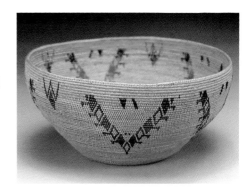

The Washoe were reputed
to be among the finest basketmakers in America and made baskets light
in weight and color. One woman in their tribe, Dat so la lee, was famed
for her weaving. It is reported that she sold one of her baskets for $1,500
in about 1900.

 This bowl-shaped basket is made of single-rod willow coils and black
figures from the root of the bracken fern. The basket is outstanding for its
even and consistent stitching.

YOKUTS BOWL,
c. 1880
Yokuts (Penutian) Family
(Tue River, Tulare
County, California)
H. 7³/4" Diam. 18¹/4"
14¹/2 stitches to the inch,
7 rows to the inch
23.145 Gift of
Catherine Marshall
Gardiner

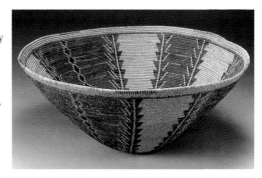

The Yokuts, who occupied the great central valley of California, were a
major basketmaking tribe whose culture declined after contact with
European civilization. They used the coiling technique almost exclusively,
sewing small bundles of grasses with sumac, redbud, or bracken fern. The
characteristic design motif is the diamond, which is said to have been
copied from the diamondback rattlesnake.

 This bowl-shaped basket is made on a coil of grass stems sewn with
sedge or marshgrass root background, bracken fern for black, and redbud
for red. The pattern combines the feather and arrowhead designs. This
basket is considered one of the finest utility specimens in the collection.

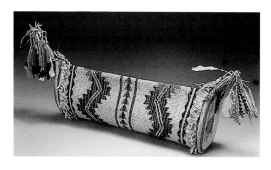

YUROK JUMP DANCE
BASKET, before 1915
Algonquian Family
(Northwestern
California)
L. 16"
9½ stitches to the inch
14 rows to the inch
23.89 Gift of Catherine
Marshall Gardiner

This woven cylindrical tube was made to be carried by men in the "jumping" dance, which is associated with the White Deer Dance held each autumn. It is made to represent the elkhorn purse used to keep the dentalium shell money, which figures importantly in the tribe's creation legend.

The dance basket, which is used as a rattle in the dance, is twined with a foundation of hazel shoots twined with bear grass and stems of maidenhair fern. Some of the grass is dyed with alder to produce a brown color. The woven piece is shaped into a tube, and the ends are closed with fringed buckskin. The woven pattern represents the middle of a sturgeon's back, with a central row of small triangles flanked on each side by curving bands edged with a zigzag motif. Horns with decorative feathers are attached to the sides as handles.

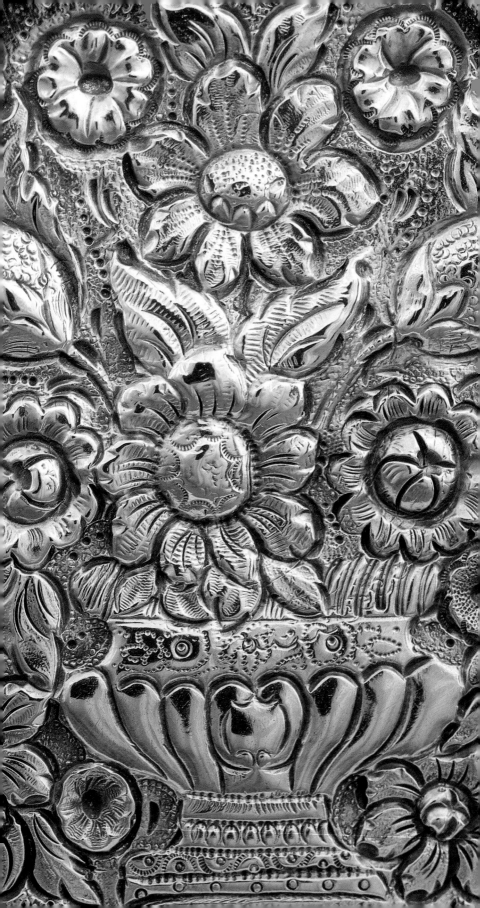

BRITISH SILVER

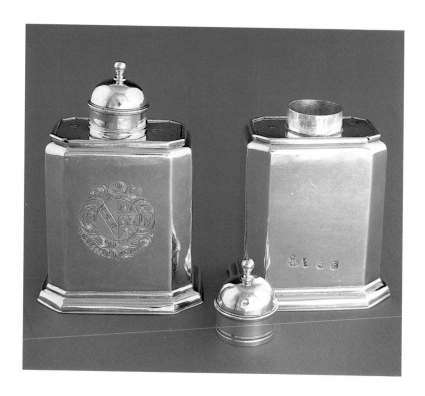

GEORGE I TEA CADDIES, 1720, Brittania Mark
John Gibbons, London
Left: H. 5" W. base 3½" L. 2¼" Wt. 12 oz.
Right: H. 4¾" W. base 3⅜" L. 2¼" Wt. 12 oz.
73.2 Gift of Thomas M. and Harriet S. Gibbons

England has required silver to be marked since 1300. From 1697 until
1739, the maker's mark, which was placed on all of his work after
assaying, was the first two letters of his surname. In 1739, it was ordered
that the initials of the Christian name and the surname be used as a
mark, and this practice has continued until the present time.

Tea was first introduced in England in the seventeenth century as a
medicinal drink. It became a fashionable beverage during the early
eighteenth century. By mid-century, silver canisters for tea were made in
pairs, one for green tea and the other for bohea, a choice China tea. A
third canister might be used for a mixture of teas and one of larger scale
for sugar.

John Gibbons entered his sterling mark in 1724. He also worked as a
goldsmith, and records show that he ceased work in 1744. These two
caddies are plain and rectangular, with chamfered (beveled) corners. The
covers slide on and have domed lids with molded finials. They are
engraved with arms and are identical in every respect except size.

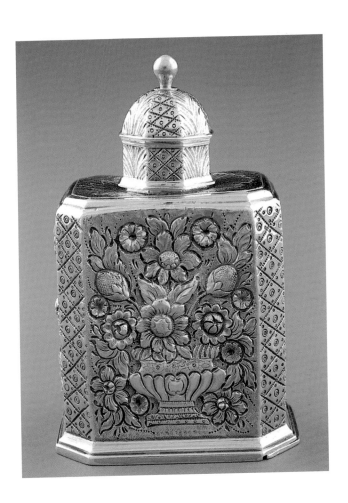

GEORGE I SILVER GILT TEA CADDY, 1724
Joseph Fainell, London
H. 5½" Wt. 8 oz.
73.3 Gift of Thomas M. and Harriet S. Gibbons

Fainell entered his mark as a silversmith in 1710. This caddy is vertical and rectangular in design with chamfered corners. It is heavily embossed with flowers in a container and a geometric design forming the background. The engraved crest consists of a crown surmounted by a cross. This tea caddy has a sliding removable base and a removable domed lid decorated with acanthus leaves and a ball finial. The caddies were fitted with sliding bases and/or lids through which they could be filled with tea.

Before the late eighteenth century, tea caddies were called canisters. "Canister" was replaced by the word "caddy," which is a derivation of the Malay *kati*, a weight equivalent to one and one-fifth pounds. Tea was sold by the kati, and the name was transferred to the case in which the tea was bought.

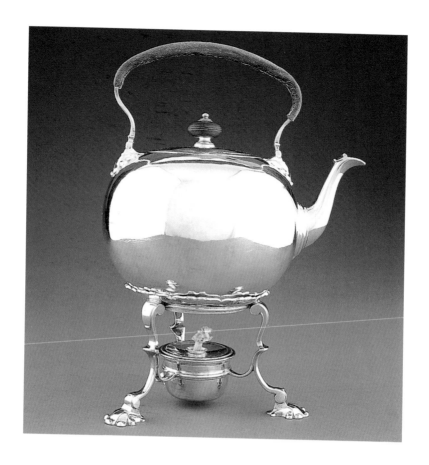

George II Skittle Ball Kettle on Stand, 1732
Benjamin Godfrey, London
Kettle: H. 9¼" (with handle) Diam. 7" Wt. 39¼ oz.
Stand: H. 4¼" Diam. 5¼" Wt. 22¾ oz.
73.64 Gift of Thomas M. and Harriet S. Gibbons

Probably because of the high price of tea, teapots remained small until late in the eighteenth century. Also because of the high cost of tea, the beverage was infused at the table to prevent waste. This practice, as well as the need to refill the teapot frequently, explains the introduction of the teapot with a lamp. The teakettles were simply designed until the rococo period.

 This skittle ball kettle was made by Benjamin Godfrey, who was apprenticed to Joseph Clare in 1722. Godfrey entered his mark as a largeworker in 1730. The kettle has a spherical body and leather-wrapped handle. The knob on the lid is ebony with a silver mounted finial, and the circular lid is attached by an indented hinge. The shaped spout is attached to the middle of the bulge and tapers in a graceful curve toward the mouth, which is typically shaped like a duck's head. The stand, which is fitted with a spirit lamp, has a shaped rim and three recurving scroll legs on stylized leaf feet.

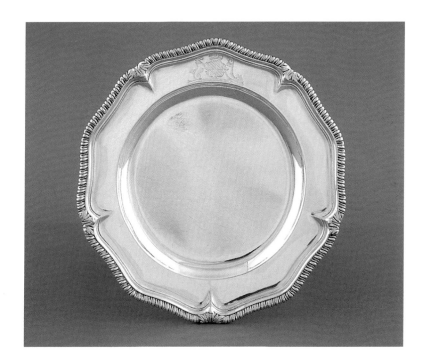

GEORGE II PLATE, ONE OF A PAIR, 1746
Paul Lamerie (1688–1751), London
Diam. 9½" each, Wt. 39 oz.
73.48 Gift of Thomas M. and Harriet S. Gibbons

In 1705, Paul Lamerie was apprenticed to a goldsmith named Pierre Platel
the Elder, who came to London about 1687. Lamerie registered his mark
as a goldsmith in 1712 and began a long and distinguished career that
lasted until 1751. He had the greatest reputation of any eighteenth-
century goldsmith and was the first to have a monograph written about
his work. Lamerie was one of the artisans responsible for the Plate
Offences Act of 1738, enacted to curb the fraud within the trade. The act
required marking of all objects except jewelry (although mourning rings
had to be marked) and reaffirmed that the silver and gold standard was
twenty-two carats.

 This decagonal plate with a molded gadroon rim has small leaves at the
incuse points of the border that are worked into the gadrooning. The
plate is engraved with a coat of arms on the rim. These plates were often
called "voiding dishes," since they were used to hold the scraps removed,
or voided, from the table.

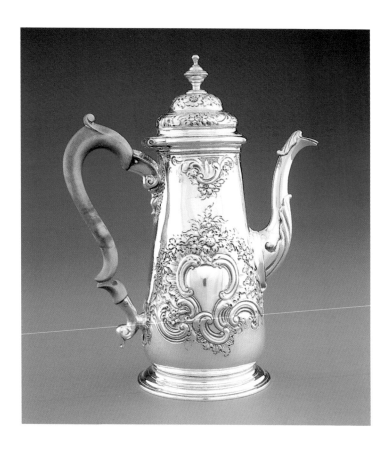

GEORGE II COFFEE POT, 1755
John Swift, London
H. 9" Diam. 4⅛" at base Wt. 23 oz.
73.36 Gift of Thomas M. and Harriet S. Gibbons

Swift registered three marks: the first two marks in 1728 as a plateworker
and a smallworker; the third in 1739 as a largeworker. He worked
primarily in holloware with a repertoire of rococo and chinoiserie designs.

Coffee, as a beverage, antedates tea in England, having been first used
there during the years 1649–1660. The first silver coffeepot is dated 1681,
and while in shape it is similar to the teapot, the handle is opposite the
spout. The domestic coffeepot changed in design from the "lighthouse"
form to the pyriform to the vase-shaped pot late in the eighteenth century.

This coffeepot has a tapered lighthouse body on a low molded foot with
a leaf design on the top of the spout and at the spout's joint. A shell motif
outlines the spout-body joint and is repeated at the joining of the
fruitwood handle to the pot. An embossed floral design with scrolls
contains an empty cartouche on both sides of the coffeepot, and this floral
design is repeated at the top edge. The lid is a stepped, domed shape with
an urn finial and a repeat of the leaf design used at the joint of the spout.
This coffeepot combines the straight-sided design of the early eighteenth
century with the foliage and rococo scrolls that appeared in the late 1740s.

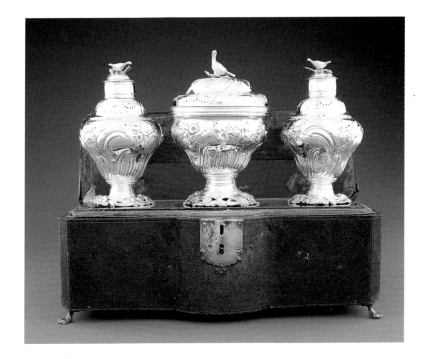

George II Tea Caddies and Covered Sugar Basin, 1757
Samuel Taylor, London
Caddies: H. 6" at finial
Sugar Basin: H. 6¼" at finial
Wt. of three pieces, 28 oz.
73.62 Gift of Thomas M. and Harriet S. Gibbons

Taylor specialized in tea caddies and sugar basins with floral chasing. He
entered his first mark as a largeworker and was a plateworker in 1773. He
also worked as a jeweler. This set with its original shagreen casket is
typical of his work. Two pear-shaped caddies and a sugar basin chased
with swirl flutes and floral garlands have cast openwork feet with the
same designs that appear on the body. Each piece has empty ornate
cartouches at the shoulder. The lids of the caddies are removable and are
surmounted by birds. The sugar basin lid is flattened toward the top and
is covered with a swirl calyx of flutes terminating in a game bird. Sugar
basins were larger than caddies because the unrefined sugar was in large
pieces.

The casket is lined with crimson velvet trimmed with silver braid. It
has silver claw feet and handle and a silver escutcheon around the lock.
The lock was added as a precaution warranted by the high prices of both
tea and sugar.

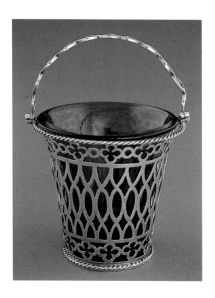

GEORGE III SWEETMEAT BASKET, 1761
John Deacon, London
H. 3" Diam. 3¹/₄" Wt. 3 oz.
73.68 Gift of Thomas M. and Harriet S. Gibbons

Silver pierced baskets were introduced during the reign of George II, at
which time they were used for bread. At the time when this basket was
made, delicately pierced sweetmeat baskets were popular and were
actually miniatures of the larger cake baskets.

 This small sweetmeat pail has a blue glass liner encased by a silver
pierced basket. The basket is bordered at top and bottom by quatrefoils
with latticework in the middle. It has twisted wire rims at top and bottom
edges and a ball handle. The silversmith, John Deacon, was also a
goldsmith who began working as a plateworker in 1771.

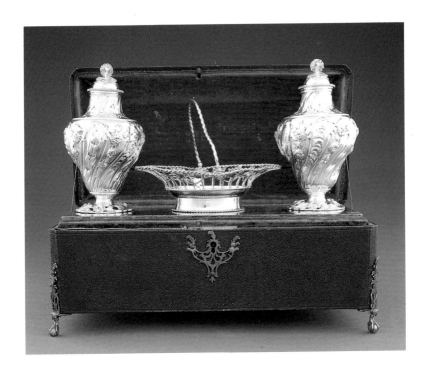

GEORGE III TEA CADDIES AND SWEETMEAT BASKET, 1764
William Plummer (1739–1791), London
Caddies: H. 6¼" Diam. at base 2¾" Wt. 7¼ oz. each
Basket: H. 1¾" excluding handle L. 6⅜" Wt. 5¼ oz.
Case: H. 7½" L. 13"
73.69 Gift of Thomas M. and Harriet S. Gibbons

Plummer first entered his mark as a largeworker in 1755. He specialized in
pierced saw-cut objects such as baskets and strainers. These two ornate
caddies have vase-shaped bodies heavily embossed with spiral flutes
alternating with floral swags. Cast foliate bases are decorated with spiral
flutes that are also repeated above the shoulders. The domed lids with a
rim of convex flutes are surmounted by flower finials.

The sweetmeat basket is designed with an oval base with a twisted wire
border and sloped sides of silver wire. The wire sides flare outward and are
appliquéd with grape and leaf designs. The rim of the basket is of twisted
wire, as is the swing handle.

The original case of shagreen (untanned leather covered with small
round granulations and usually dyed green) is lined in red velvet and has
the silver escutcheon outlining the lock and silver ball and claw feet. It is
rare to find an original case today. Cases saw constant use and were
usually discarded or replaced.

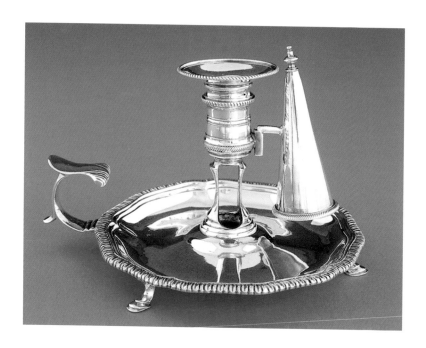

CHAMBERSTICK, 1765
Maker Unknown, London
H. 4³/₈" Diam. 5³/₄" Wt. 12¹/₂ oz.
82.39 Gift of Thomas M. and Harriet Gibbons

Throughout the eighteenth century, many types of portable chambersticks served to light the way to one's bedroom through the long dark halls and also to illuminate the room itself. Another use, which descended from medieval times, was for auction sales conducted "by inch of candle." A small piece of candle was lighted and allowed to burn itself out. The final bidder before the flame expired won the bid.

Candlesticks are rarely found complete, since the snuffers have generally been lost. This example is therefore unusual. The silver candlestick is circular, with a gadrooned rim and three hoof feet. The spool-shaped socket is decorated with bands of diagonal reeding that are repeated on the rim of the cone-shaped removable snuffer and rim of the bobechette. The handle is C-shaped, with a scroll thumbpiece. Chambersticks used ordinary candles mounted in a socket on a dish (grease pan) designed to catch the wax drippings. Chambersticks varied little in their design, which was largely dictated by their intended function.

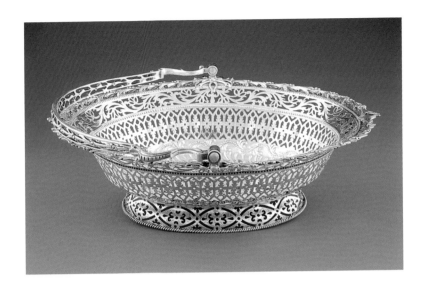

GEORGE III CAKE BASKET, 1773
William Plummer (1739–1791), London
H. 4" exclusive of handle L. 12¹/₈" W. 12" Wt. 29³/₄ oz.
73.33 Gift of Thomas M. and Harriet S. Gibbons

This type of basket, called a bread, cake, or table basket, passed through
several different styles and shapes, according to the influences of the era.
Cake baskets became fashionable accessories in the eighteenth century.
They were round or oval with intricately pierced sides and were sometimes
designed with swing handles.

 This elaborately pierced cake basket is an excellent example of
Plummer's specialty of saw-cut baskets. It features a leaf-and-scroll motif
with bead-and-scroll embossing. The wing handle with its open guilloche
pattern repeats the basket rim design. The oval pierced base has a gadroon
rim, and the interior is engraved with a cipher.

 The vogue for rococo design almost completely disappeared in 1770.
This basket is an example of the design influence of Robert Adam
(1728–1792), which was lighter and more graceful. Adam, architect to
George III and a designer, was known to produce designs for silversmiths.

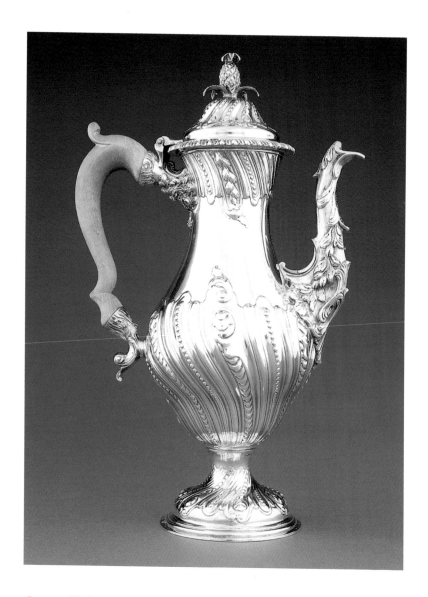

George III Coffeepot, 1773
Maker Unknown (marks rubbed), London
H. 13¹/₈"
82.16 Gift of Thomas M. and Harriet S. Gibbons

The first coffeepots of the seventeenth century resembled teapots, in contrast to this vase-shaped coffeepot, which rests on a circular foot with a domed lid surmounted with a pineapple finial. Just below the lid is a band of gadrooning. The lid, neck, lower body, and base are covered with intricate swirled flutes. Cast floral motifs have been applied to the spout. The fruitwood handle is scrolled.

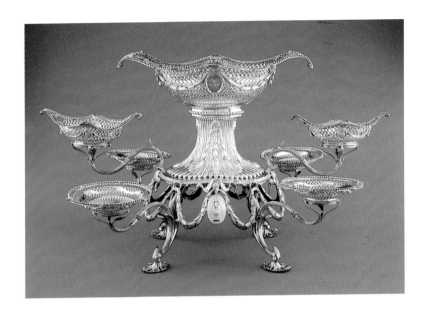

GEORGE III EPERGNE, 1773
Thomas Powell, London
H. 13" L. 23½" W. 15½" Wt. 100 oz.
71.12 Gift of Thomas M. and Harriet S. Gibbons

Goldsmith and plateworker Thomas Powell created this intricate sterling silver epergne. He first entered his mark in 1756 as a largeworker and worked until 1789. This piece provided a useful centerpiece for the dinner table; its baskets could contain sweetmeats, small cakes, and fruit. The recurving and scrolled branches, a legacy from an earlier period, support the smaller baskets and depart from the unified neoclassical design favored during the latter part of the eighteenth century. Two upper arms support removable boat-shaped pierced baskets decorated with cornhusk garlands, beaded rims, acanthus leaves, and shells at the incuse points. Four lower arms, which are also removable, have acanthus leaf ornamentation at the point of attachment and hold round, pierced dishes fluted with beaded and leaf rims. The dishes have cornhusk garlands on the underside.

The central removable boat-shaped basket with a pierced body has applied cornhusk drapery forming a medallion on each side that is engraved with a cipher. There are rosette medallions on each end of this basket. Applied beading on the rim with an acanthus and shell motif at the incuse points completes the design. The column supporting the central basket is hollow, fluted, and decorated with cornhusk drapery, cutwork, and a beaded lower rim. Ribbon and cornhusk garlands with four urn medallions encircle the lower edge of the column, which is supported by four scroll legs terminating in acanthus leaves attached to leaf-form feet.

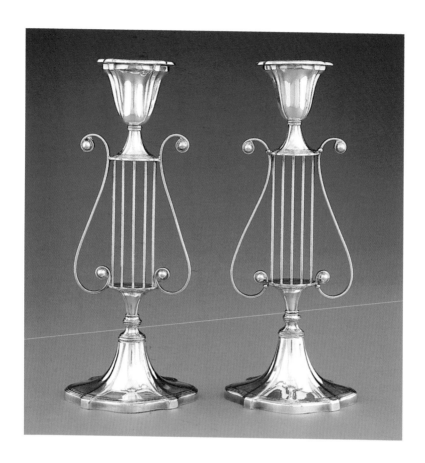

GEORGE III LYRE CANDLESTICKS, SHEFFIELD PLATE, c. 1780
Maker Unknown
H. 12³/₄ "
82.24, 82.25 Gift of Thomas M. and Harriet S. Gibbons

Candlesticks are mentioned in the Bible but were for lamps, not candles. The earliest candlesticks were "prickets," with a sharp point on the top of the shaft to hold the candle surrounded by a saucer to catch the wax drippings. Socket candlesticks such as this pair are known to have existed as early as 1560.

 With the introduction of Sheffield plate, the candlesticks increased in size and scale and required a more dignified design than their counterparts during previous periods. The lyre motif answered this need and was a popular design during the late seventeenth and early eighteenth centuries. These candlesticks have a five-stringed lyre design with scalloped and threaded bases.

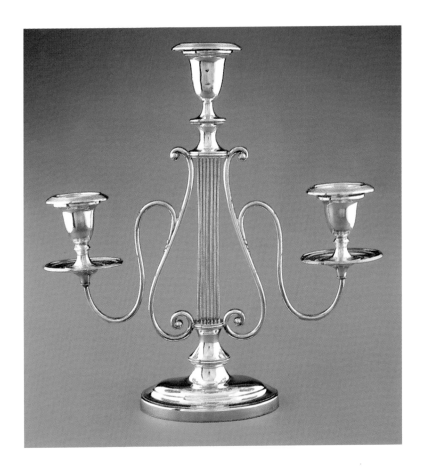

GEORGE III CANDELABRA, OLD SHEFFIELD PLATE, c. 1780
Maker unknown
H. 16³/₄"
82.22 Gift of Thomas M. and Harriet S. Gibbons

Sterling silver candelabra are rare because of the problems of weight and therefore expense. The majority of these objects were made from Sheffield plate during the period 1742–1838.

 This one of a pair of lyre candelabra with a weighted base is typical of those made during the late eighteenth and early nineteenth centuries, when the introduction of Sheffield plate and weighted bases allowed the candelabra to be produced at a lower cost and on a more grandiose scale. The design, one used frequently, involves a fluted shaft ornamented with a lyre motif rising from a domed and molded circular foot to a shoulder surmounted with a vase-shaped socket. The two branches are each shaped in identical curves and extend outward from the lyre. Their sockets with grease pans resemble the one on the parent candlestick.

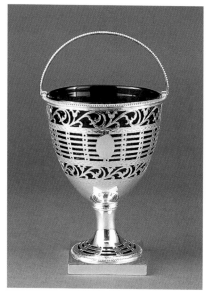

GEORGE III SUGAR BASKET, 1784
Hester Bateman (1708–1794),
London
H. 8"
2002.1 Purchased with funds
from the LRMA Guild of Docents
and Volunteers and given in
memory of Shirley Leggett

Hester Bateman is one of the best-known silversmiths of the eighteenth century. While it was not inconceivable for a woman to learn the family business and take it over upon widowhood, it was unusual for a woman to have been so very successful in a male-dominated business. Upon her husband's death, she and her five children kept the silver business open. Bateman became one of the most popular silversmiths in London, and her work is highly sought after today.

This sugar basket has all of the typical earmarks of the Neo-Classical Georgian style. The form is simple and classically inspired. It is decorated with pierced foliage, a small medallion over a grid, and trimmed in beadwork at top and bottom. There is tracery engraved in horizontal bands around the work, and a cobalt glass liner is visible through the pierced silver. The base is designed so that the round goblet appears to sit on a square base as a work of art might sit on a pedestal. Bateman, like so many Neo-Classical artists of the late eighteenth century, was inspired by Greek and Roman forms and designs. Rome in particular was wildly popular at this time due to the fairly recent discovery and ongoing excavation of Pompeii and Herculaneum. The excavation was yielding hundreds, maybe thousands, of objects which provided modern Europe with a new design vocabulary. The Neo-Classical style had emerged in France in the 1770s, along with revolutionary new ideas about humanism and democracy. The style carried its own meaning: Greek Democracy and the Roman Republic were seen by French (and American) revolutionaries as the precursors to modern democracies. Ironically, the style crossed the English channel to the British Empire and appears to have lost its political content. George III was king during the American Revolution, and so he was certainly no revolutionary. We can't read revolutionary content in the Georgian English style, even though the French did so.

JRC

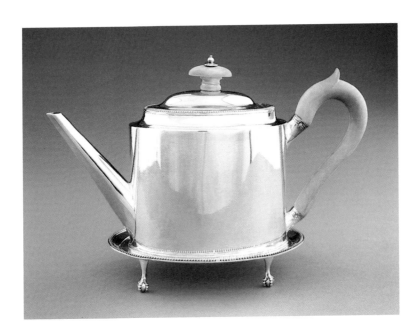

GEORGE III TEAPOT, 1785, AND TEAPOT STAND, 1783
Hester Bateman (1708–1794), London
Teapot: H. 6" L. 5" Wt. 13 oz.
Stand: H. 1" at rim W. 4⁷/₈" L. 6¹/₄" Wt. 4 oz.
72.1 Gift of Thomas S. and Harriet S. Gibbons

Among the more prominent eighteenth-century silversmiths, Hester
Bateman was presumably the head of a family concern, which, with
other family members (her husband, Jonathan; her brother-in-law,
Peter; her sister-in-law, Anne; and her son, William) lasted into the
nineteenth century. She was known for work of consistently high
quality and for her versatility: she had registered marks as a chainmaker,
smallworker, spoonmaker, plateworker, and goldsmith. She was known
as the "Queen of Silversmiths" and acquired the business upon the
death of her husband, as was permitted by law. She was the mother of
five children.
 This elegant teapot with its oval, straight-sided body and domed lid is
an excellent example of the Neo-Classical design favored during this
period. The teapot is plain except for bands of beading below the lid
and at the base. The lid has a wood lid lifter surmounted by a shaped
silver finial and is attached to the body with a flush hinge. The curved
wooden handle has a carved thumb mount.

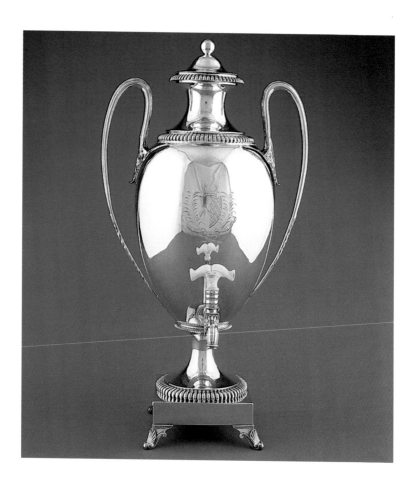

GEORGE III URN, 1787
John Scofield, London
H. 19⁵/₈" Wt. 108¹/₂ oz.
73.32 Gift of Thomas M. and Harriet S. Gibbons

Scofield was noted for his elegant candlesticks and candelabra and his impeccable craftsmanship. He was a platemaker who recorded marks from 1772 to 1796.

The demand for a larger vessel to be used at social functions caused the silver tea urn to be made. It was used to hold hot water, since tea brewed in urns was not palatable. This urn with its oviform body and high loop handles attached by acanthus leaves is designed with the classical simplicity of the period. The domed lid with ball finial is decorated with convex flutes that are repeated at the top of the body and base of the foot. The fluted spout has an ivory handle and is attached to the body with a beaded medallion. The spreading foot is mounted on a squared plinth with four feet decorated with scrolls and shells. The urn is engraved with arms on the front above the spout. A crest is engraved on the lid and base. There is a compartment for a heating iron, which was heated in the kitchen and dropped inside the urn to keep the liquid hot for hours.

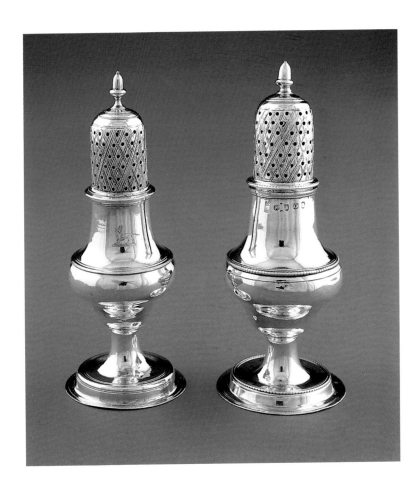

GEORGE III CASTERS, 1787–1789
Hester Bateman (1708–1794), London
H. 6" Wt. 2½ oz. each
72.5 and 72.6 Gift of Thomas M. and Harriet S. Gibbons

The caster came into use in the seventeenth century. Its use depended primarily upon the whim of its owner. It was basically a container for serving pepper, salt, vinegar, and other condiments, and its function necessarily limited the range of design possibilities. It needed to have a removable perforated top and a body readily grasped yet not easily overturned. The baluster shape came into use at the beginning of the eighteenth century and remained the basic design of casters with only minor changes.

These two casters are not identical, yet are strikingly similar in design. The removable lids on both are finely pierced and surmounted by acorn finials. Bands of beadwork, at the lower end of the lid and the shoulder on the caster at the left, edge the body and base. The caster at the right is decorated with threading instead of beading and is engraved with an unidentified crest.

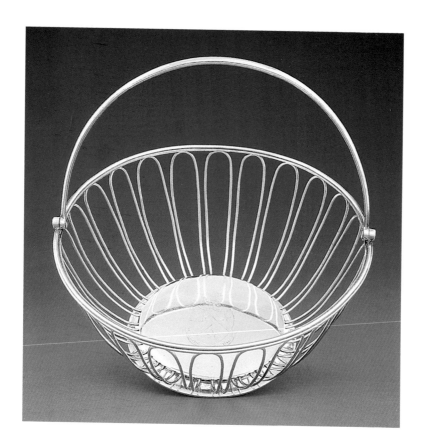

GEORGE III FRUIT BASKET, 1789
Henry Greenway, London
H. 4³/₈" Diam. 10¹/₈" Wt. 25 oz.
71.13 Gift of Thomas M. and Harriet S. Gibbons

Greenway was apprenticed to Charles Wright from January 9, 1765, until
June 6, 1772. He entered his mark as a largeworker in 1775 and as a
plateworker in 1790. This circular wire basket, with sides of high wire
loops held at the rim by a shaped wire border, features prominent engraved
arms (unidentified) in the bottom of the basket. It has a slightly convex,
shallow, footed base and a bail handle that repeats the design of the basket
border.

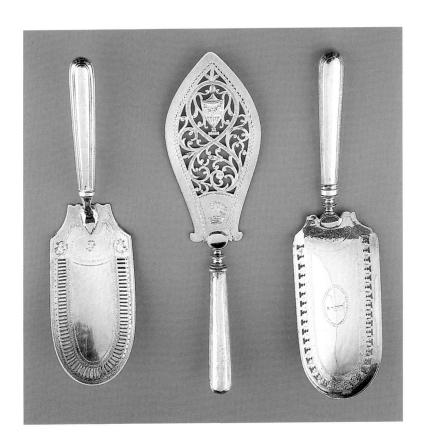

GEORGE III SERVERS, 1791–1799
Peter and Anne Bateman, London
Length of servers (left and center): 11½" Wt 5¾ oz. and 5 oz.
Length of server (right): 10¾" Wt. 5½ oz.
Left to right: 73.52, 73.51, 73.50 Gifts of Thomas M. and Harriet S. Gibbons

The flat server at the left was made solely by Anne Bateman. The other two were created jointly by Anne and her husband, Peter. The Bateman family, headed by Hester after the death of her husband, Jonathan, was known for excellent craftsmanship. These three servers are typical of the late eighteenth century, with pierced designs and bright-cut borders. The server on the left has an engraved crest centered with mailed fist holding flame-tipped sword with initial M. It has a hollow handle that was made by the artisan Mark Bock. The server in the center, called a "fish slice," has a hollow handle and a griffin on a crown engraved at the base of the blade. The flat shape is called a trowel design used until replaced by the leaf shape and the form of a scimitar. The server at right is the most simply designed of the three and is embellished only with script cipher.

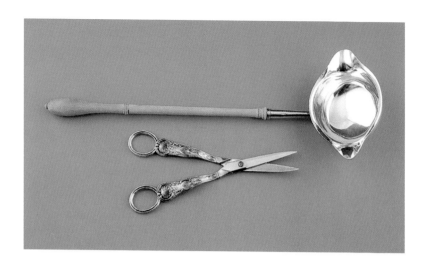

GEORGE III TODDY LADLE, 1794
Peter and Anne Bateman, London
L. 13¹/₄" Wt. 3 oz.
82.37 Gift of Thomas M. and Harriet S. Gibbons

This ladle was made by Hester Bateman's brother-in-law and his wife,
who worked as part of the Bateman family silversmithing business. It
features a double-lipped bowl with a fruitwood handle fitted into a silver
ferrule.

GEORGE III GRAPE SHEARS, 1816
William Eley and William Fearn, London
L. 6³/₄"
83.36 Gift of Thomas M. and Harriet S. Gibbons

This elegant pair of scissors was used only to snip grapes from the cluster
that was served in an epergne or basket. The design, called the "King's
pattern," is appropriate in that it features a grape motif.

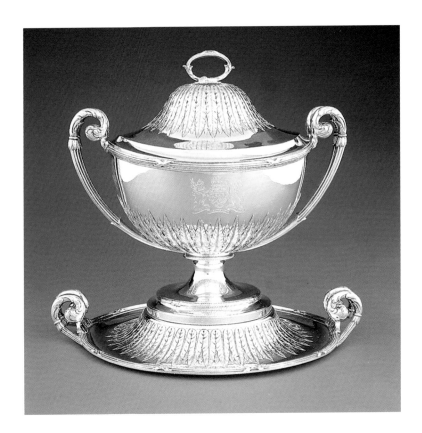

GEORGE III SOUP TUREEN AND STAND, 1795
Paul Storr (1771–1844), London
H. 12" combined W. 12" over handles of tureen
Diam. of stand 12" Wt. 105 oz.
76.10 Purchased by Eastman Memorial Foundation in Memory of
Thomas M. Gibbons

The word "tureen" is derived from the French *terrine*, an earthenware pot
used to hold soup or stew. The term is said to derive from the fact that
Marshal Turenne of France on one occasion used his helmet to hold soup.
Charles II, while in exile in France, learned the custom of using a tureen
to serve soup and brought the concept back to England. One of the
earliest silver tureens was made by Paul Lamerie in 1723. Paul Storr,
whose skill equaled that of Lamerie, probably made more tureens than
any other maker. This is one of his earliest.

 The hemispherical body with threaded rim has engraved arms above an
embossed and chased calyx of a leaf design with bifurcated handles that
terminate in foliate scrolls. The domed cover repeats the crest and the
chased leaf design and is surmounted by an openwork ribbon and tie
finial. The circular stand, which was used to prevent heat damage to the
table surface, has a raised center upon which the tureen sits and repeats
the leaf design and scroll handles.

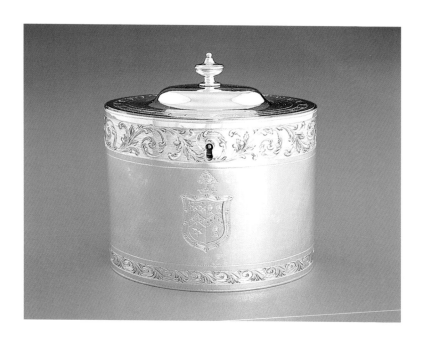

GEORGE III BISCUIT BOX, 1795
John Tayleur, London
H. 5½" L. 5⁵/₁₆" W. 3¾" Wt. 13 oz.
82.35 Gift of Thomas M. and Harriet S. Gibbons

John Tayleur was apprenticed as a goldsmith and registered his first mark
as a plateworker in 1775. He worked until 1784 and was recorded "free as
a gentleman" on July 2, 1794. This oval biscuit (cookie) box has a
brightcut floral band at the top and bottom edges. It is engraved with
both arms and crest. The stepped and hinged dome lid is topped with an
urn finial.

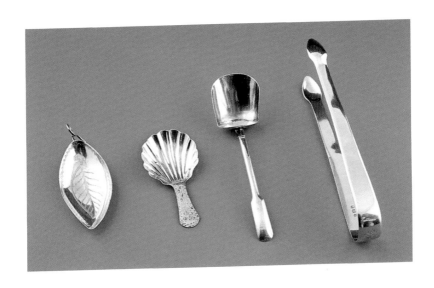

TEA CADDY SPOON, 1796
Elizabeth Morley, active 1794–1800, London
L. 3¹/₄" Wt. 0.5 oz.
82.19 Gift of Thomas M. and Harriet S. Gibbons

To measure the expensive tea, the thimblelike covers of the caddies were
originally used. Tea caddy spoons appeared toward the end of the
eighteenth century. They were made in innumerable shapes and designs
primarily in Birmingham, although London and Sheffield were also sources.
This spoon is designed as a leaf shape that is bright cut, with veined leaf
design and a handle representing a twisted stem.

TEA CADDY SPOON, 1786
Maker Unknown
L. 2⁷/₈" Wt. 0.4 oz.
82.21 Gift of Thomas M. and Harriet S. Gibbons
Shell bowl with bright-cut handles with cipher.

GEORGE III SUGAR SCUTTLE, 1817
Joseph Taylor, Birmingham
L. 4³/₄" Wt. 0.4 oz.
82.20 Gift of Thomas M. and Harriet S. Gibbons
Spoon with unadorned bowl and fiddle handle used to fill a sugar bowl.

GEORGE III SUGAR TONGS, 1797
George Baskerville (active 1732–1792), London
L. 5⁹/₁₆" Wt. 1 oz.
82.43 Gift of Thomas M. and Harriet S. Gibbons

When pieces of sugar were broken off the cone-shaped loaf, they were
dropped into the teacup by means of sugar tongs. By the late eighteenth
century, they were an accepted article of tea equipage. Samuel Johnson, who
described himself "as a hardened and shameless tea-drinker," made reference
to "the common decency of sugar tongs." The spring type, which is shown
here, was introduced at the end of the George II period and became very
popular. These lightweight tongs with plain oval claws are devoid of
decoration except for an unidentified cipher engraved on the end.

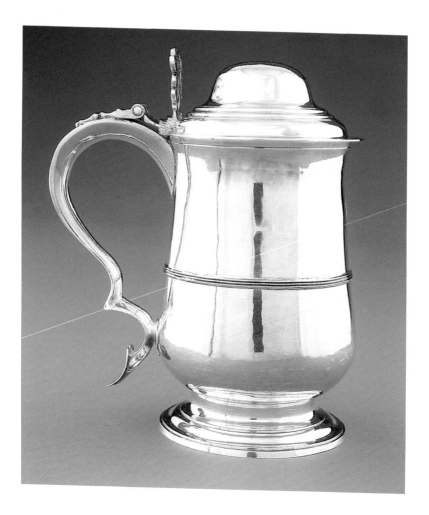

GEORGE III TANKARD, 1802
Peter, Anne, and William Bateman, London
H. 8¼" Diam. 4⅜" Wt. 26¾ oz.
73.38 Gift of Thomas M. and Harriet S. Gibbons

Drinking vessels account for an important part of English silversmithing from the days of the ancient drinking horn. Early jugs and flagons were gradually replaced by tankards, which were made in great quantity. Mugs, introduced in the late seventeenth century, were tankards without the lid and were used for beer.

The bulbous, tapered body on a circular molded foot is decorated by a raised reeded band that encircles the middle of the tankard. It has a stepped domed lid with a pierced thumbpiece and a double scroll handle terminating in a heart-shaped shield. The tankard is engraved with an initial. The greater consumption of wines and spirits that occurred during the latter half of the eighteenth century was partly responsible for the decline in the importance, and manufacture, of these vessels, which were used only for ale and stout.

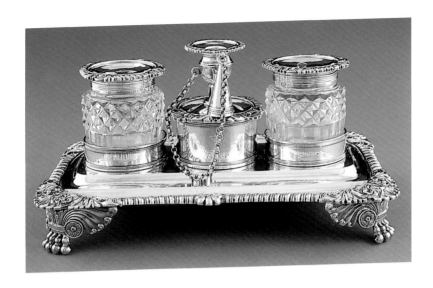

GEORGE III PARTIAL GILT INKSTAND, 1815
Rebecca Emes and Edward Barnard, London
L. 8½" W. 6" Wt. 37¾ oz.
73.67 Gift of Thomas M. and Harriet S. Gibbons

In 1808, Emes and Barnard entered into a partnership that was recorded as mark number 2309. They worked during the transition from the neoclassic style of Robert Adam (1728–1792) to a more ornate style reminiscent of Imperial Rome. This inkstand, or standish, is representative of the period, with its rectangular form, gadrooned shell, and foliate rim on four winged paw feet. At all times during the history of inkstand production, simplicity was the keynote.

The central cylindrical seal box supports a taperstick with snuffer fastened by a chain. Cut-glass jars fitted with hinged lids, one with three holes and the other with one, flank the seal box. The two jars and the sealbox are fitted with a cast motif at their upper rims that is similar to the design on the edge of the stand. The inkstand is engraved with cipher surmounted by a coronet.

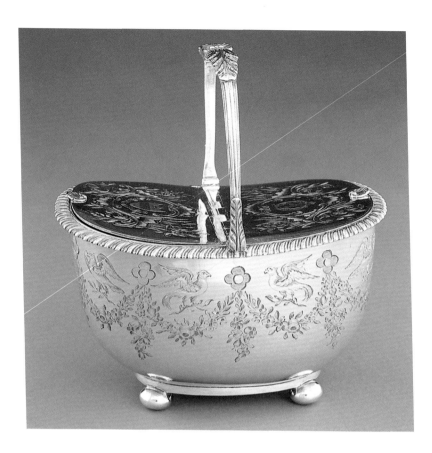

GEORGE III TEA CADDY OR BISCUIT BOX, 1817
Rebecca Emes and Edward Barnard, London
H. 7¼" W. 5⅛" L. 6¾" Wt. 25 oz.
73.42 Gift of Thomas M. and Harriet S. Gibbons

This silver container, made by the partnership of Emes and Barnard, is deep and oval shaped. Because it locks, it is thought to be a tea caddy. It has an escutcheon keyhole at each end with cartouches decorated with diaper work (surface design of a regular network of squares or lozenges). The box is embellished along the upper body with floral and bird garlands. The top rim is gadrooned, while the bottom is plain with four ball feet. The flat lid is center hinged and chased with shield and medallion in foliate cartouche and has shell thumbpieces at each end. The fixed handle with a double shell is made of heavy ribbed silver with applied acanthus leaf decoration at the center and at its attachment points to the body. One side is decorated with four birds, and the other has cartouches with diaper work. The underside has a script cipher WW.

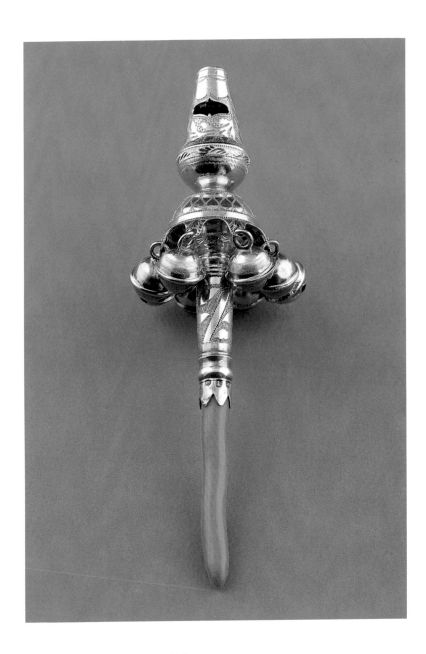

GEORGE IV BABY RATTLE, 1827
Joseph Taylor, Birmingham
L. 5³/₈" Wt. 1.3 oz.
82.34 Gift of Thomas M. and Harriet S. Gibbons

This sterling silver baby rattle has a whistle on top of a dome, to which
are attached eight bells. The decorations are bright cut. A pink coral
handle attaches to the body by a ferrule.

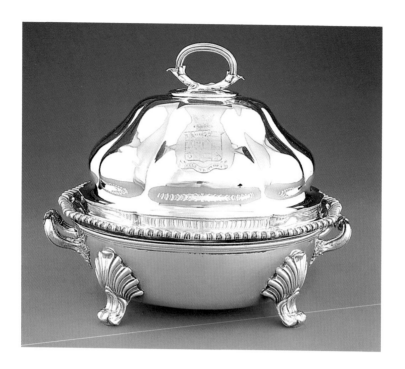

ONE OF A PAIR OF WILLIAM IV ENTRÉE DISHES WITH OLD SHEFFIELD
WARMERS, 1837
Storr and Mortimer, London
H. 10¾" Diam. 12¼" Wt. 50 oz.
73.31 Gift of Thomas M. and Harriet S. Gibbons

Entree dishes were introduced from France and were originally called
cover dishes or second course dishes. Many entree dishes were made in
sets of four to eight and were accompanied by so-called heaters in which
hot charcoal or boiling water was put. The kitchens in all large houses
were far removed from the dining rooms, and so these dishes also had
covers to help keep the food hot.

Paul Storr made the twelve-sided dish with gadrooned border. The dish
has a high-domed cover with removable reeded handles emerging from
leaf forms and is engraved with arms. Entree dishes were originally used
for a prepared dish coming between the fish and meat courses. In time
they came to be used for any dish, including vegetables and purees, that
needed to be kept hot.

The Sheffield warmer by Storr and Mortimer was designed to hold hot
water, so that the food in the dish was kept warm. The Sheffield silver
plating process was accidentally discovered in 1742 and was used until
1838, when electroplating was invented. The term Sheffield plate was
applied to objects made of copper and coated with silver by fusion; this
warmer is an example. The warmer has four scrolled feet attached to the
body with shell forms. Reeded handles join the body of the warmer with
an acanthus leaf motif. The base and water container are copper lined.

NOTES

European Art:
1. Norman L. Goldberg, *John Crome the Elder, 1. Text and a Critical Catalogue*, 2 vols. (New York: NYU Press, 1987), 1:73–74.

American Art:
2. Michael D. Zellman, *Three Hundred Years of American Art*, 2 vols. (Secaucus, NJ: The Wellfleet Press, 1987), 1:96.
3. Object files, LRMA.
4. Zellman, 1:290.
5. Object files, LRMA.
6. Zellman, 2:515
7. James Creelman, "An American Painter of the English Court," *Munsey's Magazine*, no. 2, 14 (November 1895), p. 130.
8. Zellman, 2:263
9. Earl A. Powell III, "Introduction," in *Milton Avery, Drawings and Paintings*, exh. cat. 12/15/76–4/17/77, (Austin, TX: The University of Texas Art Museum, 1976), 7.
10. Zellman, 2:835.
11. Louis Dollarhide, *Jackson* (Miss.) *Daily News*, 15 November, 1970.
12. Zellman, 2:846.
13. A. Neel, doctoral address, Moore College of Art, Philadelphia, PA, June 1974.
14. Zellman, 2:911.
15. Ibid., p. 931.
16. John Winslow, Artist Information Sheet, LRMA Files, 20 October, 1984.

Japanese Prints:
17. Frederick Gookin, Translator, c. 1925, LRMA, Registration Records.
18. Ibid.

GLOSSARY

Aizuri-é: A type of Japanese woodblock print in which blue is the predominant color.

Aquatint: A method of etching a plate for the reproduction of areas similar in tone to watercolor washes. The technique of aquatint is generally followed by engraving or additional etching of the plate.

Assay: Test to determine metallic composition.

Baize: A coarse cotton or wool fabric napped to resemble felt.

Bam-tsu-wu weave: Pomo Indian term describing a variation of coil weaving.

Beni-é: A black-line hand-colored Japanese print in which the dominant color is *beni* (a tawny yellow dye extracted from petals of safflowers) applied with a brush.

Beni-girai: Color prints using only pale pastel tints. Mostly found in Japanese prints published about 1790.

Benizuri-e: Polychromed Japanese print, at first pink and green, later with addition of yellow and purple.

Bijin-ga: Japanese prints illustrating beautiful women.

Bobechette: A collar to catch wax drippings on a candleholder.

Bright cut: Executed using short, sharp strokes of the graver, or cutting tool.

Cartouche: An ornamental shield or frame.

Caster: A container for serving condiments.

Chamfered: Beveled.

Chiaroscuro: The use of marked constrasts between light and dark for decorative or dramatic effect in paintings.

Chinoiserie: Decorative work influenced by Chinese art; the vogue for chinoiserie peaked during the eighteenth century and concluded about 1795.

Chuban: Japanese print size, about 8 x 12 inches.

Cipher: Combination of symbolic letters, for example, theinterwoven initials of a name.

Collage: A pictorial composition created by attaching paper, fabrics, and natural or manufactured material to a canvas or panel.

Copperplate engraving: Engraving made by incising a copper plate using a graver (burin), or cutting tool, with an image that will hold ink for transfer to paper.

Diaper pattern: Pattern of small repeated units that are connected.

Diptych: Artwork with two panels.

Epergne: An often ornate, tiered centerpiece including dishes, vases, and/or candleholders.

Escutcheon: A protective shield or plate, for example, around a lock.

Etching: A print produced from a plate on which an image has been fixed by the corrosive action of acid.

Ferrule: A short tube that helps make a tight joint.

Finial: A crowning ornament or detail.

Gadroon: An ornamentally notched or carved rounded molding.

Genre scenes: Scenes from everyday life, usually realistically depicted.

Gō: Japanese artist's pseudonym.

Guilloche pattern: Pattern involving two or more interlaced bands with openings containing round devices.

Hashira-é: Japanese pillar print or painting about $27^{1/2}$–$29^{1/4}$ x $4^{3/4}$–6 inches. A long, narrow picture hung on an interior post as a decoration.

Hosoban: Japanese print size. A narrow vertical print about 6 x 13 inches.

Imbrication: A repeating design with overlapping units.

Incuse points: Punched or stamped areas.

Largeworker: English silver or goldsmith qualified to make or repair large objects (i.e., holloware).

Lithograph: A print made from a flat surface treated to make the image area receive ink, while the blank area repels ink.

Monotype: A one-of-a-kind print made by painting on glass and transferring the image to paper pressed against the glass and rubbed with a smooth implement, such as a spoon.

Mordant: A substance that sets or precipitates a dye and assists in attaching it to fibers.

Nanga painting: Literary men's school of painting. Originally influenced by eighteenth century Chinese painting. Unlike other Japanese painting schools, it was not dependent on family relationships and its members sought to be individual in their painting.

Nishiki-e: Elaborate polychromed Japanese print in more than ten colors. Also known as a brocade picture.

Oban: Japanese print size. The standard format about 15 x 10 inches.

Okubi-e: Japanese bust portraits.

Painterly: Having the quality of expertly brushed workmanship; technically excellent in terms of control of brush and medium; pleasing in handling of color.

Pentaptych: Artwork with five panels.

Pillar print: See Hashira-é.

Plein-air: Literally, "open air," used with reference to painting executed outdoors.

Plinth: A block, usually square, that serves as a base.

Saw cut: (Baskets and strainers). Also saw pierced. Method of fabricating metal objects which have a perforated design.

Serigraph: Silkscreen, a color stencil process in which a squeegee is used to force ink through a fine screen on which the non-printing areas have been blocked out.

Shagreen: Untanned leather covered with small round granulations and usually dyed green.

Shibu weave: Pomo Indian term describing a variation of coil weaving.

Skip stitch: A stitch used to produce a geometric design, especially on the brim of a hat.

Smallworker: English silver or goldsmith qualified to make or repair small objects (i.e., flatware).

Sumizuri-é: A black-and-white Japanese print.

Swag: A suspended cluster hanging in a curve between two points.

Ta-pi-ca: Saucer-shaped basket.

Tondo: A circular painting.

Totemic: Involving objects that are considered emblems of a Native American tribe and that often serve as reminders of its ancestry.

Triptych: Artwork with three panels.

Ukiyo-e: Literally, "pictures of the floating world," "floating" being used in the Buddhist sense of "transient." The Ukiyo-e school in Japan with its paintings and prints sought to depict the world of everyday life and especially pleasure—theater, dance, love, and festivals.

Urushi-é: Literally, "lacquer picture." In narrowest sense, the term refers to true lacquer painting, in which lacquer serves as a binding agent; more broadly, to all lacquer painting techniques as opposed to "sprinkled" makie techniques. Also, a hand-colored Japanese print in which transparent glue is used to create a lacquerlike effect.

Warp: A series of yarns extended lengthwise in a loom.

Woof: A filling thread or yarn in a weaving that crosses the warp.

Yoko-Oban: Japanese print size with a horizontal format, about 10 x 15 inches.

INDEX